Painting the Mountain Landscape

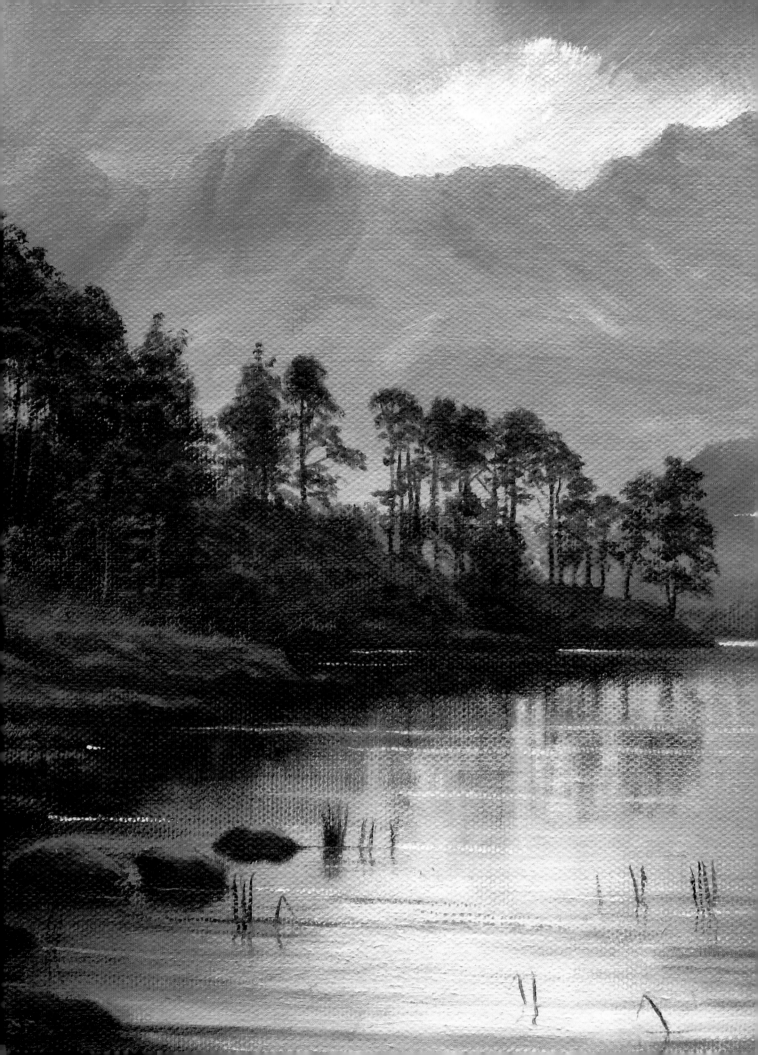

Painting the Mountain Landscape

Eileen Clark

THE CROWOOD PRESS

First published in 2021 by
The Crowood Press Ltd
Ramsbury, Marlborough
Wiltshire SN8 2HR

enquiries@crowood.com
www.crowood.com

**British Library Cataloguing-in-
Publication Data**
A catalogue record for this book is
available from the British Library.

ISBN 978 1 78500 844 3

Dedication

I would like to thank my family, including my sister-in-law, nephews and niece, and friends in the UK and abroad for all their encouragement throughout the years. Thank you to my late father, my mother and brother for so many adventures in the mountains, and to my husband and son for being my ever-obliging boat crew. Thank you also to my husband for his patience and dedication during the production of this book. Without his IT and photographic skills many of my images would no longer have been available to me.

Lastly, thanks so much to the late Peter Graham of Thornthwaite Galleries, to Beckstones Gallery, Cumbria, my friends in the Cockermouth artists, and to my wonderful framer David Scott, of Gray's Framers, Carlisle.

Acknowledgements

To Graham Clark, for photography, IT assistance and Chapter 11.

Graphic design and typesetting by Peggy & Co. Design
Printed and bound in India by Parksons Graphics

Contents

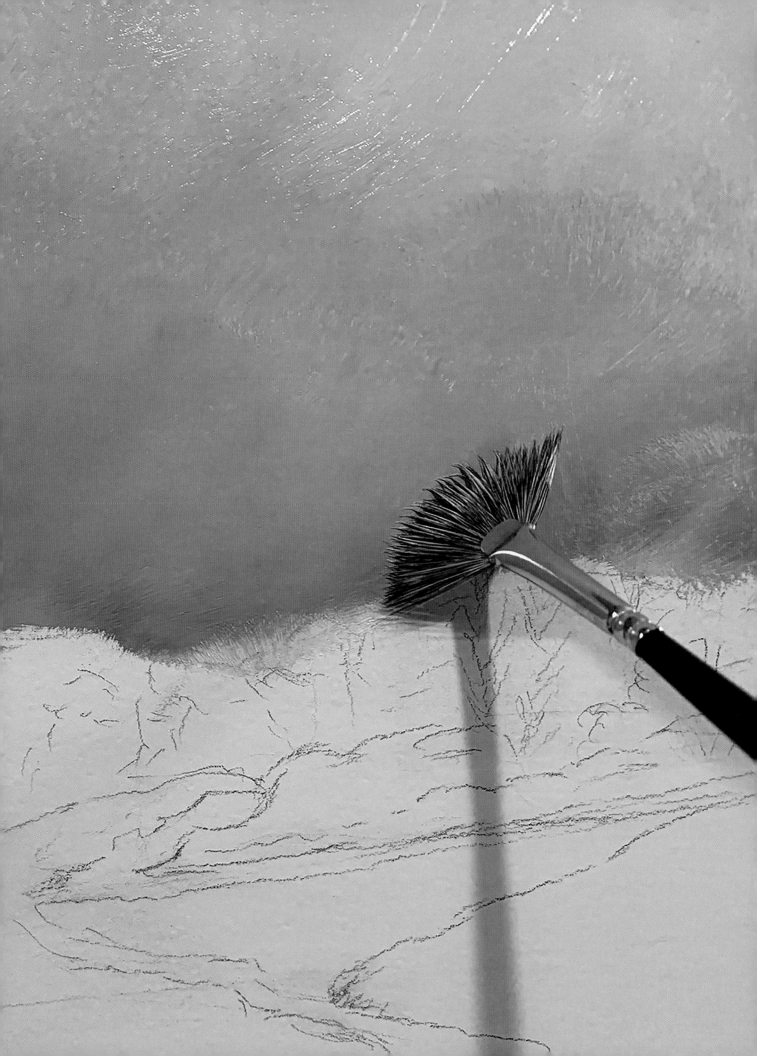

Introduction

Throughout the history of art, painters have chosen to include mountains in their works. Some artists, often working on commission, reduced even high mountains to flat backdrops against which they set religious and historical pieces and portraits. Others, like John Martin, the nineteenth-century English Romantic painter, produced vast canvases, depicting expansive and dramatic mountain scenery. Martin's work included tiny historical, mythological and religious figures – the titles often referring to stories and events involving the characters depicted, for instance, in the painting *Macbeth*. Despite the reservations of some at the time, these paintings were, and still are, loved by the public. Today, happily, artists have unparalleled freedom to paint their own interpretations of the mountains.

To many, mountains represent both a precious wilderness, which remains almost untouched, and a sanctuary – some people, visitors and dwellers alike, simply climb or walk to experience 'being there'. As artists, though, we are often trying to convey different moods and atmospheres in our work, from excitement to a sense of peace and refuge. As subject matter, the mountains are truly obliging. They offer a stunning array of changing light and colours, which transform with every visit. It would be entirely possible to paint the same mountain view many times, each picture different to the last.

Your childhood might have been spent in and around mountains, like my own, or you may be approaching them afresh. Whatever your previous experience, I hope that as you work through each chapter and step-by-step exercise, your confidence grows. Having the basic issues 'ironed out', choices such as media, surface, colour and handling of light and shade will mean that you are able to express your own vision of the mountains – and this applies whether they are the 'fells' of the English Lake District or any of the other incredibly beautiful mountain ranges around the world.

Two painters who originally inspired me as a student to seek out their work were J.M.W. Turner and Alfred de Breanski Senior, and I would encourage you to find mountain artists whom you feel to be impressive and energizing. Studying and practising these artists' styles and techniques has oddly, in the past, sometimes been seen as some kind of 'cheating'. Not so – this has been an important and respected way of learning amongst artists for centuries.

Lastly, I would like to encourage you to take notice of the technical advice given, but importantly do not allow this to stifle your own originality. The choices of mediums, brushes and surfaces are for guidance and are not absolutes. If you paint a mountain scene that you like, and you are happy with it – even if it is by accident and it breaks the rules – do not forget that you are the creator. You decide. It is your work.

◀ The art of using a fan brush.

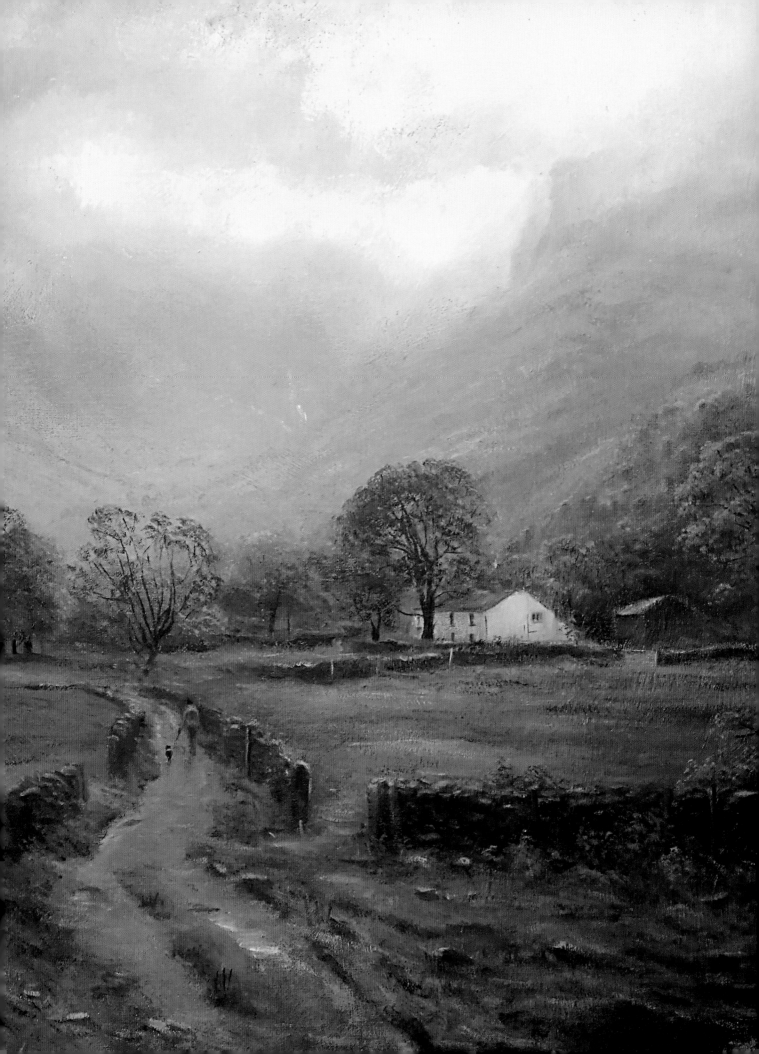

Resourcing: 'The Ins and Outs'

*Fine art is that in which the hand, the head,
and the heart of man go together.*

JOHN RUSKIN

Making a start on mountain painting will be different for everyone. It will depend very much on previous experience. If this is your first venture into painting, then you will have all the joy and excitement of exploring the extensive world of artistic materials for the first time. Beware though, it is an 'Aladdin's Cave' and the temptations are everywhere.

Before rushing out and filling a basket with numerous brushes, supports, 'magic' mediums and vibrant colours, stand back and consider what basic materials are really needed. This chapter addresses the basic needs of the mountain painter. The intention is to avoid the whole process becoming too expensive and over-complicated, and hopefully doing that without spoiling the pleasure of finding the right materials.

More experienced painters will be aware of the pitfalls of 'over-buying', but mountain painting will be likely to require a new set of 'essentials'. Items that have always been a cornerstone of your work may no longer be ideal. The well-used colours in your paint box, along with favoured brushes, may need to be added to or replaced.

Studio or outdoors?

Early decision-making is difficult without knowing where, when and how you intend to paint. One of the first decisions to make is whether to work outdoors (known as en plein air) or in the studio. A change of mind along the way, though, is of course distinctly possible. Painting, sketching and taking photographs outdoors in a mountain landscape can be a challenge, and this topic is explored in more detail in Chapter 2.

At this point, it is a good idea to buy basics for both, until preferences are decided upon. My own practice often involves gathering sketches and photographs, then returning to the studio for completion. Sometimes I prepare a support (canvas or board) by priming with a basic colour, then I paint on it outdoors, and finally return to the studio to concentrate on glazes and details. These kinds of routines are developed over time, however, and there does not seem to be a consensus amongst painters as to which is 'best'.

◀ *A Day in the Fells, Stonethwaite, Borrowdale*, detail, oil on canvas.

ACRYLICS

Pros

- Acrylics are easy to set up; can be painted on just about any surface.
- They dry very quickly, so it is easy to build up layers of thin and thick textures (excellent if you are creating the varied appearance of a mountainside, or using texture to create drama, as in a mountain storm scene).
- It is easy to create a sharp outline and clean colours using acrylics because of the drying time. For instance, acrylics would be a good choice to provide sharp clarity in order to make a ridge or a mountain summit stand out against the sky.
- Water is the only thinner needed for washing and thinning (although there are lots of specialized mediums for acrylics), and this avoids the smell and fumes of oil painting mediums.
- Unlike oils, the colours of acrylics do not fade over time.

Cons

- Some acrylics dry darker because of the white binder, which dries clear – buying good quality acrylics (such as Golden) will help to avoid this. This can cause difficulty in controlling contrasts, which are often a key element of a mountain landscape.
- Acrylics are much harder to blend than oils due to their quick drying time. Unwanted edges appear between sky and mountain ridges, or in vegetation. This can be very frustrating and often difficult to get rid of. Slow-drying acrylics help to avoid these issues.

OILS

Pros

- Oils are excellent for blending. The colours of the mountainside, and those of the sky and the mountains, often blend very subtly into one another. Using oils, which dry slowly, helps enormously with this blending process. Unattractive edges can be easily blended away.
- Colours can be adjusted, modified and merged. This allows 'wet on wet' over a number of days when using standard oils. Drying (curing) time can be extended further by adding various oil solvents.
- Oils are perfect for 'glazing' (a process in which a thin layer of paint floats over an opaque layer that is still visible and reflects the light). This technique is invaluable to the mountain painter who wants to achieve 'glowing' mountainsides and skies. My favourite combination is a Titanium White base with a thin glaze mixed from Burnt Sienna, yellow and red.

Cons

- Oils (unlike acrylics) need a specially prepared surface, as otherwise the oil will be absorbed into the support.
- The colours of oils, although they do not change or lighten as they 'cure', can fade or yellow over time.
- Solvents or resins are needed for cleaning and thinning, unless using specialized water-soluble oils. Most of these solvents will create fumes that can be very unpleasant, especially if working in an enclosed space.

WATERCOLOURS

Pros

- Watercolours are inexpensive, and can be purchased in small blocks or tubes. They are very easy to transport and to use in their simplest form.
- They can be painted on special paper, which is cheaper than either canvases or boards.
- Paper and paints are lightweight, especially appropriate if you are travelling on foot into the mountains.
- They dry very quickly, and so painting layers of colour and washes can create wonderful, luminous effects of light and shadow.
- They offer a wide variety of techniques to master, such as 'dry brush' and 'wet brush'.

Cons

- They can lighten and change colour as they dry.
- Mistakes are difficult to rectify by painting over, and often the artist has to 'make the best of them'.
- They are very susceptible to damage by water, which is not ideal for the mountain painter, especially if you live in an area prone to rain. I have discovered this in the English Lake District a number of times, to my cost.

BASIC MATERIALS: WHAT DO I REALLY NEED?

Studio basics

This section begins with studio basics. Quite a lot of outdoor equipment, discussed later in this chapter, can be found amongst your main supplies. Some people have a completely separate kit for outdoors and only replenish as necessary; others make up a new set each time. A compromise solution is to have a basic outdoor set that is modified and checked according to the needs of the outing. One advantage of this strategy is that the dried-up old paint tube is spotted before a several-mile journey into the mountain scenery has been made.

Paints

The array of paints on offer is enormous. Most of the step-by-step exercises in this book use largely acrylics or oils. I personally find these two the most conducive media for capturing all the different moods of the mountain landscape. The other great advantage of oils and acrylics over some other media is that mistakes are much easier to rectify, especially when working on a large studio piece.

Over the last few years, the technical aspects of using both oil and acrylic paints have changed rather dramatically. We now have oil paints like Holbein Duo Aqua Oil, which can be thinned, mixed and washed out with water. Also available are paints like Golden Open Acrylics, which dry in a similar timeframe to oil paints. Some of the old rules have broken down, but they are useful to know and, unless you are buying special paints like the two mentioned here, they still apply.

Colours

Colours that may have the same name can appear slightly darker or lighter, more or less intense, and more or less transparent depending on the media and the support ('support': the surface on which the media is applied). Ultramarine Blue, for instance, a colour that you will come across in every chapter of this book, can appear differently in its various forms. Although different forms of Ultramarine Blue will usually be an intense blue, tending towards red on the spectrum, the colour found in different media will often not be identical.

It is easy to be attracted to some of the most beautiful, vibrant colours, which are available in all the above mediums, but it is likely that a spending spree will result in many tubes left in the cupboard, unused. The colours

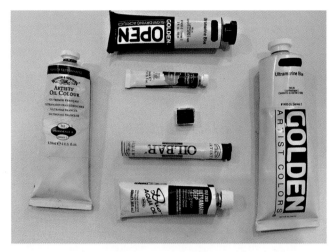

Ultramarine Blue, pictured here in seven different media is, in my opinion, one of the most important colours to the mountain painter, as it links sky, mountains and water. Shown as follows: large tube (left) oil paint, large tube 120ml Winsor and Newton; large tube (right) acrylic paint, large tube 120ml Golden. Small tubes and blocks from top to bottom: slow-drying acrylic paint (created with a drying time equivalent to oils), 59ml Golden Open; water colour in a tube (in liquid form), 8ml Cotman; watercolour in a small block (part of a small set), Cotman; oil colour in a bar which can be used like paint when mixed with oil, or applied directly onto the surface and then blended, Winsor and Newton; water mixable oil, 40ml, brushes can be washed out with water, Holbein Duo Aqua.

needed to paint a mountain landscape will vary according to the chosen mountain range, and also to the season and to the weather at the time. It is likely, however, that over time you will favour some colours over others – and will mix them to meet the changing circumstances. Some manufacturers have special 'landscape' packs, which contain earth and sky colours. My main objection to these packs is that all the tubes are usually the same size in a pack. I find that some paints, such as Titanium White and Ultramarine Blue, are used in much greater quantities than those used to tint other colours. I always have Alizarin Crimson, for instance, but use only a little, and a large tube lasts a very long time (as long as I don't leave it open in its acrylic form, of course).

Try mixing the essential shades together as shown in the four photographs on page 12. The step-by-step exercises in this book are based mainly around the colours that are recommended here. They are also the ones I could not do without. I am not suggesting that you limit yourself entirely to these colours, but at this early stage it is not necessary to have a greater range. At the beginning of each exercise there is a brief list of the paints and supports that are needed. If you prefer oils to acrylics you will find that quick-drying oils are recommended, as are water-based oils for those who prefer to avoid the fumes.

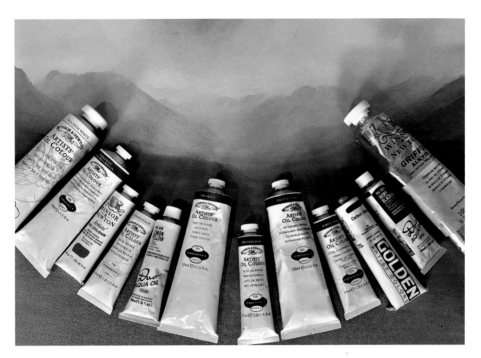

Mountain colours: these colours, with careful mixing, can provide all the hues and tones a mountain painter might desire, from the brightest highlights to the deepest rich shadows. For me they are essential, and I rarely need to buy any new colours, although it is always fun to experiment.

Burnt Sienna, mixed with a little Winsor Yellow and Titanium White, will produce a rich, earthy mid-brown.

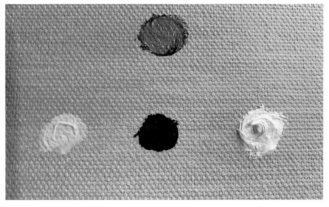

Add some Lemon Yellow to Alizarin Crimson and Titanium White to produce a glowing rich orange, suitable for highlights in vegetation.

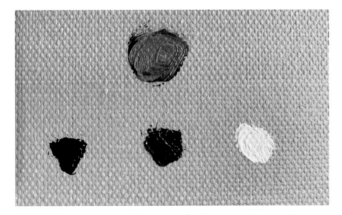

Mixing Ultramarine Blue with Sap Green and Titanium White produces a rich, natural-looking green for painting woods and foliage.

Ultramarine Blue, Sap Green and Burnt Sienna mixed together produce a deep rich shade, ideal for dark mountain shadows.

PAINTS: ESSENTIAL COLOURS

Underpainting White 120 ml: Better and safer than Titanium White for underpainting, this paint can be tinted to provide a coloured ground.

Titanium White 120ml: A large tube of this is most economical and will probably be needed. This is the whitest of the whites, and opaque. It is the best white for really bright highlights in the sky, water and rocks. It is good for mixing rather than underpainting.

Colours pictured here from left to right: Top: Underpainting White; Titanium White; Alizarin Crimson; Naphthol Red; Burnt Sienna; Burnt Umber. Bottom: Winsor Yellow; Lemon Yellow; Sap Green; Prussian Blue; Ultramarine Blue; Ivory Black.

Alizarin Crimson 40ml: This colour could easily be overused. It is a strong tint and tends slightly towards blue. Mixing it with other colours creates some deep rich tones (a basic palette conventionally includes both a warm and a cool red, but I find Alizarin Crimson the most useful if you have a limited budget and want to buy only one red).

Naphthol Red 40ml: A modern pigment. Bright, powerful and can easily be overdone.

Burnt Sienna 120ml: A warm earth colour that can be used to create a glowing appearance on the mountain landscape and sky. It is particularly useful when painting autumn and evening scenes. Mixed with white, yellows and reds, it helps to emphasize warm highlights.

Burnt Umber 40ml: Like Burnt Sienna but darker, this colour is a rich earth with red undertones. Mixing a little blue with Burnt Sienna will create this tone, if you wish to economize. It is particularly helpful when painting areas of dark mountainside and vegetation.

Winsor Yellow 40ml: Combined with a small amount of Burnt Sienna or Alizarin Crimson, either this yellow or Lemon Yellow will boost the warmth and strength of highlights, particularly on vegetation and high pastures. As with any yellows, they can be overused and become dominant.

Lemon Yellow 40ml: Lemon Yellow is considered a cooler yellow as it tends towards green, whereas Winsor is warmer and more transparent.

Prussian Blue 40ml: This colour is closer to yellow than red, compared to Ultramarine Blue. I use this colour mostly to create a cyan effect on water or sky. It is a strong colour and its blue/green tone can become too overbearing if used liberally in a mountainscape.

Ultramarine Blue 120ml: This blue is indispensable. It is perfect mixed with Titanium White for skies, water and snow, essential for shadow colours and, usefully, it is a transparent oil paint – so good as a glaze. Mixed in varied quantities with Sap Green, it helps to create the illusion of distance in woodland vegetation. Unlike Prussian Blue, it does not have a hint of green.

Sap Green 120ml: This green is particularly useful for painting vegetation and green mountain slopes – not as bright as many greens but easily brightened by mixing with other colours. Using it helps to avoid garish greens and instead create more subtle colours.

Carbon or Ivory Black 40ml: A small tube should suffice. Carbon blacks are more transparent than Mars black, which is much darker and denser – and I find too strong. Ivory Black has a brown tone, which is helpful when painting vegetation and moorland in autumn and evening scenes. Mixed with white, yellows and reds, it helps to emphasize warm highlights. As a rule, my advice is to use black sparingly; mixing dark shades is preferable to create richness.

Supports (the painting surfaces)

There are now so many supports to choose from, deciding which one to select can be mind-boggling. Gone are the days when artists had no option but to struggle with long preparations of stretched canvases, wood or paper, though some artists still prefer to start from scratch.

There are three key questions to ask yourself when buying a support:

1. Does the surface match the paints that you have chosen? Many surfaces will take both oils and acrylics, but it is best to check. It is stated clearly on most supports which paints are appropriate.
2. Do you want to prepare your own surface, or buy one already prepared? Preparing a support yourself may involve the following:

'Stretching the surface'. Canvas has to be stretched over wooden stretcher bars. Watercolour paper, because it will buckle when wet, must be soaked and then stretched over a strong solid board (unless it is 200lb weight or over, which is high quality, more expensive paper). There are lots of instruction videos and sheets available; you will find these easily on the websites of the art retailers who sell the supports, but although the instructions are simple, the processes are time-consuming.

'Sizing'. This is not 'sizing' in the sense of what dimensions to use; instead it refers to the process of applying a glue-like substance in order to make the canvas or wood less porous, and to protect it.

'Priming' means coating the surface with an undercoat, which protects it and allows better adhesion of the paint.

If this is all new to you, then my advice is to choose one of the many quality, pre-prepared and readily available surfaces – often less expensive than buying all the equipment needed to do it yourself.

3. Is the support available in the size you would like to use?

Some supports are not viable at large sizes; for instance, thin panels are vulnerable to warping. Most manufacturers supply a large array of sizes in landscape formats that are suitable for mountain paintings. If you come across 'French Standard' sizes, these refer to the sizes of canvas used at one time by most artists, and this standardization dates back to the nineteenth century. Now, the sizes are rarely classified in the same way, and the best tactic is to get out your measuring tape. I have a set of templates, drawn up on a large cardboard box, which helps me envisage the size when I am ordering. The standard proportion for a landscape canvas is usually around 3:4 (height to width), which allows for development of foreground, midground and distance in a mountain landscape. If a more elongated size is needed, the French 'Paysage' sizes, which have a lower ratio of height to width, are still available from some suppliers.

A word of warning when deciding on the support: be aware that different countries often use different standard sizes. If the canvas or board is bought from a manufacturer outside your country of residence, it may be a struggle to find standard frames nearer to home. This is not a problem if using a bespoke framer, but can be difficult on a tight budget.

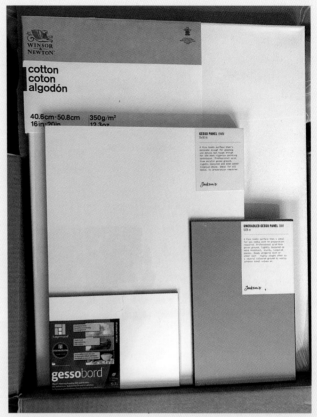

SUPPORTS

For the purposes of the step-by-step exercises later on in this book, either boards or canvases are needed. For each exercise I have indicated roughly the size that is most appropriate, but there is no specific limitation on size. Have a look through the book and decide which exercises you would like to try before buying supports. Most large, reputable manufacturers produce fully prepared surfaces, including canvases and boards, which come ready to open up, put on the easel and paint. Do not forget the importance of weight if planning to carry the canvas or board. High quality canvas with strong stretcher bars can be surprisingly heavy.

All these supports seen in the photo are ready to use. The canvas is stretched and prepared with an acrylic primer. This does not prevent painting on a coloured layer as a base. Notice that it is pinned at the back, which is useful if you want to use it unframed. Boards are an alternative to a canvas, and I recommend that you give both of them a try. Some artists find that they like the slight 'bounce' and texture of a canvas, and some the more solid, smooth feel of the panels and boards.

The availability and diversity of these boards have increased hugely over the past few years, and prices have fallen. You can now buy them coloured, like the one in the photo, which is coloured with an umber wash – a neutral base colour which is particularly appropriate for mountain scenes.

Panels and boards are usually 'cradled' or 'uncradled', meaning that they either have a wooden support framework at the back, or are completely flat. The uncradled variety of panels are lightweight and excellent for carrying into the mountains. Cradled panels and boards are stronger, heavier, less liable to warp and better for studio work.

Supports pictured here from top to bottom, clockwise: Winsor and Newton cotton canvas, 16 × 20in, medium surface, back stapled and gesso primed; can be used for acrylic or oil painting. Jacksons Gesso Panel, 11 × 4in, fine tooth surface, cradled and primed; can be used for all media. Jacksons Uncradled Gesso Panel, 6 × 9in, fine tooth surface, primed, umber wash; can be used for all media. Ampersand Gessobord, 5 × 7in, fine tooth surface, primed, uncradled; can be used for oil, alkyds, acrylics, collage and mixed media.

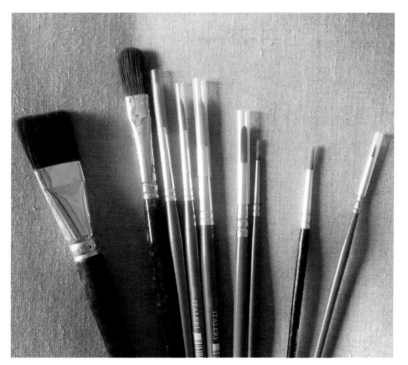

Round and flat brushes: all these brushes are synthetic, but similar shapes and sizes will be available in natural materials such as bristle and hog if you prefer them. (From left to right) **Flat brush:** a Galeria short-handled one-stroke/wash brush, 1in wide. This brush is strong but soft, and loads easily. I find this style of brush highly effective when painting in a coloured ground. Although it is designed for acrylics, it works with oils too. Its softness means that it is ideally suited for blending, especially when using diluted media for the initial coloured layer of paint. **Filbert brush:** a Galeria long-handled filbert brush, size 12. The filbert-shaped head has both the advantages of a round and a flat brush. This is a large brush that works well with thick paint. **Round brushes:** all these brushes are somewhat confusingly classed as 'round' brushes. This brush shape comes in various forms. Some have a sharp point, while others are round at the end. I find the round-ended brushes essential for painting the details of mountains and skies, but the pointed ends more difficult to handle. Again, the choice of brush is closely linked to painting style, and some artists find the pointed ends essential for detailed work. Notice the little plastic sleeves on the tips which protect the fibres. Hold on to these, as they help prevent accidental twisting and bending of the fibres, and can be re-used.

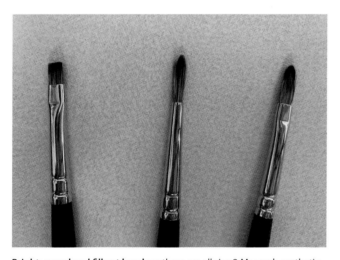

Bright, round and filbert brushes: these are all size 2 Monarch synthetic brushes, but are available in many sizes and in natural materials. (From left to right) **Bright brush:** these have a square end with an inward curved tip. They are useful for heavy filling as they hold a lot of paint – similar to a flat brush, but easier to control when making short strokes. **Round brush:** round brushes are extremely versatile and essential for fine lines and detail. **Filbert brush:** this is an oval-shaped brush. The edges are soft and round, and it is a useful brush for blending.

Brushes

There is no substitute for spending time experimenting with brushes to find out which ones are most suitable for your individual style of painting. I use both filbert and flat brushes, but often complete a painting using only fan brushes and a couple of round ones, (which I sometimes flatten out slightly or mould to create certain effects). Brushes come in many sizes and shapes. It is important to be able to recognize the ones which will be most useful for blending skies and mountain surfaces, and for painting details such as trees and vegetation.

Common brush sizes range from size 00, which is a very small brush, to the large, size 20. For the purposes of this book, the brushes needed range from size 1 to size 12. It is safest to buy from a recognized name who uses standardized measurements to begin with in order to avoid confusion about shapes and sizes. Sometimes, though, it is possible to find very economical brushes on offer or in a bargain basement store, which will do the job well. It is often worth buying one or two and giving them a try.

Some artists, particularly oil painters, insist that they need brushes made of animal hair. However, there are many, like me, who find that modern synthetic brushes function as well as, if not better than, the natural brushes which they are designed to replace. They work well with

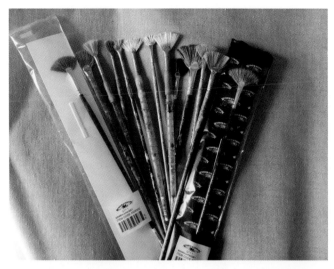

Fan brushes: this is my current collection, including some old ones and some new, which are still in their packaging. The soft-tipped fan brushes are the most suitable for blending, and the stiffer and older ones are perfect for creating rough textures. Trimming the ends off the tips of fan brushes can give them a longer life, and they can also be used to create interesting effects.

both acrylics and oils, and they also seem to survive mis-treatment really well (few artists can claim to have always treated their brushes with absolute respect, although we may try).

The fan brush is one that should not be overlooked. Mountain painters work with landscapes in which variations in tone are commonplace, and therefore must find a brush which meets this need. I often wonder how I managed to paint mountains and water at all before I discovered the fan brush. As a tool that creates various textures and simultaneously and easily blends tones, it is unbeatable.

It might take some time before you know which kinds of brushes to use regularly, if you are new to painting. At this stage, do not buy too many of one particular kind until you become familiar with your preferences. Conventional advice will often indicate stiff brushes like 'hog hair' and soft brushes like sable (or similar synthetic substitutes) for oils; squirrel hair for watercolours; and usually synthetics for acrylics. Long-handled brushes allow the artist to see more of the composition as they paint, whereas short-handled are more useful for close, detailed work.

WHAT TO BUY

BRUSHES

The sizes recommended in each step-by-step exercise in this book are intended only for initial guidance, and as you develop your own mountain painting techniques and style, as you surely will, you may find that other shapes and sizes are preferable. Some synthetic brushes are described as suitable for acrylic or oils, and can be used for the exercises, as long as you clean them well in between.

At this stage, a basic brush set for the exercises would comprise:

- 2 small, round brushes: approx. size 2 for detailed work
- 2 medium, round brushes: approx. size 6 for filling in larger areas
- 3 fan brushes: small (approx. size 1 to 2); medium (approx. size 4); large (approx. size 6 to 8)
- 1 large flat soft brush, 1in wide: a wide brush is important for laying down and blending a first coloured layer of paint. For painting base layers on bigger canvases, simply buy a larger brush
- Sometimes these brushes can be purchased in packs of two or three and are more economical. It is handy to have a couple of spares within reach

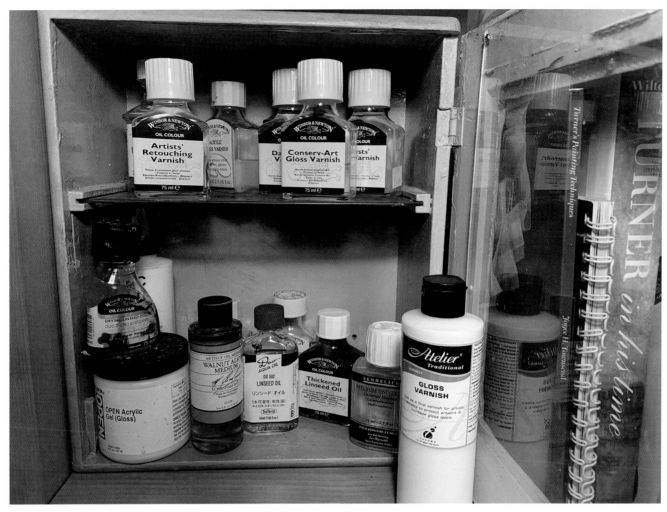

This little cupboard contains an assortment of mediums and varnishes which I have come to rely on over the years. I find that buying small bottles like these means that they are easy to transport and there is less wastage. Some of these varnishes are available in spray form, which are often easier to use on large finished pieces in the studio.

Mediums: thinners, bulkers, driers, extenders

It is now possible to buy a plethora of different mediums, which basically change the properties of the paint. They can do one or several of the following: create body, create texture, dry the paint quickly, extend drying time, create extra gloss or create a matt finish, increase the flow … the list goes on. If you decide to experiment with any of these, and you are in doubt, then stick with thinners and cleaners that are recommended by the manufacturer for each product. This helps to avoid expensive mistakes. For the purposes of the painting exercises in this book, I have occasionally advised the use of an Alkyd Medium which will allow oils to dry faster, or quick-drying oils, so that time does not become an issue.

MEDIUMS

When using oil paints:

- Refined linseed oil, 75ml bottle: all major manufacturers supply this for standard oil paints.
- Linseed water-soluble oil, 55ml: this medium is needed only if you decide to use water-soluble oils like Holbein Duo Aqua, which can be thinned and cleaned with water. This is not essential, but helps to produce a glossy appearance.
- Walnut Alkyd Medium, 118ml: this oil is often used instead of linseed oil. The Alkyd variety shortens the drying time and so is recommended for short exercises.

When using acrylic paints:

- Water: acrylics will mix and clean out with water as long as brushes are cleaned while still wet.
- Most manufacturers supply mediums that increase flow and gloss, such as GAC 500 Gloss Extender made by Golden, but these are not an essential buy.

When using watercolours:

- Water: like acrylics, water can be used alone, but there are numerous mixers which can be added for different effects.
- Gum Arabic, 75ml bottle: many artists swear by Gum Arabic, which is already used as a binder in the manufacture of watercolours. Used as an additive, it increases gloss, transparency and colour intensity.

PRIMERS AND VARNISHES

- 1 spray can Artist's Retouching Varnish, 400ml: for oil and acrylic paintings.
- A can of primer will be useful if you decide to buy canvases or boards that need to be primed.

It takes about twelve months before the average oil painting is completely cured, but retouching varnish can be used for recently completed paintings to refresh gloss where the painting has sunk, or used all over as a protection. These retouching varnishes can also be used for acrylics. Final varnishes are available for all the media I have mentioned except watercolour, and come in gloss, satin and matt in both liquid and spray form. Be careful, though – some gloss varnishes are extremely shiny. Buy small amounts to begin with and test them.

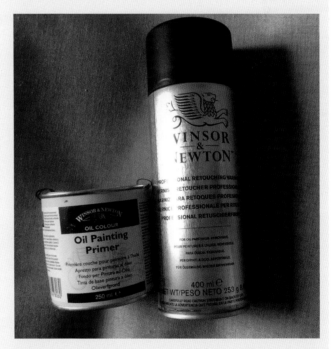

Be especially careful to read the instructions for any primers or varnishes that you use, as 'drying times' are crucial and can be different with every manufacturer.

Cleaning materials and general supplies

Some artists claim that using white spirit to clean oil brushes causes excessive drying, so advocate less damaging solvents to clean brushes. These include white vinegar, oils or soap. If brushes are not dry, it is easy to remove most of the paint using a soft paper towel, then rub in a little oil and finally use liquid soap and water to wash them through. This is my preferred method. My advice is to make a habit of always cleaning acrylic and watercolour brushes with water immediately after use. Dried-on acrylic paints are really difficult to remove, particularly from synthetic brushes. 'Brush Cleaner and Restorer' is available from manufacturers like Winsor and Newton for both oils and acrylics, and does surprisingly well at reviving dried-up brushes which appear to be lost forever.

General essential supplies include containers for brushes and liquids (which can be bought or improvised), and also a palette for mixing. Wooden palettes are expensive, and often heavy. Lightweight plastic and disposable paper palettes (which are available for acrylics, oils and watercolours) are more practical for using outdoors.

WHAT TO BUY

CLEANING AND GENERAL SUPPLIES

- 1 bottle of white spirit for use with oil paints, but only if you are happy using strong solvents
- 1 roll of soft paper towels or a pack of soft cloths (try to find lint-free)
- Bottle of liquid soap
- Disposable paper palette or plastic/wood palette for mixing

Studio furniture

Studios come in all shapes and sizes, and sometimes space is at a premium. However, there are some items that are absolutely essential: an easel and an area around it, and space to stand a few feet away from the picture; a table or trolley of some sort on which to place paints, oils, water and brushes; a storage area for storing and drying paintings. Lastly and very importantly, lighting. Even studios flooded with daylight sometimes need a little extra in a particular direction (the topic of lighting is discussed further in Chapter 3, 'A Studio Piece').

WHAT TO BUY

STUDIO FURNITURE AND LIGHTING

- An easel: some easels can be hugely expensive, but that does not mean that a costly one will be right for you. A lightweight easel, which can be folded and used for both studio and some outdoor situations, is a good place to start. These are available in aluminium, light enough to move with ease, but also acceptably stable. However, some artists prefer the larger, heavier wooden easels which sometimes have an attached box in which to keep paints immediately at hand.
- A table: a high, lightweight table or trolley will make mixing paints and selecting brushes easy. It is also more practical to light a high piece of furniture, so that you can see the colours clearly.
- Storage drawers or rack: household and DIY stores often have storage units which will serve as well as specialist furniture, and at a fraction of the price.
- 'Daylight' light bulbs and/or fitting: depending on how much daylight you have available, finding daylight bulbs for existing light fitments might be enough. If this is insufficient, a daylight fluorescent tube or an LED 'strip' lamp in a directionally adjustable fitting allows light to be shone onto the painting. These are generally available from specialist suppliers of artists' equipment, or (frequently more cheaply) from other online sources.

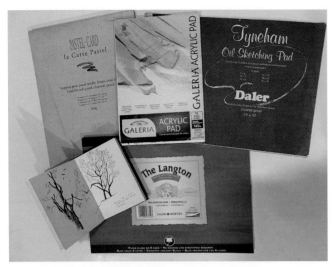

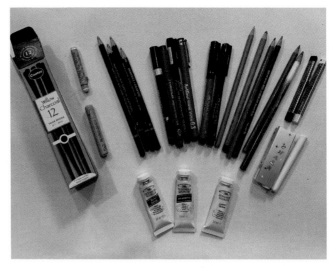

Sketch surfaces: these are easily transportable supports from my supplies, in the form of pads containing several sheets. (Clockwise from top left): **Pastel pad, Sennelier**: this paper is textured for use with soft pastels and charcoal. **Acrylic pad, Galeria**: heavy paper, prepared for acrylic painting. **Oil sketching pad, Daler**: heavy paper, prepared for oil painting. **Watercolour pad, Daler Rowney**: pre-soaked and pre-stretched paper block for use with watercolour paints. **Sketch pad**: widely available in many sizes and excellent for sketching in pen or pencil. Simple pencil drawings can be perfectly adequate preparation for studio pieces, especially if combined with photographs. Using watercolour pencils or coloured charcoal pencils is an effective, simple way of adding colour, and easy to carry.

Sketch kit: this selection of charcoals, pastels, pencils, fine-liner pens (some available in rich earth brown) and gouache paints are a sample from my collection, which has grown over the years.

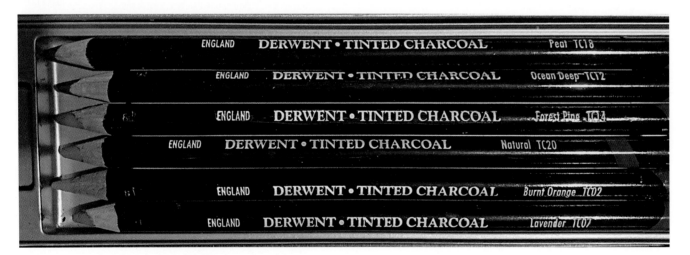

Charcoal pencils: tinted charcoal pencils like these, which are available in muted tones, are ideal for mountain sketches. They can be sharpened and are easy to blend.

Out and about (en plein air) 'sketch kit'

Keeping the artist and his or her equipment dry in challenging mountain conditions is discussed in Chapter 2, but even if the trip and the distances are short, it makes sense to have waterproof clothing and some kind of protective cover for equipment and supports. The minute it takes to make a quick dash to a car can still be time enough for damage to occur.

Supplies from the studio can often be used outdoors. Do not be tempted, though, to haul a vast bag of pens, pencils and pastels on your ventures into the mountains. The selection of materials is much easier to complete at home before you leave. Think about choice of support first, and then pick out mediums that are appropriate.

SUPPORTS, PASTELS, PENS, PENCILS

Paints and supports for work to be finished outdoors can be taken from studio supplies. If you decide to produce sketches only, start initially with a skeleton sketching kit, but make sure that the medium matches the support. My advice is to limit your purchases, to begin with, to the following:

- Pencils: 1 × HB; 1 × 2B; 1 × 4B
- Pastel pencils: 1 tinted pastel pencil (warm brown tone); 1 tinted pastel pencil (cool blue/purple tone)
- Supports: 1 × sketch pad, small to medium (smooth paper); 1 × pastel pad (textured paper for soft pastels)
- Pencil sharpeners and erasers: try to buy these from an art store for use with soft pencils, as they are specialist items. General-use sharpeners will often break the soft pencil and pastel tips, and regular erasers may be too hard

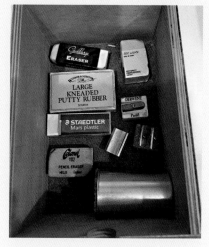

The putty rubber and the special Derwent pastel sharpener, pictured here, are particularly suitable for use with soft pencils, and are available widely from various manufacturers.

Carrying supplies

Equipment needed for transportation will depend on how deep into the mountains you intend to travel. A large 'Pochade Box' is a purpose-built box with a lid and extending legs which usually converts to a small easel and contains all equipment. This item can be a well-organized solution and is usually readily available from art stores. The larger boxes, however, are best suited to a vehicle-based outing when the intention is to stay close to the car or van.

A climb or longer walk rules out a lot of these boxes. Modern Pochade Box equivalents can be bought as lightweight rucksacks, but be prepared – they come at a price. A more economical solution is to buy simple, thin, waterproof, plastic lunchbox containers to carry materials, and organize them in a rucksack. A foldable, lightweight easel, brought from studio supplies, might also be appropriate. The tiny plastic bottles used in aircraft travel are useful for carrying water.

Instead of an easel or Pochade Box lid, try using a small rigid plastic sheet or piece of card with a couple of bulldog clips to secure the surface. This should fit easily into the rucksack and will often suffice to hold a sheet in place, but will not, of course, replace an easel. Remember, though – unless the easel is heavy and stable (an unlikely choice for outdoor work), it can be more of a liability than a help in windy conditions in the mountains.

A digital camera

A digital camera is, in my opinion, absolutely essential. More detailed technical advice on choosing an appropriate camera is included in the final chapter of this book. It is important to note here, though, that a camera suitable for photographing landscapes – to be used as source material for finished pieces – may well not be suitable for archiving work. You may already possess a camera that is adequate for taking pictures for reference use later in the studio, and in fact many modern smartphones have more-than-adequate cameras which will allow an easy upload

CARRYING SUPPLIES

- A Pochade Box with extending legs or, alternatively, less expensive containers and easel for use close to a vehicle
- Lightweight, rainproof rucksack
- Plastic containers (lightweight, leak-proof sandwich boxes)
- Small plastic leak-proof bottles
- Piece of card or plastic to hold support
- Bulldog clips

of images to a computer at home. If you do decide to buy a camera for information gathering, choose one that is lightweight but has enough resolution for details to be seen when necessary.

Mountain painting, I am delighted to say, has been revolutionized by modern technology. There was a time when artists, such as the nineteenth-century French Barbizon Group and the Impressionists, sought the great outdoors to find the light. En plein air originally meant in the full air. Lighting was poor in the studio, where artists struggled with gas lights and candles. Daylight – diffused often by large white umbrellas – supplied excellent light for painting landscapes. The introduction of tube paints in a limited capacity also encouraged artists to paint outdoors, in oils mostly or watercolours – as acrylics did not exist.

Previously, artists needed to mix their paints in the studio from raw materials – now an uncommon practice. By contrast, today we are surrounded by a magnificent array of materials from which to choose. We have paints which will dry or stay wet for as long as we want, and which can be mixed into every conceivable colour. Good quality materials are available for drawing and painting at a reasonable price, and we have cameras which allow us to record sharp, detailed images when sketching is too difficult or inadequate.

Now is the time to gather together some of these materials as you develop your skills. Try to resist buying too much too soon and, if you can, limit purchases to the items in the 'What to Buy' lists at the end of each section in this chapter. These should cover, at least for the moment, all you need to begin to explore the challenges and the great rewards of mountain painting.

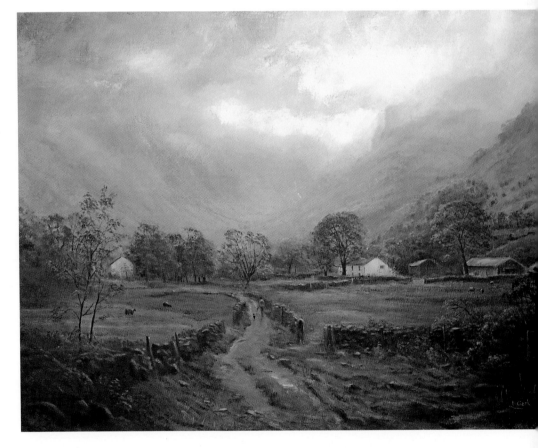

A Day in the Fells, Stonethwaite, Borrowdale, large oil on canvas. Borrowdale is a valley in the central English Lake District (the site of ancient volcanoes), where there are many walks which pass by traditional dry-stone walls, along pack horse trails and by centuries-old deciduous woods. A small side turning leads off to the south-east of the main valley, where Eagle Crag hangs high above the tiny hamlet of Stonethwaite. A mountain stream, quiet in summer and wild and bubbling after winter rains, runs nearby. The valley of Langstrath leads away from Stonethwaite, into the mountains under High Raise and Glaramara. Remote but accessible by road, and by foot along the Cumbria Way (a long-distance Cumbrian footpath), it is an ideal place to set up an easel to paint, or to sit on the grass and sketch. A large, detailed painting like this one, however, would have begun life as a number of photographs and sketches, and progressed in the studio to a finished piece. Most of the sky and fellside was painted using small to medium fan brushes. The detail of the fellside, mid-ground and foreground was developed using round brushes, mostly small. It is a painting based around various mixes of four main colours which I consider essential 'mountain colours': Sap Green, Ultramarine Blue, Burnt Sienna and Titanium White. The starting point in the studio was a large, primed, stretched canvas coated with a warm brown ground.

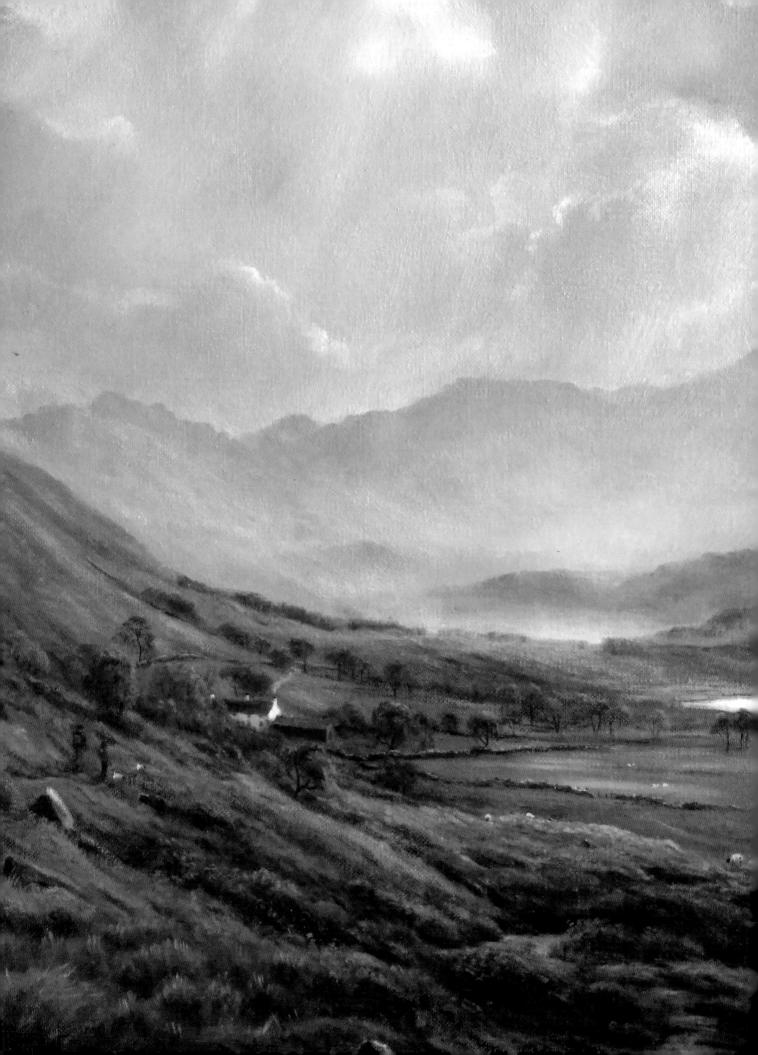

Subject Matter and Composition: Finding the Mountains

By lakes and sandy shores, beneath the crags
of ancient mountain, and beneath the clouds.

SAMUEL TAYLOR COLERIDGE

Having waded through catalogues, internet sites and art stores, you will hopefully have gathered together a small collection of necessities and are raring to get started. You may discover, as you progress, that you desperately need a certain item and others, sadly, are wasted. It takes some time and experience of your own working practices to know what is really needed. Part of knowing what to take with you on the search depends, of course, on where and how you decide to go.

CHOOSING A SCENE

Access

If I were asked to pick the most important key to successfully choosing a subject, it would be familiarity. Getting to know the mountains should not be underestimated. Repeated exposure to their shapes and moods so that you can 'see them with your eyes closed' is, in my opinion, invaluable. Artists who are physically able and who live in and around a mountain range, often walkers or climbers, will find familiarization much easier of course. However, if you live in a city, can only visit on infrequent holidays, or are less physically able, solutions are at hand – which I will explore later in this chapter. Residents of mountainous areas may still find difficulties in dealing with the weather – dangerous in winter or too hot in summer, and there remains the challenge of carrying equipment, as discussed in Chapter 1.

En plein air!

The weather: enemy and friend

If you are an experienced mountain climber, walker or boat enthusiast, you will no doubt have found solutions to keeping your equipment and yourself dry against the elements. This can certainly be challenging to the mountain painter, for example, in the English Lake District. Although the climate is admittedly not as savage as in some environments, sudden and very wetting rain can easily ruin work and can mean a premature return home if you are not prepared.

◀ *Under Clearing Skies, Blea Tarn, The Langdales*, detail, oil on canvas.

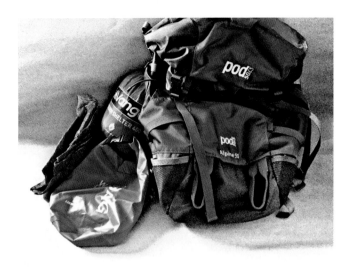

Defeating the elements: items that have proved especially useful to me over the years are pictured here, from left to right. **Very lightweight cheap tarpaulin:** these are available at any DIY store and are useful for sitting on or covering equipment. **Waterproof dry bag:** to be found in most outdoor shops. Just fold over the top to make great dry storage. **Storm shelter:** these can be found in climbing stores and were originally designed for survival, but brilliant to keep everything warm and dry, like a very small tent. **Lightweight rucksack with extra drybag inner:** again these are available from climbing suppliers and will carry a small Pochade Box and a few extra bits. The extra dry bag is useful.

If this is your first time out, it is worth working out which extra items you can carry and which will provide the best solutions for the climate you are dealing with. Remember also that the wild weather, which can blow away and saturate your delicate painting, can also conjure up the most stunning skies and light effects.

High mountain climbing may not be everyone's forte, so finding and accessing a viewpoint will need some planning, and obviously it is important to stay safe. That said, my advice would still be – if you can visit a location, do so.

INFORMATION-GATHERING, SKETCHING AND PHOTOGRAPHY

Over the years I have spent a great deal of time walking and hiking in Cumbria, also as a canoeist and passenger on the lakes. Some places have become my favourites, such as the view pictured in the painting *By Quiet Waters, Calfclose Bay*. Luckily, the changing light and seasons mean that these places nearly always have something new to offer. I hope that the following description of my practice will be helpful to you, and although it may not always be possible to visit in person, technology now provides us with unprecedented opportunities to research and view the landscapes of the mountains.

Having decided on subject matter, try to view it from several different viewpoints, looking for angles which will allow recession and give the impression of high valleys and mountain ridges one in front of another. Ideally, find scope for foreground and mid-ground features, and avoid blank stretches of water in front of flat mountain faces.

Sketching or photography

Both sketching and photography play important roles in preparation for a finished piece. Sketching is helpful in that it forces the artist to think, in detail, about the exact relationship between different forms, and is of course great practice for 'drawing' with the paint brush. Having sketched a tree or boulder, you will be more confident when painting it into the final scene.

Sometimes you may find that information-gathering in the form of a sketch becomes a finished piece in its own right. This is quite different to a planned piece of finished work which is intended to be completed en plein air, where it is usual to be set up at a certain vantage point with the equipment (*see* Chapter 1). Sketching in its simplest form only requires a pen/pencil and a pad, and can be completed in a matter of minutes. It is worth doing several sketches, therefore, to build up a collection of images. Often these kinds of images have a freshness that is more difficult to achieve in finished work. Try not to be over-critical of your rough work – always take it home and reappraise it, as you may find that in a frame it is surprisingly attractive.

If you can, as well as sketching and painting, take lots of photographs of the subject. Copying a scene from a photograph is, however, a different matter; it is a tedious process and is likely to result in a painting which appears lifeless. On the other hand, photographs are an enormous help in both construction of the composition and also in allowing the study of details, especially foreground. I take many, many digital photographs on my trips out, but my final piece will bear only a passing resemblance to any one of them. I use them, instead, as a reminder of the particular shapes of the mountain tops, the colours of the shoreline, and most importantly the elusive changing light.

Remember to photograph not just the skies and mountains, but also the foreground and mid-ground features including clumps of grass and reeds; trees and bushes; sheep, rocks, and boulders – all for reference later. This has its rewards when studying them at home on a phone,

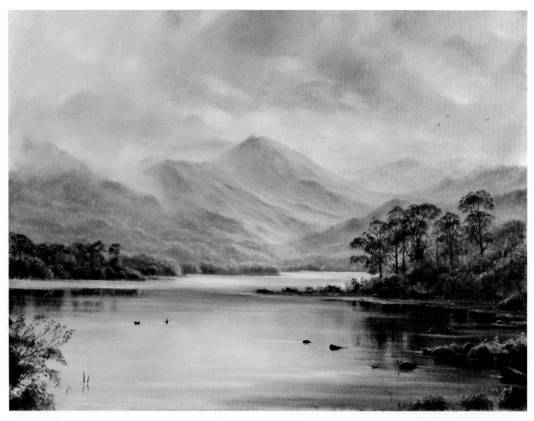

By Quiet Waters, Calfclose Bay, Derwentwater. The view across Derwentwater towards Catbells and Grisedale Pike (the central peak in the painting) is one of the Lake District scenes that I often find myself revisiting. It offers all the necessary compositional features: foreground and mid-ground interest, recession and distant hanging valleys. The lake provides plenty of light bouncing off the water and leads the eye to the mountains, which rise up not far away on the other side of the lake, at just the right distance to see the range. Too far away and they become incidental to the picture; too close means that only one shoulder or peak can be featured. In addition, the subject has good access. It is easy to park, and then walk a short distance to the bay, where there are plenty of dry areas on the shore to set up equipment.

A sketch of trees, Calfclose Bay, Derwentwater. These trees grow in a group on a promontory and are typical of the area. Their interesting shapes are very distinctive and very much an important part of the scene, contrasting with the blue-toned, craggy mountain slopes and woods behind. A study of this kind will help when you come to paint the final picture, as you will already be familiar with the shapes. This gives you a head start and allows time and energy for concentration on the other elements of the work, such as colour and lighting.

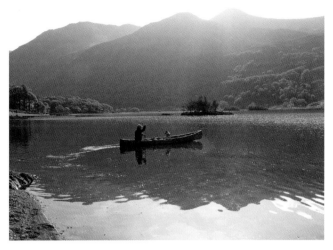

If you are lucky enough to find a crew who can be 'press-ganged' into photo/sketching trips, do not miss the opportunity. Views from the water often open up exciting new vistas, and as the boat moves away from the shore more of the mountains behind it are revealed.

Make sure that the crew are aware that your concentration is on the mountainscape and therefore you are unable to offer to paddle. Taking equipment by boat with assistants is considerably easier than carrying it!

camera or computer screen, when details such as colours and light effects, which were missed at the time, become apparent. Photographs will also provide a vivid reminder of the experience of being amongst the mountains – short videos even more so.

It is also important to remember that information-gathering does not mean only visual information. Knowing about the natural and human history of a mountainous area and how it was formed will give you an extra understanding of the landscape (for instance, geological processes and the resultant types and shapes of the rocks, local weather patterns and the kinds of human activity, such as sheep farming).

New viewpoints
Moving only a few yards in either direction can radically change a composition. Be prepared to explore viewpoints and resist the temptation to make camp at the first acceptable spot. Part of my own practice is photography from a canoe or boat, which sadly is not possible for many, and would not have been for me had I not had a great deal of assistance.

If there is the chance of taking a boat or ferry trip on a river or lake, I would encourage you to do so. Apart from the opportunity to record a view from the water, it will also provide a more comprehensive view of the mountain ranges from different angles. Photography is the best option for a boat trip, however, because the movement makes drawing or painting accurately exceedingly difficult. Dry ground definitely has its advantages, too.

Compare the painting *The Old Jetty* on page 29 with the photograph of the same are pictured below it. Notice that the eye level in the painting is lifted just slightly, which allows the low-lying, sunlit fields in the mid-ground to be visible. The grazing sheep add interest to the painting in the foreground, as do the remains of what looks like an old jetty in the water. The final painting was completed over a number of weeks using several glazes and with the addition of details using fine brushes, unlike the preparatory painting which was completed quickly as groundwork.

Mountain painting for the less physically able
I hope that less physically able mountain painters will not be discouraged by images of artists ascending the peaks or taking to the water. Quite a few of the paintings that I have completed as gallery pieces and commissions have been constructed from sketches and photographs taken from areas which would be accessible by wheelchair or disability scooter, and some of the most impressive views of the mountains of the Lake District national park are accessible by road and well-maintained paths. The UK internet site *Lakedistrict.gov.uk*, for instance, points out that there are 42 'miles without stiles' routes across the park.

Happily for all of us, but particularly those who find access difficult, the internet provides us with enormous opportunities to put together visual and other information on an area we wish to paint. A simple search and a click on 'Images' will reveal a plethora of pictures to choose from – and videos are available, some of which will give you 360-degree views. There is no shame in browsing to see

The Old Jetty, Crummock, (detail) is a studio piece produced after a number of visits gathering sketches and photographs, both on the water and along the shore. It features the marshy fields which lie between Crummock and Buttermere (two lakes close together in the western part of the Lake District). Buttermere is not visible, but the mountain range beyond rises at the far end of the lake and is impressive from this viewpoint. The area also allows extensive views of both lakes and the mountain ranges surrounding them.

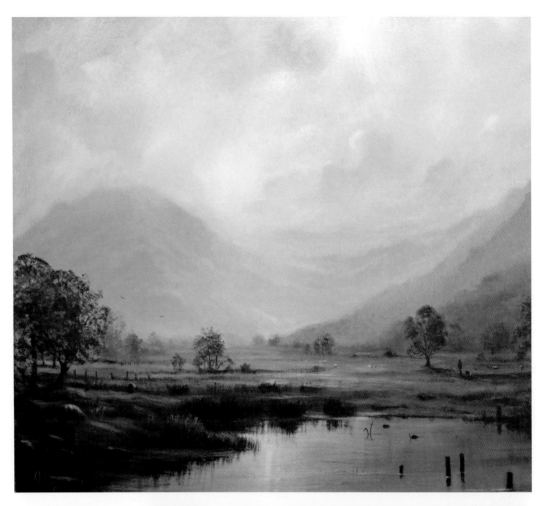

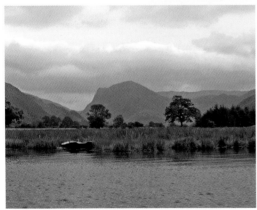

The head of Crummock Water: this photograph was taken from the canoe and is of a view which would not have been possible on foot, although access is good along the shore and provides lots of opportunities for effective compositions.

Fleetwith Pike and Haystacks from Crummock Water. This painting of the scene was in preparation for the studio piece, and took a fraction of the time to produce. It was painted largely using a medium-size fan brush. Large brush strokes block in the main areas of colour and tone (which create a sense of distance across the marshy fields to the lower slopes), and the strong outlines of the mountain range.

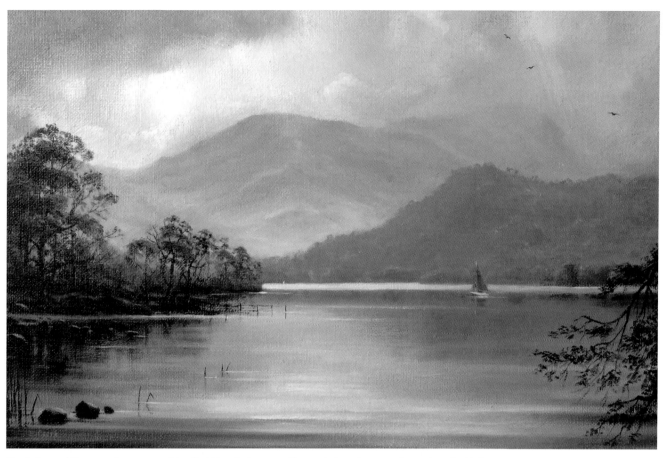

Gentle Breeze, Ullswater, oil on canvas, 16 × 6in. This painting, a small commission piece, was focused on the high mountains at the top end of Ullswater, but also on a small sailboat with red sails, which was important to the clients.

how other artists and photographers have dealt with the subject matter. Copying the images is, of course, a different matter as copyright laws apply to many images on the web.

My advice would also be to draw on the many internet groups who publish pictures by their members, especially climbing groups. Forums such as Facebook often have groups who share pictures daily. We in the UK have a group called 'I love the Lake District!', which I find contains much inspiration. It has 125,000 members at the date of writing. Also, friends and family who enjoy walking are often happy to take photographs of their visits which might prove helpful, and luckily these can now be easily shared using digital media.

Sketch, painting or commission?

How you approach the information-gathering stage will naturally be influenced by the intended final outcome. Enjoying some time casually sketching or painting can produce some very satisfactory results, but producing a larger studio piece, or a commission for a client (even more restrictive), demands a different way of working. If the purpose is to produce a larger, more finished artwork then the approach will have to be much more focused. Consider the following:

1. Composition: do you have enough sketches/ photographs from various angles to choose the most effective view?
2. Size of canvas: will the view you have chosen expand successfully onto a larger canvas in the studio?
3. Details: have you recorded enough of the detail of the scene (foreground and mid-ground in particular), which you can draw on later?

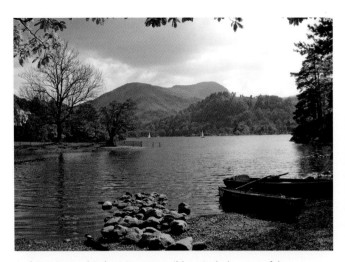

At this point on the shore it was possible to include some of the interesting mid-ground and foreground features, such as the small fence and varied trees, as well as the stretch of the lake and the mountains beyond.

Sketch, Ullswater. A number of sketches and photographs, like this one, are usually necessary to complete a commission or studio piece. Sketches done on the spot can have a pleasing freshness. Hold on to them, as you may want to frame them later.

4. Lighting, tonal contrast, colour: will your sketches be sufficient when you come to paint the lighting effects on the mountains and the colour variations?
5. Client stipulations (if this is a commission): have you complied with the stipulations made by the client, and how can you satisfy these while producing a successful painting?

Painting a scene as a commission means you have to consider the requests of the client. Often clients or friends would like a painting as a gift that has meaning for them or their family, as with the painting *Gentle Breeze, Ullswater*. The memory of red sails on a Mirror dinghy sailing across Ullswater, with St Sunday Crag standing above the lake, was of special significance to the client. Here it was necessary to find a foreground on the eastern shore which would allow a view of the mountains behind, and a stretch of lake on which a boat might be sailing by.

There are many views from the lake shore, but the one in the photograph allowed the sailboat to be an important feature while not diminishing the imposing shapes of the fells. Notice that the small boat is slightly offset from the centre of the painting to avoid splitting the composition into two halves, and in addition its position reinforces the sense of the journey along the lake. The size of the boat has the effect of emphasizing the height and majesty of the mountains, while the red sails help to give the boat prominence. Notice that the photograph contains some foreground details – boats, shoreline and rocks, which have been deliberately omitted, while others have been included. This was a small painting, and heavy foreground detail would have created a cluttered effect, distracting from the mid-ground subject and mountains.

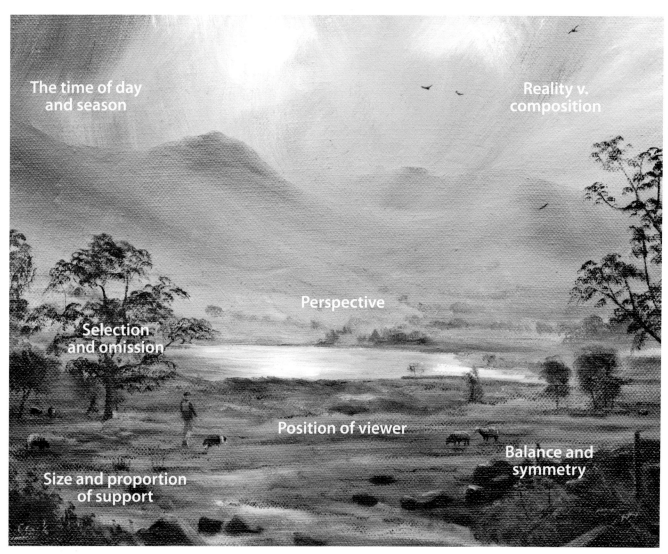

The time of day and season

Reality v. composition

Perspective

Selection and omission

Position of viewer

Balance and symmetry

Size and proportion of support

These are issues to consider when choosing your vantage point. Sometimes they conflict with one another, and finding the best compromise can take some time.

THINKING TIME

En plein air

Whether you decide to brave the elements and paint en plein air, or retire to your home or studio armed with photographs and sketches, allowing yourself thinking time is essential. Obviously, studio work allows more opportunity for this, but many artists feel that this is at the expense of freshness. If you are working outdoors, decisions about the composition, lighting and tone, and colour must still be made, but less time is available to consider your options. The style which you use for these time-limited works will necessarily be different to your studio style. Use

of detail is likely to be restricted, as will your use of fine brushwork and glazing if drying time is needed. The use of washes, especially for watercolourists, is a must.

A comparison of the photograph and the *Little Langdale Tarn* painting from the same vantage point reveals the main features of the landscape, which remain the same in both. The mid-ground trees, marshland and the woodland and fields on the opposite shore are similar. The profiles of the ridges and slopes, although hidden in low cloud in places, again are clearly viewed from the same angle. Some elements, though, are different. Looking at the photograph, it is clear that changes have been made. Some of the elements of the scene, such as the large wooden

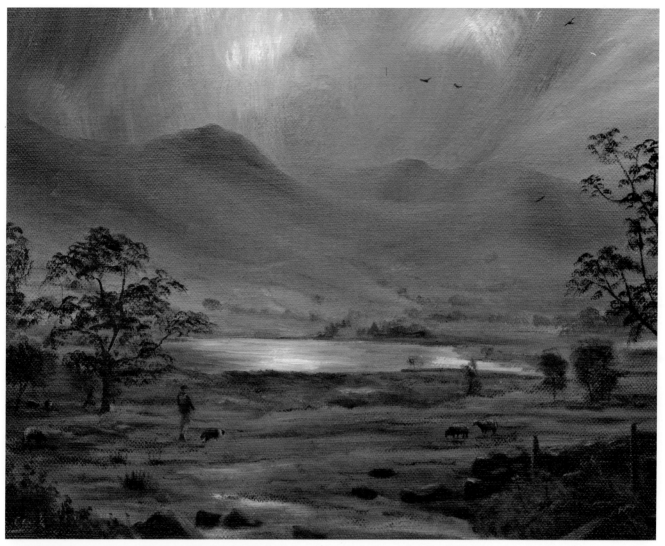

Little Langdale Tarn. Here is an example of a fairly small painting, the majority of which was completed en plein air. It is a painting of the tarn which sits in the Little Langdale Valley in the Lake District ('tarn' refers to a small lake or pond in upland areas of the northern UK). It is possible to easily access this view – across the tarn towards the Tilberthwaite Fells – from the narrow mountain road which passes by the tarn on the way to Greater Langdale and Blea Tarn.

post in the foreground, would detract from the scene – as would the tree on the left, which obscures the view of the tarn and the mountains. The walking figure and dog (crossing the field at my request!) help to lead the eye to the light splash on the water and across the tarn. Most artists are painfully aware – whatever they paint – that there is always a conflict between exact representation of a subject and a balanced composition that is pleasing to the eye.

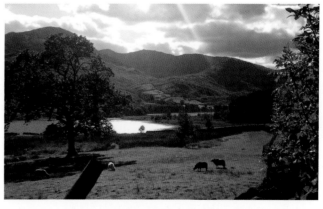

Photograph of Little Langdale Tarn. There are often a number of points along a small mountain road where it is safe to stop and look past the traditional dry-stone walls that are a distinctive feature of the Lake District mountain scenery. Here it was possible to sketch, or take photographs of the tarn and the fells beyond.

This detail of the painting shows the quick, broad, impressionistic brushwork used to capture the bright sunlight breaking through the clouds onto the Tilberthwaite Fells. Also, it shows that the painting, unlike a studio piece, does not rely on blended colour produced by a number of thin glazes, but instead rich colour has been used over a medium canvas, primed using a Burnt Sienna wash.

Decision-making

Under Clearing Skies, Blea Tarn, the Langdales (the painting pictured as a detail at the beginning of this chapter and in full at the end), was commissioned by clients who have a long-standing love of the mountains, the Lake District, and this particular place. It was important to follow their requests regarding the viewpoint and the various elements of the landscape for which they had developed such an affection, while still achieving a pleasing composition.

I chose this painting for this section because, in order to complete it successfully, it demanded a great deal of thought at the early information-gathering and decision-making stages. Even at the most preliminary stage, decisions made then will influence the final composition. This is true of the majority of work, not just commissions and finished pieces.

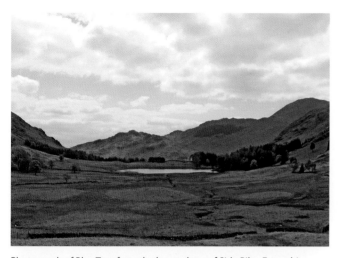

Photograph of Blea Tarn from the lower slope of Side Pike. From this vantage point, on the lower slopes of Side Pike, it is possible to see the mountains beyond and the tarn lying in the hanging valley, but it was necessary to go further up the slope to take in other features of the landscape. Looking at this photograph, it is easy to see how a composition using this view would have been problematic. The foreground is almost non-existent and the mid-ground lacks interest. These areas would all too easily divide into unconnected zones.

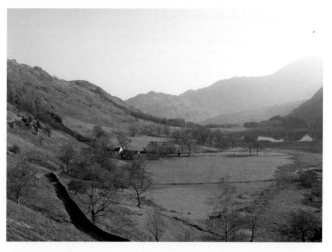

Photograph of Blea Tarn, moving up the slope. Further up the slope, the ascent reveals a number of excellent features which enhance and balance the final composition: the cottage and trees in the mid-ground, and vegetation in the foreground. The large featureless marshland in the mid-ground is foreshortened and overlapped by the foreground, and is therefore no longer a problem.

Size and proportion

Unless you are using a thin support, such as heavy paper, size and proportion are very difficult to change. Stretched pre-primed canvas and boards are not designed to be trimmed down. Deciding on whether you want a square, landscape, portrait or elongated shape to capture the view in front of you must be a priority.

The proportions of *Under Clearing Skies*, which measured approximately 19in high × 28in wide, are those of a slightly elongated landscape format ('standard' landscape format is squarer – approx. 16in high × 20in wide). This allowed for the inclusion of the full width of the hanging valley. Using an even more elongated support (often used by sea painters) can present problems for the mountain painter, however, as it becomes more difficult to avoid unwanted 'zoning' of mid-ground, foreground and background.

It was necessary to make several visits to this area to find a suitable viewpoint that included all of the following: the tarn; a good wide view of the sides of the valley; and the impressive profile of Wetherlam, viewed looking through the pass which stands between Great and Little Langdale.

Careful choice of a vantage point helps to eliminate the related problems of unwanted partitioning within the composition; these include horizontal banding and over-powering symmetry, both of which I will explore further in Chapter 3. Look for features in the mountainscape, such as vegetation and craggy outcrops, which will allow you to balance your composition. A landscape that is too strongly symmetrical will have the effect of splitting the composition perceptually into two separate sides. Imagine, for instance, that there was a building with a similar shape and brightness as the little cottage on the left, sitting at the exact corresponding position on the right of the picture. If both were featured in the painting, the illusion of a division between left and right would be created.

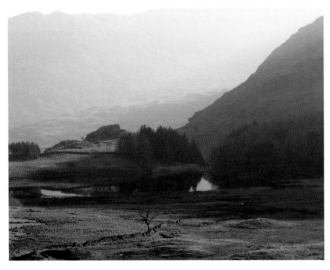

The tarn in winter. Because of its situation in the hanging valley, there are times of year when the sun only reaches the tarn for a short time.

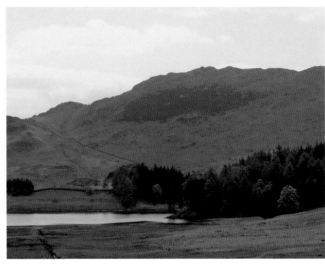

The tarn in summer. In the summer, the chances of catching the tarn and surrounding fells in the sunlight are much greater.

Selection and omission

Selecting attractive aspects and shapes over obtrusive and unnatural-looking features is a process which should be taken into consideration, whether you are working en plein air or towards a studio piece. It is often important to make these selections at this stage, early on in the process. The photographs above of Blea Tarn in summer and winter demonstrate the kind of choices made when information-gathering for the finished painting.

It was important to find a time when the reflected light on the fellside and the tarn was strong. In the winter, at times, it can seem rather dark and foreboding. Some of the trees in the valley are bare, as they are deciduous. The lack of foliage and a darker fellside would have created a more dramatic but less peaceful atmosphere. Notice, though, that the dark reflections of the trees, which are visually interesting, are retained.

The figures and the cottage, although small, help to emphasize the size of the shoulder and the other mountain range behind it in the mid-ground and background. They should help the viewer understand the distances involved, as they look across the valley. They also balance the light on the water on the right of the composition, but do not create a strong, unnatural symmetry because the tarn is a very different feature, and further from the centre line.

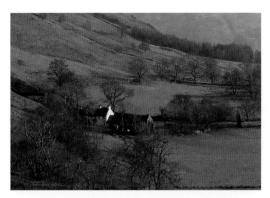

This attractive building, which stands a little uphill from the floor of the valley, is an old building in keeping with the landscape. It works in the composition on a number of levels: as an indicator of scale and as a strong though small area of white to balance other areas of reflected light in the composition. At certain vantage points it is hidden by trees.

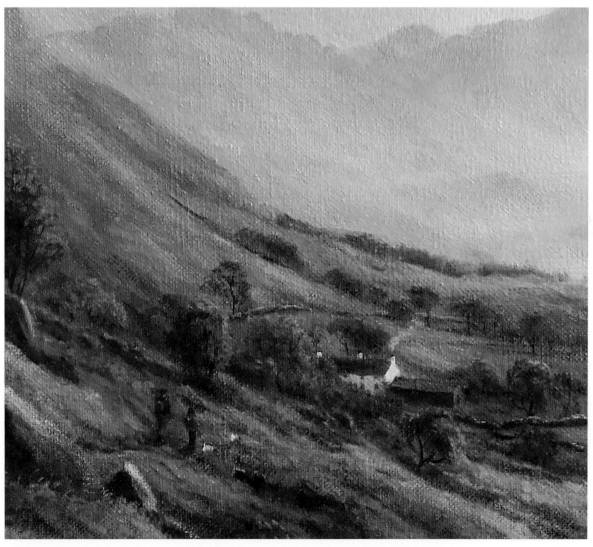

The vantage point of the composition was chosen so that trees did not obscure this little cottage. The two hiking figures with their dogs (the clients themselves) are small and blend with the landscape. Larger figures would have become the focus of the picture and detracted from the tarn and the mountains.

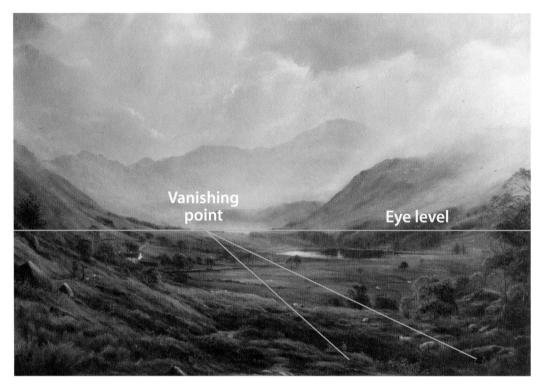

Using a simple 'eye level' line and 'vanishing point' makes it easier to work out relative positions and scales. The viewer's position here is above the hanging valley, the cottage and the lower slopes of the fellside. It is possible to see a large part of Wetherlam Fell and the slopes to the right of the tarn. The 'eye level' (my eye level) is at the height of the lower slopes of the mountain, and above the trees in the foreground on the right. Between the vanishing lines it is clear that the sheep become smaller and smaller, until they will not be visible at all.

Perspective

Perspective, proportions and the position of the viewer are features of composition which are closely related. Getting them right when dealing with a mountain landscape is a challenge. Most people feel daunted when they first try to apply the rules of perspective, which are complicated – whole books have been written about them. Using the complex rules of perspective on a cityscape, which is made up of lots of artificial straight lines, is difficult enough. Trying to use them to create the impression of distance when painting a landscape, which is comprised of a huge variety of irregular shapes, can be both counterproductive and frustrating. There are, though, some basic points that are simple and helpful.

The 'eye level' or 'horizon line' is actually your own eye level, which is drawn as an imaginary horizontal line on the picture – anything above it is higher than your eyes and anything lower is below. When you move, so does the eye level and the 'vanishing point' too. The converging lines, which disappear to what is described as the 'vanishing point' (and there can be two or more, depending on

angle of view), are like the lines of a long straight road or railway track, which seem to disappear into the distance where the lines meet. We know that the lines do not actually meet, but they appear to do so.

A person walking along the track, between the lines, will appear to become smaller and smaller as they progress towards the vanishing point, at which point, they 'disappear'. This is important to the artist, because making the figure appear smaller creates the illusion of distance for the viewer. The mountain painter does this by using the features of the landscape to produce the impression that the peaks are receding into the distance. Trees in the foreground of the composition become much smaller in the mid-ground, and then tiny clumps on the distant ridge.

I think it is unhelpful to try to draw in a mass of vanishing points as guides. A practical approach is to draw in an 'eye level' and perhaps one obvious vanishing point. Another trick to work out the relative sizes of objects at varying distances is to hold a pencil or thumb extended upright in front of you at arm's length, squinting with one eye (remembering to keep your arm fully extended) while

you visually align the top of an object with the top of your pencil/thumb. Then, slide your (horizontal) index finger up and down your pencil/thumb until this marks the bottom of the object. If you want to be more accurate, you can use a ruler and read off measurements.

Remember, though, that artists are often somewhat liberal with the rules of perspective in order to satisfy the needs of their composition. I suspect that few mountain paintings would comply absolutely with the rigour of perspective rules and measurements. Instead, their intention is to portray the sense of space and majesty of the particular mountain range they have chosen. My own opinion is that it is more important to concentrate on close observations, painting practice and careful choice

of vantage point. As these practices become routine and progress, the understanding of proportion and perspective will naturally follow.

This chapter has been about finding the subject matter. Before you go on to produce a finished painting en plein air or a studio piece, do give yourself plenty of time to investigate and get to know the scenery available to you. Allow yourself sufficient thinking time, and do not look on paintings which fall short of your ideals as failures, but instead as good practice. Whether your journey is on foot, by vehicle or through the modern digital media, I hope you find many opportunities to really enjoy the experience of the mountains, as well as painting and drawing them, and are then ready and energized to tackle Chapter 3.

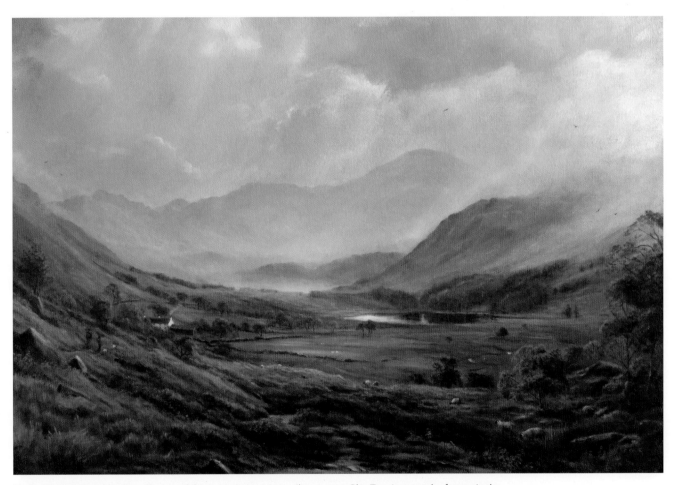

Under Clearing Skies, Blea Tarn, The Langdales, commission piece, oil on canvas. Blea Tarn is a stretch of water in the hanging valley between Great Langdale in the north and Little Langdale to the south, an area which is particularly loved by walkers, artists and photographers. Moving on and up from Little Langdale along the small winding road, flanked by stone walls, Blea Tarn comes into sight. Access to the tarn itself is by an easy track, and the fellside surrounding it provides a huge variety of inspiring views from which to choose. The weather can change from moment to moment as shadows and clouds cross the valley. One minute the tarn is basking in glorious sunshine and then, within a very short while, great columns of rain sweep in, smudging and fading the outlines of the surrounding fells.

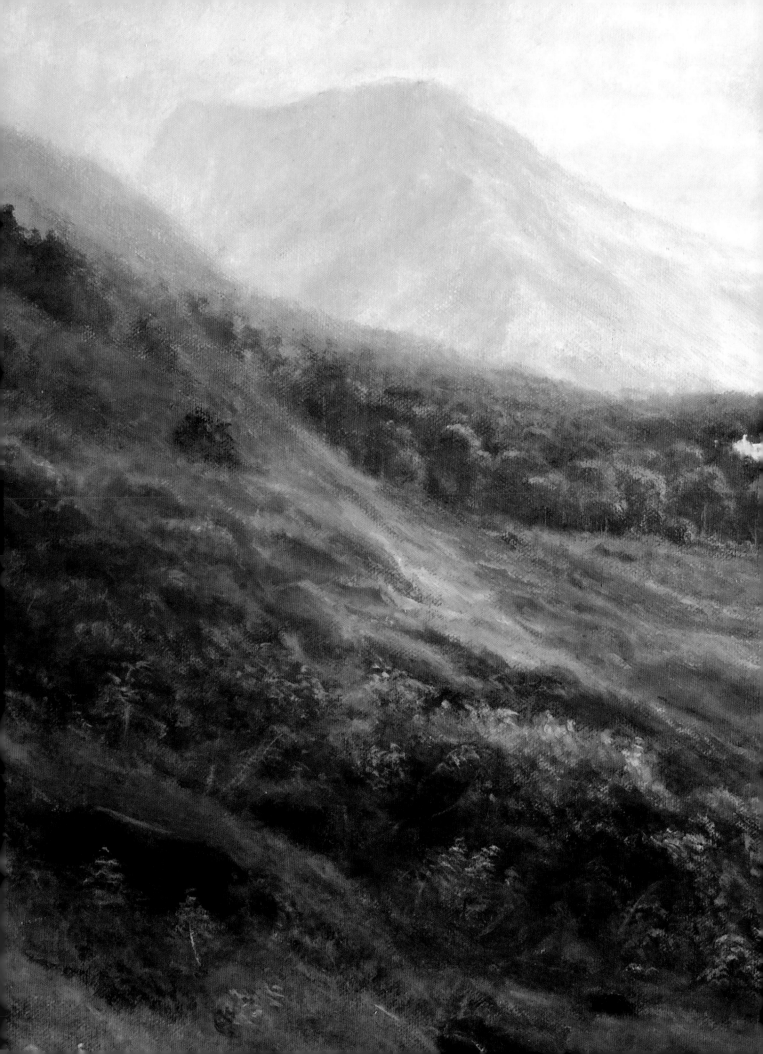

A Studio Piece

Nature is painting for us,
day after day,
pictures of infinite beauty.

JOHN RUSKIN

Having run through the choices and decisions outlined in Chapter 2, you have hopefully reached this point with an idea, albeit in its early form, of the kind of mountain scene you wish to paint. This chapter outlines the groundwork involved in the process of producing a studio piece. The step-by-step exercise at the end of this chapter is a complex piece, involving a number of different skill areas. If you decide to give it a try at this point, you may need to refer to later chapters, which cover these issues in greater detail. Alternatively, you may choose to simply read through the stages, and return to the step-by-step exercise when you are ready.

I have included a selection of the various photographs and sketches made in preparation for this studio piece, *From Rannerdale to Haystacks* (*see* the end of the chapter for the finished work). You will notice that my composition is not a perfect match for any of the sketches and photographs pictured here; however, most were essential to the process.

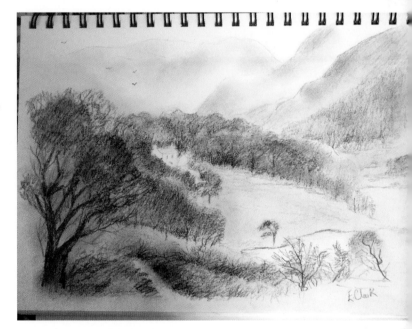

Sketch of woods and fellside, looking towards Buttermere. Preparatory work in sketchbook in 2B and 4B pencils.

◀ *From Rannerdale to Haystacks*, detail, oil on canvas.

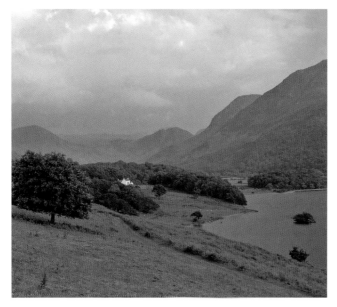

Photograph of a view from above the fellside path, looking towards the Haystacks range.

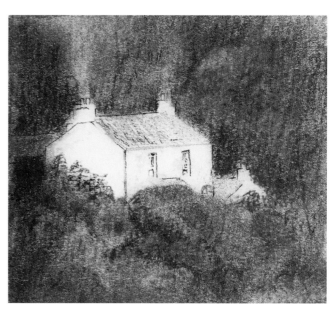

Preparatory sketch of Wood House (cottage on wooded ridge in mid-ground) in pastel and 2B pencil.

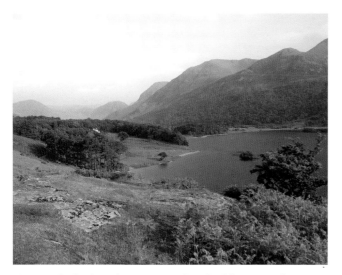

Photograph of rocks and vegetation to the side of the main path.

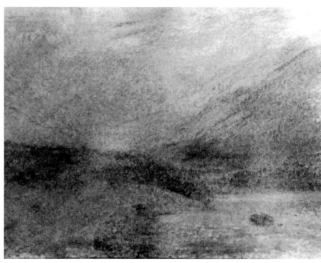

Basic colour study in watercolour.

The mountain range pictured in this exercise is one that I know very well. It offers many outstanding viewpoints for artists and photographers, and changes in character and colour on just about every visit. It is much loved by both visitors and local residents. This particular view of Fleetwith Pike and the Haystacks range has some attractive features, but is also quite challenging. The viewpoint is from a low, rugged fell named Rannerdale Knotts, which is covered in thick areas of bracken.

Remember, though, that nothing is set in stone yet. Allowing ideas to evolve, if possible, in these early stages is important. If every element of the scene is replicated, you are likely to end up with a picture that is perfect in verisimilitude, but is wooden, crowded and unbalanced. Concentrate instead on visualizing how to create the most balanced and effective composition.

This small path winds its way through the high, thick ferns, disappearing then reappearing in the distance. It helps to lead the eye over the woods and cottage and to the high peaks, which stand at the southern end of Buttermere. Crummock Water is visible, but Buttermere is hidden by the wooded ridge.

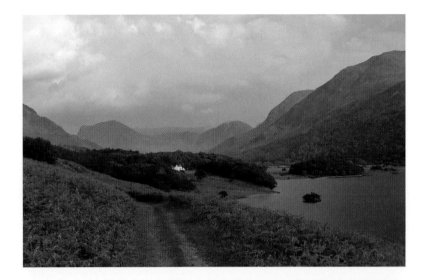

Studio piece: full pencil sketch. Compare this sketch to the photographs I have taken. This rough outline sketch is about half the size of the canvas that I intend to use, and I have already started modifying the scene. At this point, studying the photographs and my sketches, I was worried that the large block of trees in the mid-ground, although important to the scene and an interesting feature, could be overwhelming. I have already pushed the trees back a little, and have made the proportions less elongated. I will have to remember to use light to minimize the impact of the woods further.

CHOICE OF MEDIA

Choosing your canvas or board for the finished work will, of course, depend on many factors. My advice would be, if you set out to produce a finished piece with all the work it entails, buy the best quality canvas or board you can afford. It is deeply disappointing to find that, having produced one of your best works of which you are justifiably proud, it has been painted on the least stable, lowest quality canvas.

For this piece, I chose a Winsor and Newton cotton canvas, which has been primed with titanium dioxide gesso primer. It has a medium texture rather than a rough one, as I wanted to include some foreground foliage detail, and also to blend areas of colour easily in the sky and mountain background. A rough canvas would create a

different impression. Some artists use this to great effect, creating woodland and fellside textures by dragging the brush and allowing the canvas texture to show through. Of course, once again, the choice of size and proportion is tied to the subject matter. It is difficult to do justice to a vast mountain range and great, majestic cumulus clouds using a 12 × 16in (height by width) canvas. Small canvases and boards are more suited to a specific view or intimate scenes, such as those based around a small mountain beck. The canvas I chose here is 20 × 24in. This is large enough to create a sense of space between the foreground and the mountains sitting beyond the ridge and lake.

Check the canvas for knots or faults. It is really annoying to discover later that right in the middle of the beautifully painted sky or smooth water, repeated strokes reveal a little knot, picking up paint as you go. Better to

check before you start. Amongst the ferns and bushes, you can sometimes thankfully 'find' a useful rock or clump of foliage as a disguise, but a discovered knot, in some parts of the painting, may mean that reworking is the only option.

As discussed in Chapter 1, artists have a huge array of paints and brushes to choose from. When developing a studio piece, it is important to take into consideration the size of the work and timescale involved. For instance, if you choose slow-drying oil paints, the work may take a long time to dry in between layers. Selecting the size of brushes will usually be influenced by the dimensions of the painting, but the shape of the brush is something that painters learn to choose to enhance their individual style. In each step-by-step exercise in this book, brushes are suggested that are suitable for the particular piece of work. I would recommend that you explore other shapes to establish your preferences, especially before beginning a large studio piece.

STUDIO LIGHTING

When painting en plein air, the choice of lighting is extremely limited, usually consisting of whatever light the mountain landscape has to offer. In the studio, however, decisions will have to be made and will affect the work. One thing to consider is the destination of the painting. It is unusual for an artist to be able to control the lighting used by a gallery or exhibition which displays work, and so the colours and contrast of hung paintings may be disappointing. The subtle greens and blues of high mountain ridges, painted under certain lighting conditions in the studio, may look just slightly dull on the gallery wall. In my experience, the blues, greens and browns of the mountain landscape fare best, and suffer less from these changes, if they are painted in natural light. You may be lucky enough to have a studio with plentiful light throughout the day, and in this case you may rarely have to resort to artificial light. Remember though, that even natural light can be misleading. A blast of sunlight might make the colours seem lighter than they will later appear.

If I am working without daylight, I tend to work under two or three 'daylight' bulbs in extending light fittings. These can be purchased widely. An extra option is an 18w daylight fluorescent tube, which can easily be directed onto the painting, available widely from suppliers of artists' materials. These do tend to cause a slight blue

cast, but at least this avoids the risk of finding that a warm sunlit valley painted in artificial light is sadly, in daylight, a washed-out yellowy-green. Watch out, too, for halogen lights, which give out a warm but misleading yellow glow – and have been my downfall on a couple of occasions. Efficient LED lighting is also now available in a variety of colour 'temperatures' (from 'warm' to 'cool').

UNDERPAINTING

The underpainting of the canvas might seem to be a rather tedious and unimportant affair, but not so. Whatever is painted onto the canvas at this stage will have a huge effect on the colours and textures of the finished piece. Think carefully about the colour of the ground. A few experiments before starting to paint will not go amiss, and will demonstrate the complementary effects of the ground on the colours chosen for the composition.

For instance, you may want a warm glow to underlie your painting of green/blue mountain slopes. If so, use a warm ground that will occasionally show through later coats and help, as do most coloured grounds, to tie the whole composition together. A white canvas or support will make it hard to judge colour strength, as all colours will look stronger against a white background. Neutral colours, browns and blue-greys are the standard base shades, although white will result in brighter colours – as the

In the early days I flirted with several grounds. A particular dark brown, I remember, dulled down my Sap Greens and left me with a lacklustre fore and mid-ground. Now, I nearly always use a mixture of Burnt Sienna, Ultramarine Blue and Underpainting White. These colours, along with Sap Green, also form the basis of my mountain colours – and in my opinion are the perfect mix for painting the Lake District mountains. You may well discover that another colour mix is appropriate to reflect the mountain range you are studying, and therefore a different mix of ground will be more successful. Allow this base layer to dry thoroughly before starting the composition.

Impressionists discovered. It is likely that you will eventually discover a ground colour which works for your particular style, and which will provide a foundation for most of your work.

TRANSFERRING THE COMPOSITION

It is possible to transfer a planned composition directly freehand onto the canvas. If drawing freehand, though, a simple grid drawn up on the plan and then on the canvas can be helpful for basic guidelines. Other methods include special tracing papers, which allow direct tracing, but obviously this would not work for a plan that is half the size of the canvas. There are also gadgets, sold by both professional and amateur artists' materials outlets alike, which will project the image onto the canvas from the photograph or sketch. I have never used one of these, but I would imagine if an exact copy were required they might be useful.

An important point to remember here is that if you are drawing onto a coloured undercoat, the marks made by a light pencil might not be visible or adhere. When drawing onto a canvas coated with a base colour, use a very soft, neutral light-coloured pastel or chalk, keeping it as delicate as possible and avoiding engraving any small lines into the underpainting layer. Some artists use charcoal to mark up their canvas, others oil pastels.

Take care not to use these drawing mediums too heavily as they may be absorbed into the paint and affect the purity of tone, especially white. Remember too, that no matter how much detail you draw onto the prepared canvas, unless you intend to fill in areas in the style of a mosaic, the carefully detailed preparation will be lost when colours are blocked in and blended.

DIRECTION OF TRAVEL

Now that the outline of the composition has been transferred onto the support, it is important to stand back. In fact, try to do this at every stage. It is so easy, especially when dealing with a large canvas, to become enthralled with a particularly attractive part of the scene – a stone wall; a distant mountain peak; mid-ground woods or a foreground rock – only to discover that the overall harmony and balance have been lost. Having put in the work, you will probably be reluctant to tone down an area, but sadly, this may be necessary. Once the composition is sketched out on the canvas, think again about the overall patterns of light and shade, particularly important when creating a mountain scene. For instance, large areas of dark craggy shapes, one on top of another, against a vast, light sky might look empty and unattractive.

Do not be afraid to make changes at this stage. Look at the whole canvas. Consider the compositional balance. Are there large, blocky, dark or light areas which will lack interest? Will the light sky seem too empty? Do the shapes and size of the mountains really portray their majesty and size, or do they appear minimized and flattened under an over-dominant sky? Is the foreground too 'in your face', as if everything else is hidden behind it? This may be the intention in some compositions, but will take the emphasis away from the peaks. Here, I want to work up the details in the foreground. Most importantly, though, I want the eye to be drawn over the foreground paths and ferns, past the mid-ground ridges and woods, then onto the mountains beyond and the Haystack ridges.

Another mistake to avoid when painting the mountain landscape, which is entirely predictable, is the trap of 'zoning' (as discussed in Chapter 2). It is easy to unintentionally separate the sky, the distant mountains, mid-ground and foreground. These different areas can seem disconnected, but hopefully this can be avoided by balancing areas of light and shade, and by integrating the tones and colours of each zone as much as possible. It is also possible to use features such as trees and woodland to cut through zones and thereby link them visually.

For this exercise, I slightly adjusted the proportions on the canvas when transferring the outline. I was still concerned about the dominance of the woods in the mid-ground, and was thinking about how to use the light and the juxtaposition of the surrounding fells to offset this. My final composition is less elongated horizontally. I know this area well, and I am always impressed by the view from the valley bottom or from the slopes, where there is a powerful sense of being surrounded by the 'bowl' of the mountains. I want to somehow portray the feeling of being encircled by these high fells, but also to preserve an impression of distance.

Studio Piece, From Rannerdale to Haystacks

When you do decide to complete the following step-by-step demonstration piece, you may want to use either your own sketches and photographs, or instead the composition which I have chosen. If you choose a scene of your own, try to choose both mountain slopes and woodland with strong recession.

- Quick-drying oils, water-based or standard oil paints depending on preference (I am using Holbein Duo Water Soluble Oils, which have excellent colour coverage). You can add a little alkyd walnut oil or linseed oil to increase flow and decrease drying time, but avoid adding too much as this will hinder the washing-out of brushes with water:
 - Underpainting White
 - Titanium White
 - Ultramarine Blue
 - Sap Green
 - Burnt Sienna
 - Lemon Yellow
 - Naphthol Red
- Walnut Alkyd Medium (using this will mean that your standard oil paints will dry much more quickly), or linseed oil
- Palette for mixing
- Wide soft brush, 2 to 3in, for painting in warm ground (most wide soft brushes will do, but make sure it does not have loose bristles that will embed in the paint)
- 1in flat brush
- Fan brushes: 1 large, 2 soft medium and 1 soft small (try to gather a collection of fan brushes, as these are very useful for blending)
- 2 or 3 round brushes (1 × small size 2 approx., 2 × medium size 4 to 6)
- Small round brush for fine detail, size 1
- Chalk or soft pastel
- Support: 20 × 24in pre-primed medium canvas or board
- Brush and equipment cleaning materials: paper towels, lint-free cloth, white spirit for oils, or linseed oil and soap

Step 1: Sketching the outline. If you have chosen a tinted ground as I have here, try using light chalk marks as indicators. If painting on white, a soft light pencil will do just as well. Keep drawing to a minimum as this is only a simple guide. Notice how I have drawn a horizontal line in chalk, to give myself a rough indicator as to the balance between sky and land.

Step 2: Establishing a sky base. The three main colours used in this sky are Titanium White, with Ultramarine Blue and Burnt Sienna. Introduce more white and very little blue to lighten the tones. It is easier to enrich the colours of the sky later if necessary. My advice is to start using muted colours and an extremely limited range. This way you have greater control as you develop the sky and the background mountains. Mix in a little Burnt Sienna (a very little) as the sky approaches the mountain ridges. The sky is usually lighter with a yellow/orange tinge as it recedes. If you have used a warm base, this will help to unify the sky with the rest of the composition. Remember, too, that perspective applies to the sky as it does to the land, and any clouds nearer to you will appear larger (*see* Chapter 5, 'The Sky', for more detailed advice on painting the sky).

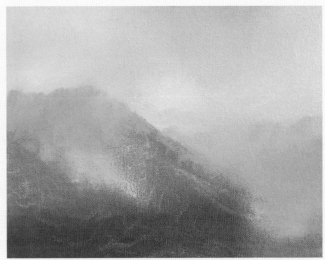

Step 3: Painting the distant fells. Working downwards is a particularly effective direction of travel when painting a mountain landscape. The colour and tone of the sky and the mountains are in most cases intimately related. When painting the distant mountains, use almost the same mix as the sky, only just slightly richer. Map in the ridges with a soft size 6 round brush. While the paint is still wet, use a soft medium fan brush to blend the sky and the ridge (it is possible for you to do this having allowed the sky to dry, but this would involve repainting and blending the sky at the horizon).

Step 4: Painting mountain ridges coming forward. Most mountain ridges become more defined and richer in colour as they layer up from the distance to the mid-ground. As you move forward towards the mid-ground, add a little more colour to slightly darken the tone each time you paint a ridge on top of a more distant one. A size 6 brush is suitable for this step. The slight changes in tone and colour can create a pleasing harmony and can be a gift to the mountain painter. The conical-shaped fellside on the left of this picture, called Fleetwith Pike, has an interesting and attractive shape. An irregular ridge runs down the front face, and there is usually a shaded side and one that catches the light, especially at the base. This mountain is painted in slightly richer, darker tones as it is closer.

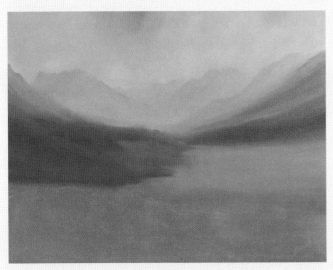

Step 5: Establishing the mid-ground woods colour base. Using a size 6 round brush and a medium fan brush for blending, build up a colour base for the mid-ground woods and the mid-ground shoulder. Use a mixture of Ultramarine Blue, Sap Green lightened with Titanium White, and a small amount of Burnt Sienna. This colour should not be highly saturated. Use as much blue as green in the mix and save the more intense greens for foreground colours. This ridge of trees poses a challenge as it could form a dark block at the centre of the composition. Try to integrate it as much as possible.

Step 6: Establishing mid-ground to foreground colour base. Mix a richer green by lightening with Titanium White and adding less Ultramarine Blue. Using a flat brush (here I am using a 1in flat brush) or a large fan brush, paint in the extensive area of fellside which forms the mid-ground to foreground area. Mix in a little Burnt Sienna and Ultramarine Blue to vary the shade. The colour should become richer in the near to mid-foreground. These colours should be toned down as they recede towards the wooded shoulder.

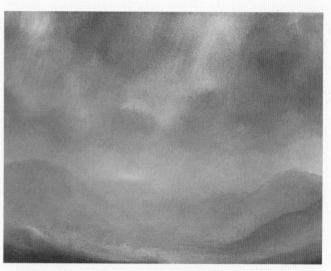

Step 7: Back to the sky. Mix some light greys to create the cloud colours. Use mostly Titanium White tinted with a varied mix of only a little Burnt Sienna, Naphthol Red and Ultramarine Blue (*see* Chapter 5, 'The Sky', for more detailed instructions on mixing 'chromatic greys'). Use a size 4 to 6 round brush to define the shapes of the clouds and a medium, soft fan brush to blend out any unnatural boundaries. For highlights on the clouds, tint Titanium White with a little Burnt Sienna. Go on to Step 8 while the paint is still wet.

Step 8: Painting the mountain and sky margin. As in Step 3, when developing the sky it is important not to create an unnaturally strong visual boundary between the sky and the mountains. Use a soft medium fan brush to blend the margins of sky and mountains as you did before. Redefine the shapes of the mountains using a round brush, size 6 or smaller where necessary, and then re-blend.

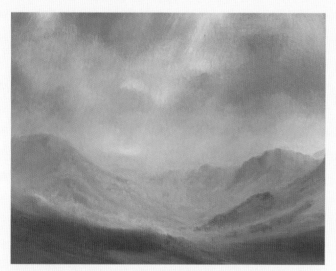

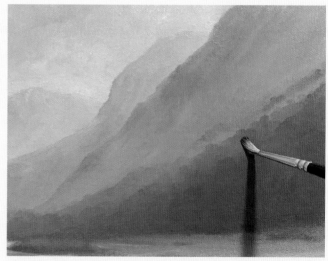

Step 9: Defining mountain shapes. Avoid strong tonal contrasts or heavily saturated colours in the mountains at a distance. Leave room for developing these in the mid-ground and foreground. Use a size 4 to 6 round brush or smaller for this more detailed work. Mix Titanium White with a little Ultramarine Blue and tint with Naphthol Red to create the purple shades of the shadows. Tinting white with Burnt Sienna will create warm highlights for the ridges catching the light. Tone down with blue if necessary. Add a tiny amount of green to the mix for highlights on the lower slopes (*see* Chapter 4, 'Light is Everything', for more detailed advice on painting mountain highlights and shadows).

Step 10: Painting the mid-ground wooded slopes. The mid-ground wooded slopes become richer and darker on the right of the composition as they progress towards the viewer. These are catching only a little light, which is glancing off the tops and sides of some of the trees. Add in a little extra Sap Green and a small amount of Burnt Sienna and Ultramarine Blue to the mix of mountain colour, each time a new ridge overlaps one behind. Paint using a size 4 to 6 round brush. Emphasize the points where the dark profiles stand out against a lighter background (*see* Chapter 9, 'Trees, and Some Special Magic', for more detailed advice on painting woods and trees in the mountain landscape).

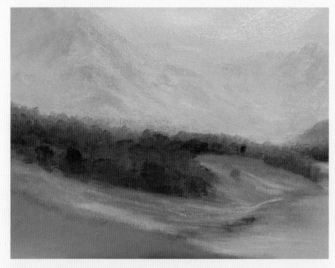

Step 11: Developing the mid-ground woods. The next step involves developing the mid-ground woodland area. This element concerned me at the early stages as a possible problem. If this were painted as a dark block, it would divide the composition and be over-dominant. When dealing with a large woodland block like this one, try to use the light on the trees to create texture by varying the tone and colour. A size 4 to 6 brush, lightly loaded and dabbed on the area, will allow you to develop some tree shapes with highlights. Suggest the shapes rather than attempting to paint the exact form of all of the trees.

Step 12: Developing the mid-ground fellside and bracken. The blues/greens of distant slopes become more yellow in the foreground, and the warm hues become more brilliant. Mix richer greens and warmer tones for this area. Use a small to medium fan brush to create textures, and apply a variety of colours on the slopes and in the foreground. Vary the strength and length of brushstrokes to produce the textured quality of the vegetation, and try to follow the shape of the slopes using a varied, sweeping downward motion. Mountainsides are very rarely a flat colour.

Step 13: The sky again. The previous steps have established a solid base of hues, contrasts and shapes. The next steps involve strengthening contrast in tone, saturation and details. As before, work from the sky downwards. A size 4 round brush is suitable for the details in the sky, and a soft medium fan brush, as in previous steps, for blending unnatural boundaries. Use Titanium White tinted with Ultramarine Blue for the lightest areas of the clouds, and mix several light chromatic greys to define further the shapes of the darker clouds. Use a soft medium fan brush to create the impression of light shafts (crepuscular rays) breaking through the brighter areas of the clouds (*see* Chapter 5, 'The Sky', for detailed advice on painting crepuscular rays).

Step 14: Painting more highlights and shadows on the mountains. Add definition to the shape of the mountains by strengthening and adding highlights and shadows. For the lighter areas use a brighter shade of Titanium White tinted with Ultramarine Blue and Burnt Sienna. Do this very sparingly, using a size 4 round brush or smaller. The lightest lights on the mountain will be applied later on in this exercise. Lower down the slopes, add a little Sap Green to the mix. Very often, the lower slopes in the bowl of a mountain valley catch more light and are a little greener in hue. Add a little more blue, and Burnt Sienna or Naphthol Red, to create the deeper blue/purple shades for the shadows, where the mountainside does not catch the light.

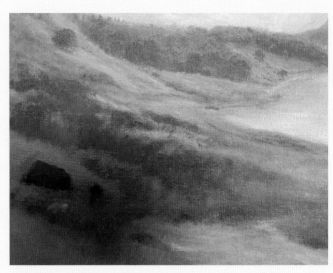

Step 15: Defining the mid-ground woods, more details and highlights.
Remember that the intention is to 'suggest' woods. Using a round size 4 brush or smaller, paint in some lighter areas on the tops of the trees that catch the sunlight. Do this sparingly. As the woodland recedes, the tops of the trees become much less distinct and colours less saturated. Paint in a lighter mottled area to suggest the tops of the trees in the mid-distance. Add more definition to the tree shapes, using a darker tone. Create this by adding a little extra blue and Burnt Sienna to the colour base that you have already mixed for the woods.

Step 16: Emphasizing mid-ground to foreground rich highlights.
Mix both warm colours and greens for the lighter areas of mid-ground vegetation. Enrich Burnt Sienna with small amounts of Lemon Yellow and Naphthol Red to create a warmer tone. Add Titanium White to lighten these mixes. Apply these colours with a round size 4 to 6 brush, using varied brushstrokes to emphasize the areas where the bracken and the grasses catch the light. Burnt Sienna, Ultramarine Blue and Sap Green mixed in various amounts will create rich, dark tones. You need also to build up some darker areas. These will be essential later to allow the strongest contrasts when painting the bright ferns and vegetation (*see* Chapter 4 'Light is Everything', for advice on painting light on vegetation and rocks).

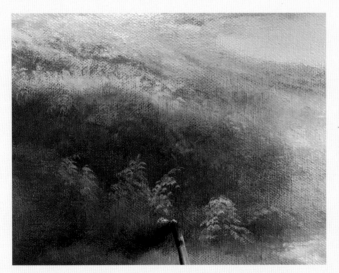

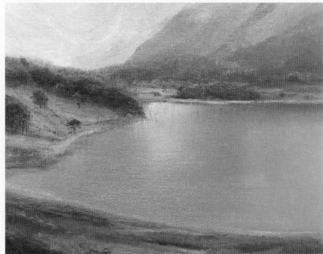

Step 17: Developing foreground, more details and highlights. Use a size 2 to 4 round brush to paint in some bright detail, such as the distinctive pattern of ferns against the background. Use a mixture of the warm and green tones created in Step 16. Choose a few of the lightest ferns or areas of vegetation, and paint them in more detail. I usually use a small round brush which has been pinched between my fingers to create an edge for the sharper details. Alternatively, a pointed round brush or small fine filbert could be used for these effects. Allow the paint to dry.

Step 18: Creating more definition on the water. Mix a mid-tone shade of grey using Ultramarine Blue, Burnt Sienna and white to enrich the colour of the water. Use a soft medium fan brush to apply the colour with downward strokes, then blend with horizontal strokes. Paint in some thin columns of white, which reflect the brightest areas of sky where the cloud is broken. Be careful not to overdo the white. While the paint is wet, gently blend the lighter columns with the darker areas using horizontal strokes.

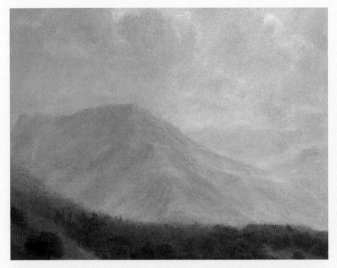

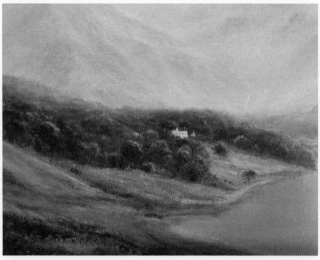

Step 19: The sky and mountains, final run-through. Stand back from the painting at this point. From a distance, it will be more evident which areas of the painting need greater emphasis, brighter contrasts, darker shades and highlights. This is the final run-through from the sky downwards. It is not essential to work from background to foreground, but it is easier to manage contrasts and richness by starting with the areas of lowest contrast. Use a very thin layer of Titanium White to lift the highlights on the clouds and to emphasize crepuscular rays. Use a soft medium fan brush to soften edges. Add some fine highlights to areas where the light reflects on the mountains, particularly in the valley bottoms. This should be limited to a few strokes only. If it is overdone, the effect of light on mountainside will be lost.

Step 20: Mid-ground woods, emphasizing final highlights and details. Using a fine size 1 to 2 round brush, emphasize the highlights at the tops of the trees. The base for these was painted in Step 15. Tint some Titanium White with Burnt Sienna and Lemon Yellow to create the warm highlights. Do this very sparingly. Too many will destroy the effect of light touching the tops and sides of the trees. Using a very fine brush size 1 to 2, paint in a couple of fine lines to suggest trunks of trees reflecting light. Using the same brush, paint in the cottage which sits in amongst the trees in the woodland. Tint the white to slightly tone it down, as a pure bright white will cause the cottage to be over-dominant in the composition.

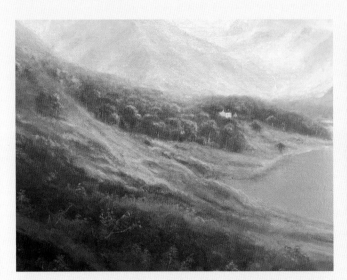

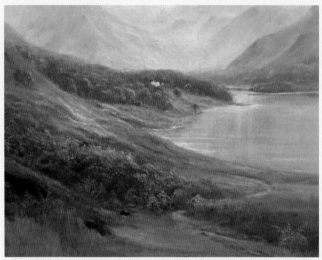

Step 21: Emphasizing rich hues on the mid-ground fellside. Mix some rich highlight colour by adding Titanium White to Burnt Sienna. Enrich this with Naphthol Red and Lemon Yellow. Pick out areas where the vegetation will catch the light most. Paint on the brighter shades to create these stronger and richer highlights. Deepen the shadows where necessary, using an Ultramarine Blue glaze. Try to avoid creating large blocks of colour. Instead, try to vary the tone and texture.

Step 22: Finishing the foreground details. Anything you paint in the foreground will inform the viewer about the shapes and structures in the mid-ground and in the distance. Use a small to medium round brush to develop the shapes of the ferns and the pathway, by strengthening the lights and shades and adding detail. Ferns, in particular, grow chaotically. Try to use energetic brushstrokes to evoke the variation in the vegetation.

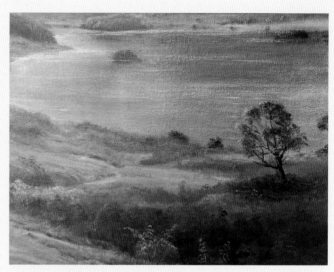

Step 23: Finishing the lake surface and painting the islands. The lake is not the main focus of this composition. Avoid creating a large bright area. Also, notice that any reflections will not be sharp from this viewpoint. Darken some of the water by mixing a deeper shade of grey and, using a medium round brush, apply with downward strokes. Do the same with lighter shades, and use a fan brush to blend them with gentle horizontal strokes. This will give the impression of a disturbed surface. Use a fine brush to paint in some delicate white lines to suggest light reflecting from the water. Paint in the small islands using a small round brush (*see* Chapter 8, 'Water', for more detailed advice on painting mountain reflections). Allow the paint to dry.

Step 24: Painting in the lake edge and vegetation. Make sure the work is dry before you try to paint the border between vegetation and lake. Use a medium round brush to paint in the same warm colours as the mid-ground moorland and ferns. Try to pick out areas along the edge of the vegetation that catch the light. Do not make the edge uniform in colour or tone, as this will look unnatural. Varied textures and tones on the vegetation will add interest to the mid-ground area, and break up any unwanted blocks of colour.

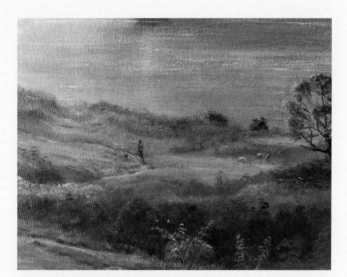

Step 25: Finishing touches. Stand back from the painting once more, and look for areas which require stronger highlights or shadows. With oils and acrylics, it is possible even at this late stage to emphasize shadows or lift highlights, but be careful not to overwork and it is safer to let it dry. If you are satisfied, put your brushes down. If not, it is always worth taking a little time away from the painting and coming back to it the next day with fresh eyes. I have added a small walking figure with a companion to the composition, on the receding path. The figure is helpful in that it tells the viewer about the scale of the fellside, ferns, pathway and mountains. Lastly, I added some small sheep in the mid-ground. They are characteristic of the area, and anyone familiar with these mountains will know they can appear just about anywhere in the scene.

This chapter has covered the principal stages involved in completing a more complex studio piece. The step-by-step instructions follow a replicated pattern, which works downwards from the sky to the foreground, adding detail, enriching hue, and increasing the contrast between light and shade. Rigidly adhering to these stages is not essential, but initially this routine makes the overall balance of the composition easier to control. The temptation to go on adjusting the work, especially in the mediums of oil and acrylic, is familiar to most artists – but my advice is to be wary of adding 'just one more little detail or highlight'. If you feel satisfied with your work, it is time to wash your brushes, clean your palette and move on to the next exciting project.

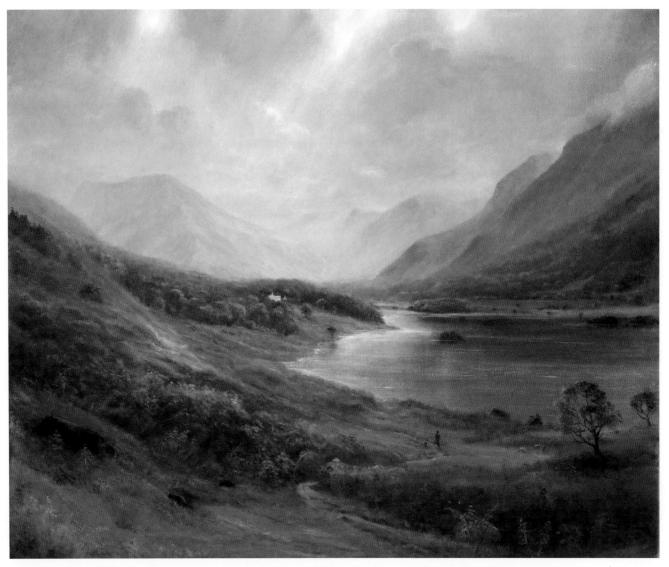

From Rannerdale to Haystacks, studio piece, oil on canvas. This studio piece was painted using a small palette of colours, mixed to produce a range from the cool colours of the high peaks to the warm tones of the close mountain slopes. Ultramarine Blue, Naphthol Red and Burnt Sienna are the main hues, mixed in various quantities with Titanium White to form the sky and the high mountain range. The colours of the woods and the rich vegetation are created by mixing white with Sap Green, Ultramarine Blue, Burnt Sienna – and for the brightest highlights, Naphthol Red and Lemon Yellow. The effectiveness of the composition relies on the sense of recession. It extends all the way from the rich bracken of Rannerdale Knotts in the foreground to the light falling on the Haystacks range, and then to distant Great Gable, cloaked in clouds.

CHAPTER 4

Light is Everything

Come forth into the light of things,
Let Nature be your teacher

WILLIAM WORDSWORTH

The title of this chapter is 'Light is Everything' because the light in the sky and the way it falls on the landscape has the power to change the appearance of just about every element in a painting. How the light affects the mountain ridges, the valleys, the woods and the water is a continual challenge to the mountain painter. It can transform dark ridges into distant grey/blue amorphous shapes, appearing and disappearing on the horizon. It can enrich the grey-greens in a valley and turn them into the warm, yellowy, sap green of new growth, and turn a flat, navy stretch of water into a glistening and shimmering mass at the foot of the crags. Not only this, but the effect it has can be transient, and gone before the artist has lifted their brush or pencil.

Because observing and painting light on the mountains is so very important in order to describe their form, the advent of the digital camera and the ability to take many photographs and store them cheaply is, to me, nothing short of a miracle. As an artist who is fascinated by and wishes to capture the transient and often dramatic effects of light on the mountain landscape, you may well want to sketch and paint en plein air. However, I would encourage you to also take many, many photographs and study them closely when you are at home. If it is not possible to make trips out, you may be able to ask others to record their excursions digitally, and these can provide excellent material for study.

The painting detailed at the beginning of this chapter, *Buttermere Basking in Sunlight*, with a full version at the chapter's end, is one of my personal favourites. Hopefully, it demonstrates some of the important techniques involved in capturing the effects of shafting sunlight on the main elements of the mountain scene.

◀ *Buttermere Basking in Sunlight*, detail, oil on canvas.

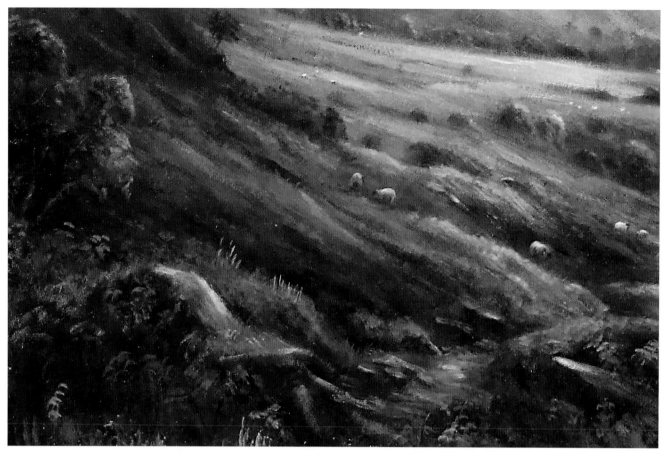

Crack of Thunder, Wastwater, western Lake District, detail. This detail (the full painting can be seen in Chapter 6, 'Storm in the Mountains') is from the left foreground of the painting. The rocks are volcanic, from lavas formed by eruptions several hundred million years ago. There are many large and small boulders strewn around the landscape of Cumbria. Some were left by glaciers, and although weathered to some extent, many have sharp edges. The Lake District is renowned for its damp weather, as are many mountain ranges, and the planes and the edges of these moist rocks and crags reflect both the light in the sky and that from surrounding vegetation (here, it is storm light). Usefully, this helps to connect the foreground in this painting to the lake in the mid-ground, to the valleys in the distance and to the flash of light breaking through the clouds.

DESCRIBING FORM

Observing and painting light on mountains

Light areas and shadows on crag faces ('crag': a steep mass of exposed rock), rocks and boulders are deserving of close scrutiny and can have complex surfaces. Practising painting the shadows and various angles and planes helps to avoid a lumpish, nondescript appearance and also tells the story of the geology of the landscape. Are the rocks, for instance, worn round by weather or are they sharp, hard volcanics or slabs of slate left in a glaciated valley?

Light on Rocks and Boulders

Try this exercise using a fairly warm ground. Here, the tinted ground is a light mixture of Underpainting White, Burnt Sienna and Van Dyke Brown (Hue). You will notice that black is included here in the list of colours. Use this very sparingly. I tend to avoid using black, if possible, as it can have a deadening effect. Try, instead, to mix the darkest shades from other complementary colours, as I often do. Please refer to Chapter 5 for detailed instructions on mixing 'chromatic greys'.

You might choose one of your own sketches or photographs for this exercise, or alternatively use the photograph featured here.

I have used this detail, from a photograph taken in the Crummock Water Valley in the Lake District, as the subject matter for this exercise.

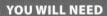
YOU WILL NEED

- Medium-size fan brush (fine) for acrylic or oil paints
- Sizes 1, 2 and 6 round brushes for acrylic or oil
- Acrylic or quick-drying oils (I am using Golden acrylic paint):
 - Underpainting White
 - Sap Green
 - Ultramarine Blue
 - Carbon or Ivory Black
 - Burnt Sienna
 - Titanium White
 - Van Dyke Brown Hue
 - Lemon Yellow (or other mid-tone yellow)
- A support: I am using an ordinary pre-stretched pre-primed medium canvas for this exercise, but a pre-primed board would do just as well
- Palette for mixing
- Medium for thinning: water for acrylics; quick-drying linseed or alkyd walnut oil for oils
- Brush and equipment cleaner: water for acrylics; white spirit (or specialized brush cleaner if you dislike or cannot tolerate the smell and fumes) for oil paints. Oils and soap rubbed into the brushes can be used if you intend to opt for an alternative method of cleaning, as described in Chapter 1

Step 1: Laying the vegetation. First, paint in a broken texture using Sap Green, Titanium White, Burnt Sienna, Van Dyke Brown Hue, a little Ultramarine Blue and black (only use black very sparingly, if essential). Vary these colours, and make largely vertical and diagonal short strokes with both a medium fan brush and a round size 6. Vary the length of strokes and pressure to create the texture. Add a little Ultramarine Blue and Titanium White to lighten the mix, and paint in the mid-ground vegetation. This will create the impression of receding fellside.

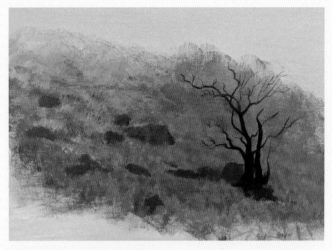

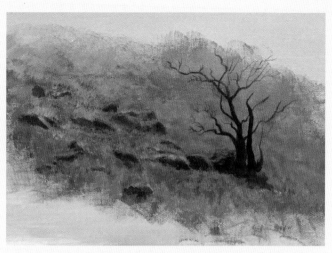

Step 2: Basic rock shapes. Check that the vegetation layer is dry. Paint the rocks over the top of the basic layer of vegetation using a round brush about size 6. Fill in the basic shapes of the rocks using a middle-range neutral grey-brown. I used a mixture of Burnt Sienna, Ultramarine Blue and Titanium White. Look carefully at the shapes, omitting any incongruous shapes and avoid overcrowding the area with too many rocks, which will distract the eye.

Step 3: Basic planes: light and shadow. Either allow the basic shapes of rocks to dry, or use blending in this next stage for a softer effect. Think carefully about the surface planes of the rocks. Which ones point directly towards the brightest light source in the painting? Which planes are in the darkest shadows and in the lightest areas? Paint in the basic dark shadows and the light areas. Use a fine size 1 or 2 brush to pick out any dark cracks in the rock faces.

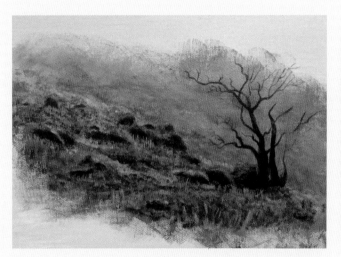

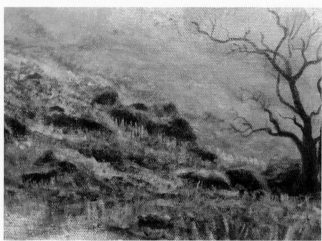

Step 4: Emphasizing shadows and lights. Again, you can either allow the previous layers to dry, or use blending here for a softer effect. Build up the layers of vegetation around the rocks, and emphasize the shadows and highlights caused by the rocks sitting within the vegetation. Use Ultramarine Blue and Burnt Sienna, mixed with either Van Dyke Brown (Hue) or black as a thin layer to deepen the shadows. Titanium White, toned down with these colours and with a little Sap Green, can be used to create a variety of colours reflecting on the surfaces of the rocks.

Detail, Step 4. Notice how the darker shadows help to make the rocks sit naturally within the vegetation.

Step 5: Highlights and sharp edges. Allow the painting in Step 4 to dry. Build up the highlights on the sharp edges of the rocks, and on the damp reflective areas also. Use a smaller brush, as a size 1 or 2 makes it easier when painting tiny highlights. Remember that when the light falls on the rocks, the green colour of the moss is more apparent. Also, reflected light from the surrounding vegetation can produce a green or orange glow. The highlights will rarely be pure white. If you use Burnt Sienna with a little yellow and red, the highlights on the rocks will stand out against the green vegetation. Some rocks have a naturally blue tinge.

Step 6: Adding more vegetation. Make sure that the paint is dry. This is important when sharp details and highlights are wanted. With a fine brush, paint in a few strands of vegetation around and over the top of the rocks, using a mix of white, Burnt Sienna, Sap Green and a touch of Lemon Yellow. This will suggest the kind of ferns or grasses growing around the rocks. Do not be tempted to try to paint a whole plant, unless you want to be a botanical artist! These details will catch the light, and will link well with distant trees and vegetation on the mountain slopes – which may also be partially illuminated.

Final touches. These last details in the foreground will integrate the rocks into their surroundings and will make distant vegetation and rocks more convincing, as they will be interpreted as similar structures.

Light on mountain tops and crags

The issues involved in painting rocks and boulders found on the ground frequently apply to the painting of the rock faces and crags on the mountains. This is to be expected, as they are often formed by the same process. Again, close attention should be paid to the way in which light falls on the various planes, fissures, overhangs and grassy ledges that make up an outcrop.

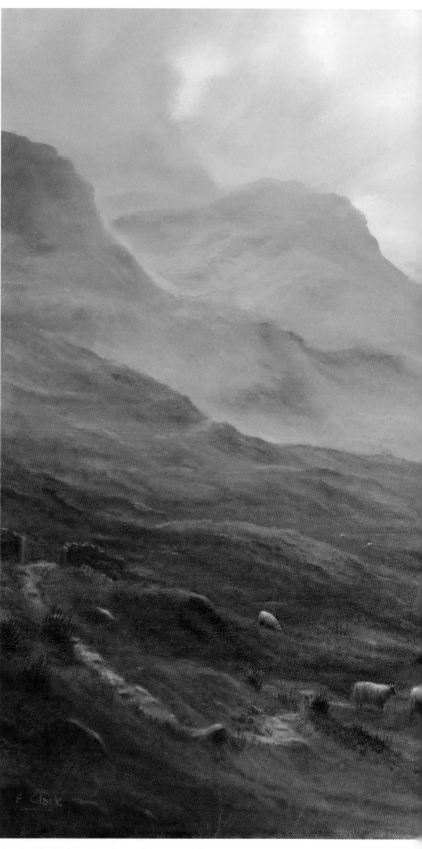

Crossing the Beck, Honister Pass, oil on canvas. This is a view across one of the many mountain passes in the Lake District. The ridges that hang over the Honister Pass are very dominant here. The way the light helps to define their varied shapes, as they line up one over another into the distance, is an important feature of this painting.

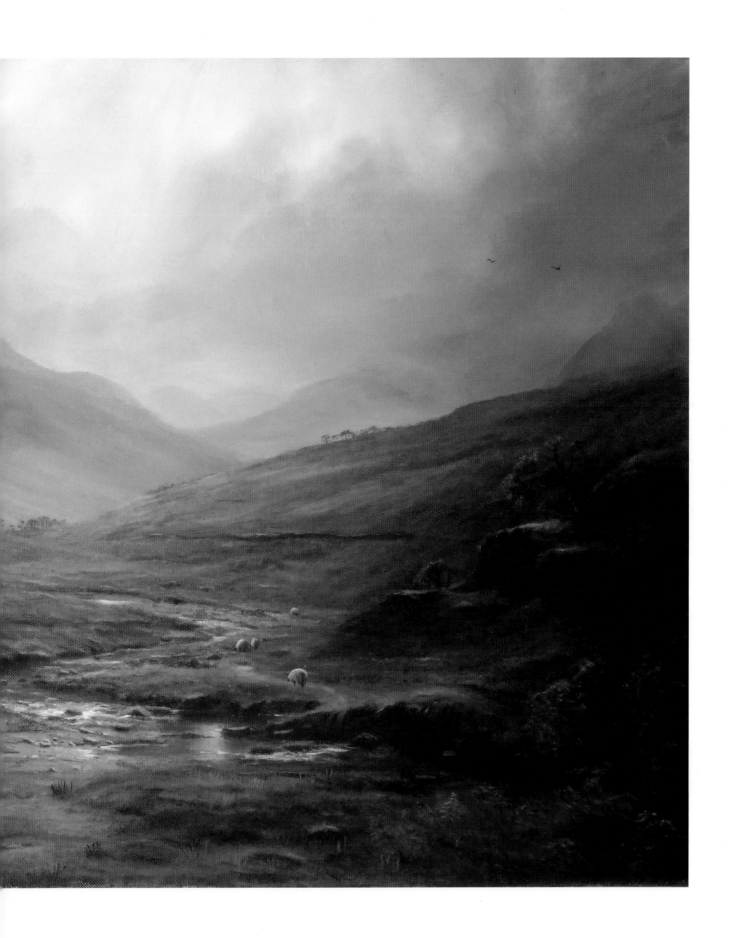

Colour version of a mid-ground detail from *Crossing the Beck, Honister Pass.*

Black-and-white version of the same detail from *Crossing the Beck, Honister Pass.*

The two details above from *Crossing the Beck, Honister Pass* are from the large oil painting pictured overleaf, but the second one has been converted to black and white. Look at the colour version of the mid-ground detail from the painting. The mountain ridges change in colour as they recede from a brown hue to blue. Now examine the black-and-white version. It becomes more obvious, in monotone, how important the light is as a definer of form. It is easier to see how ridges become lighter as they recede, and the dark mid-tone strokes pick out the darker faces of the crags. As the sunlight is coming from an area above and to the rear of the sky, the smoother, grassy lower slopes are catching the light. Some of the rocky outcrops are in the shadow of the clouds, causing even deeper shadows.

Colour version of *By Quiet Waters, Calfclose Bay, Derwentwater*, detail.

Black-and-white version of *By Quiet Waters, Calfclose Bay, Derwentwater*, detail.

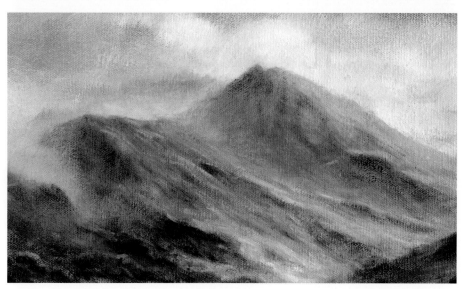

The next two details are from a painting called *By Quiet Waters, Calfclose Bay, Derwentwater*. As with the previous image, the second detail is the same as the first, but has been converted to black and white.

In the colour detail of the painting looking across Derwentwater, again the light (which is coming from quite high in the sky on the right of the picture) is spilling down, lighting up the smooth light-yellowy-green slopes. The darker blue areas define the shapes of the crags and ravines, which are in shadow.

The black-and-white version of the same detail shows even more clearly how the shapes of the crags and gullies are determined by the direction of the light. This particular fell, which is called Grisedale Pike, has a very distinctive shape that demands accuracy if it is to be recognizable. The marked shape and the curve of the slope on the right have challenged me many times.

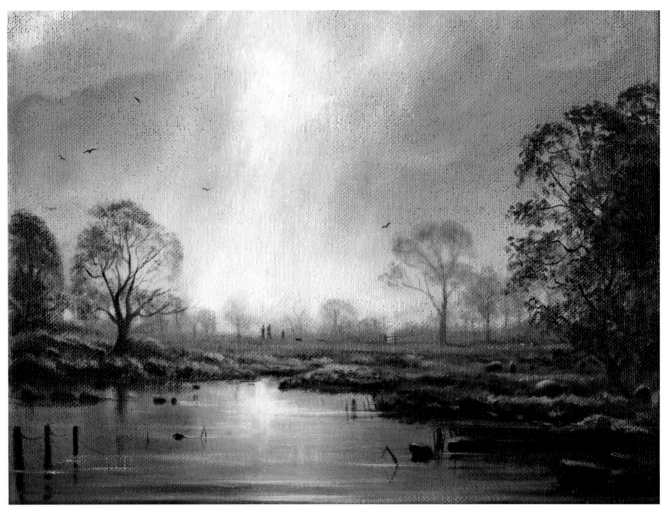

Through the Mist, Crummock. This is a painting of Fleetwith Pike and Haystacks, which are fells situated in the Western Lakes ('fells': local name for mountains and hills in the UK Lake District). The view here is from the valley floor near Crummock Water. This range was featured in the previous chapter, 'A Studio Piece'. Notice how the distinctive shapes of the Pike and Haystacks are almost completely lost in the intensity of light reflected from a low winter sun, magnified and bounced around by a rising mist. The light is brighter at the floor of the valley as it hits the thicker mist, which is only gradually lifting in the middle of the day.

LIGHT AS DIFFUSER

When the atmospheric conditions combine sunlight with low cloud or mist, the shapes of the summits appear and disappear as they are caught in the shifting light. Sometimes the tops of mountains are completely obliterated, even close by, and sometimes gently softened in the far distance. Features which have been clearly defined – trees, figures, rocks and crags – become much less distinct. These effects are helpful when trying to create atmosphere and to capture the mountains at their most beautifully mysterious. Luckily for us, digital photography allows us to gather many images to study as the effects are frequently fleeting.

A short exercise which might help you to master the control of diffused light is to try painting scenes close to monotone. Mix a series of tones from deepest (I used Ivory Black for the purposes of this exercise) to lightest (I used Titanium White). Having mixed these tones on the palette, use them to produce or copy a rough landscape sketch in which some of the features, such as trees or mountain ridges, are only subtly different to the tones of the background – creating the effect of shapes in the mist. Use the darker tones to build up foreground features. Limiting the palette in this way forces concentration away from colour and onto the effects of light and shade. Keep in mind that this is an exercise in judging tones in monotone. Later on in the book, having studied mixing dark chromatic greys, you will probably find that you use black much less.

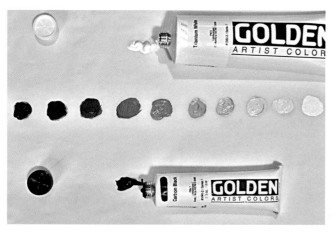

Mixing tones: here I have mixed a range of tones from black to white. Try this exercise with two or three colours only, for instance Ultramarine Blue, Carbon or Ivory Black and Titanium White.

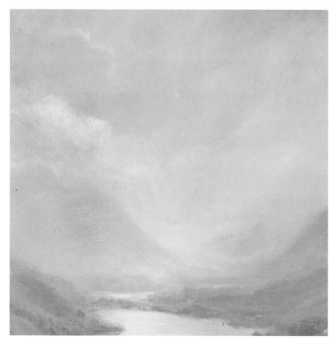

In this detail of *Buttermere Basking in Sunlight* you can see that the mountains in the distance (even those in sunlight) lose their distinct edges and their colour saturation, as do the edges of the lakes and distant fields. The bottom of the valleys will usually, if they are flat, reflect the sunlight more intensely, contrasting with the slopes – which are slightly darker. There are areas where the clouds are passing over and also areas of bright sunlight, reflected in the distant water. The rays of sunlight which emanate from the top of the composition and shine down are sometimes diffuse, sometimes bright – lighting up the distant slopes.

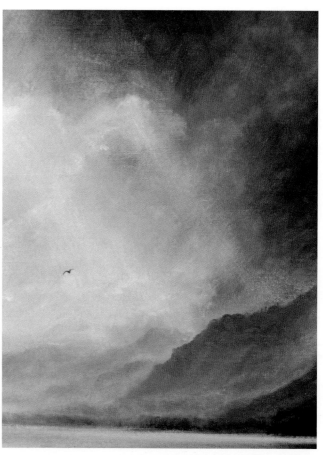

In this detail from *Hunting Osprey, Bassenthwaite, Morning Sky* the rays are more defined and the dark sky and fells behind make them more obvious. They add atmosphere to a painting that is dominated by the sky.

Crepuscular rays

This brings us on to 'crepuscular rays', which are a common feature of most cloudy mountain landscapes. These are the rays which, one or more at a time, break through the clouds like a spotlight onto the land, water or clouds below.

Sometimes the rays become more diffused as they pass through low cloud or mist, creating dramatic effects. They add interest to a mountain scene which may otherwise be rather flat, and they can also help to lead the eye across the landscape.

Crepuscular Rays in the Mountains

Try this short exercise to practise painting crepuscular rays of sunlight shining through the clouds onto the mountainsides. This demonstration was painted on inexpensive rough canvas with the intention of making the brushstrokes clearer. It is meant to be a quick and experimental exercise, but if you are dissatisfied with the effects created, let the paint dry (this should only take a few minutes for acrylics or fast-drying oils) and start again. I have painted a warm base layer over the white-primed canvas, but I have left parts of this unpainted so that the layers are more visible. However, as you may wish to work this sketch up to a finished piece if the exercise goes very well, it might be wise to paint to the edge of the canvas.

YOU WILL NEED

- Medium-size fan brush (soft) for acrylic or oil paints
- Size 2 round brush for acrylic or oil
- Support (cheap rough canvas or board will do, but make sure it has been pre-prepared and already primed with an acrylic base layer)
- Acrylic or quick-drying oils (I am using a quick-drying acrylic):
 - Ultramarine Blue
 - Carbon Black
 - Burnt Umber
 - Burnt Sienna
 - Titanium White
- Palette for mixing
- Medium for thinning (water for acrylics; quick-drying linseed or alkyd walnut oil for oils)
- Brush and equipment cleaner, as for previous exercise

Step 1: Paint in basic layers of tone. Using Ultramarine Blue, Carbon Black (very small amount), Burnt Sienna and Titanium White, mix three or four different tones in muted colours to suggest areas of cloud, sky and mountains. Using diagonal strokes with the fan brush, paint in these areas. These strokes will help to create the effect of the shafting light on the mountains.

Step 2: Blend the tones and increase tonal contrast. Using your fan brush again, blend the areas of paint so that their edges are softened. Smooth in some lighter tones to suggest mist lying in the valley bottoms. Add a small amount of Burnt Umber, Burnt Sienna or Carbon Black (as always, use black sparingly – it is better to mix dark shades from other colours if you can as you progress) to the mix, and apply as a thin layer to create slightly darker tones suggesting closer ridges and areas of cloud. Add a little appropriate medium, if necessary, to increase flow when applying these thin layers. Allow to dry.

Step 3: Add the lights. Dab in some small areas on the edges of the cloud using Titanium White tinted with a tiny amount of Burnt Sienna. Use a size 2 round brush (I am using a Winsor and Newton Monarch brush here). Do this sparingly until you see the effect in Step 4. You do not want a 'whitewash'. Do *not* allow this to dry before you go to Step 4.

Step 4: Dragging the paint. Use your fan brush on wet paint to drag down the white paint, to suggest the shafts of light emitting from behind the clouds. These strokes should be gentle and roughly follow the initial diagonal strokes that you painted in Step 1. You will notice that as the paint is 'dragged' it becomes less intense and defined, mimicking the rays of light as they become more diffuse away from source. If you are dissatisfied with the intensity of light, repeat the exercise. The Burnt Sienna will add a little warmth at the edge of the clouds.

Step 5: Create some details. Use a mixture of Titanium White and Burnt Sienna (a very small amount) to highlight small areas which show where the light lands in the cloud, or in the valleys. Use a size 2 round brush to dab these in and soften and blend some of them. Avoid large areas of white, and use your fan brush to blend in any areas which look unnatural. Pick out some details in darker tones to suggest trees and rock outcrops. Again, use a size 2 brush or smaller. Allow to dry.

Step 6: Deepen the tonal contrast. Finally, deepen the contrast, if you want to, by enhancing the darker tones of the sky and the mountain slopes. Use a thin mix of darker paint, Ultramarine Blue and Burnt Sienna, as a thin glaze (mix in a little medium if necessary, to increase the flow of the paint). The same applies to the light areas, using Titanium White and a little Burnt Sienna. This will create a more dramatic effect, but be careful not to obliterate the mid-tones when you emphasize lights and shades. Too many heavy, large areas of contrasting tones will cause a loss of any subtle touches that you have created. A word of caution here: rays from the sun can radiate out from behind a cloud in just about any direction. For this exercise, it is assumed that the light is coming from one direction only.

TIMES OF DAY

The time of day, along with the weather and the seasons of course, has a great influence on the colours, the contrasts, the variations of tone and the definition in the composition. If you choose to paint a scene at a specific time of day and come back to it later, it is likely that you will find that the patterns of light and shade and the colour will have radically changed. This is particularly so for the mountain landscape. In the morning, large areas of the valleys and slopes will still be in shade, with the rising sun catching the edges of the cliffs and crags. The lower slopes and vegetation will be left in heavy shadow, not fully silhouetted but certainly in shadow. The same will apply in the afternoon and evening when the sun will have moved off whole valleys well before it has set elsewhere.

The three paintings reproduced here on pages 69, 70 and 71 feature lighting that is subtly changed by the different times of day: morning, afternoon and after sunset. They all contrast quite strongly with *Buttermere Basking in Sunlight* featured at the start of the chapter, where the light is that of an afternoon in summer.

The sun is not very high in *Morning, Derwentwater*, and is masked by clouds. It is not painted using the pastel colours of early morning, but nevertheless the greens are somewhat muted. The woods and lower slopes are in shadow and (although they are close by) the craggy tops are painted as soft-edged.

Now look at the end of this chapter at *Buttermere Basking in Sunlight*. The sun is still quite high, the greens and yellows are intensified, and most of the slopes are lit on either side of the lake. The mountains look benign in comparison to some mountain paintings in which the dark craggy shapes and deep woods are emphasized.

The next picture is called *Light in the West, Derwentwater*. Compare this view to *Morning, Derwentwater*. The sun has not yet set in the painting *Light in the West, Derwentwater*, which depicts a late afternoon in September. The sunlight can still touch the edges of the trees, which retain many leaves, and it catches on the reeds and ridge tops – which are also highlighted using a mixture of Burnt Sienna, Lemon Yellow and Titanium White. When I want to blend the colours to avoid a hard edge, I paint in the highlights while the other colours are still wet. The colour of Grisedale Pike and the surrounding fells is becoming cool, and I have mixed in more Ultramarine Blue to the blend to emphasize the colour shift. Notice that the mountains, at this time of day, often take on a purply-blue hue, while the sky has become more yellow as it borders the tops of the fells.

Now compare both scenes to the painting, *Roosting Time, Buttermere*. This is a small painting and almost monochrome. The sun is no longer able to reach this particular valley. Most colours have been drained and darkened, and the painting relies for its impact upon the contrasting silhouettes of crags, trees and birds, and on the reflections. The brightest lights reflect on the water and lead the eye over the top of the dark trees to the mist in the high valley, which catches some of the remaining light in the sky.

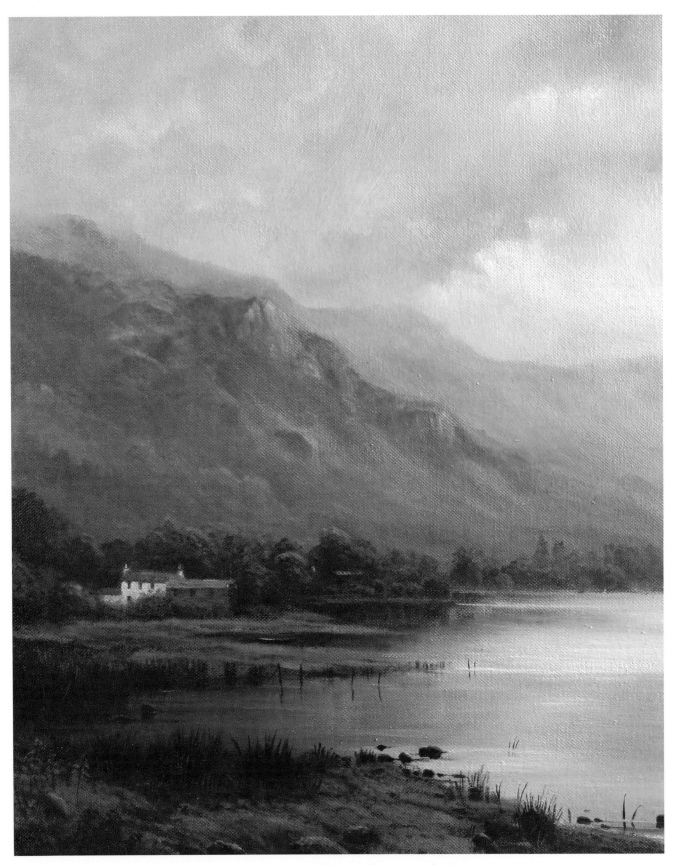

Morning, Derwentwater. This is an autumn view of Derwentwater and Walla Crag in the western Lake District.

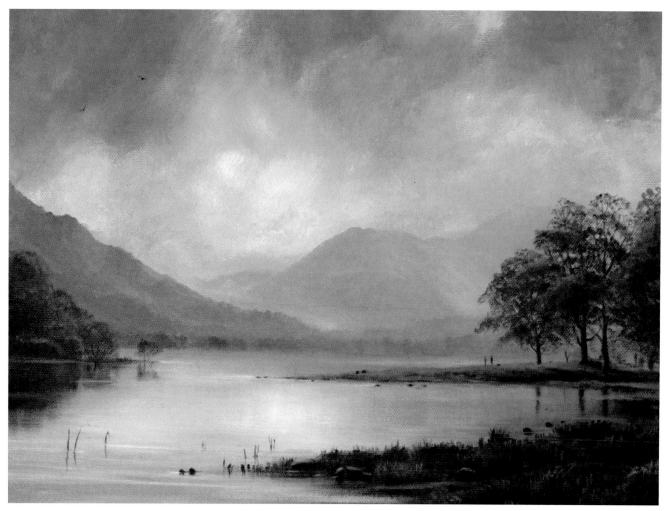

Light in the West, Derwentwater. This view is looking west in the late afternoon (before sunset), in the opposite direction to *Morning, Derwentwater.*

Shadows

Shadows, like light, vary with the time of day, weather and season. Try to look carefully at the colour of the shadows you are painting. They are rarely purely black or purple, and usually vary in tone and texture. The conventional rule of using a complementary colour for painting a shadow can be useful, but my advice is to look at how the colours and the textures relate to the rest of the picture. Automatically using a complementary colour can make a shadow look out of place.

This is particularly relevant to painting the mountain scene, as intensity and hue of shadows are so variable. A shadowed area will be quite different on an area of woodland compared to that on a flat rock face. Building up shadows using a neutral base first (as demonstrated earlier in this chapter when painting a small group of rocks) and then using darker layers to follow is a very effective way to create the depth of colour that the shadow requires – at the same time integrating it with the landscape. Building up layers will also help to create variation and texture. It is particularly appropriate if you have decided to plump for oils, which mixed with linseed oil will allow you to subtly use successive layers to deepen and enrich the colours. Most shadows have a blue tone, so using Ultramarine Blue in the mix is a safe strategy.

Some shadows are also, like light, definers of form. The shapes of the outcrops and gullies are described by the depth of the shadows just as much as they are by the highlights. These kinds of shadows are not the same as shadows cast by a rock or a tree, but instead they are the natural colour of the rockface or vegetation when it is away from the source of light. The shadows cast by an object are a different kind of shadow. These shorten and lengthen depending on the time of day. Crags cast shadows on the

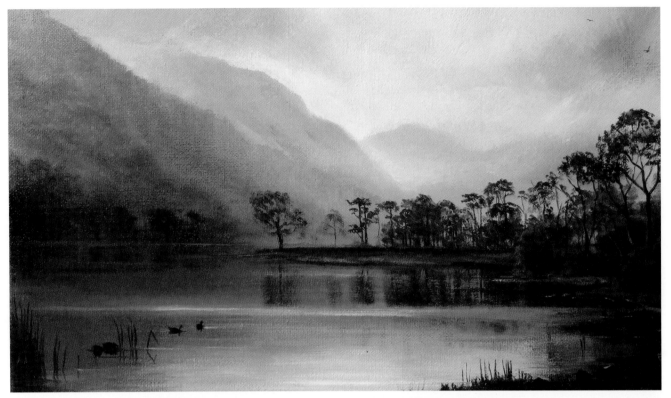

Roosting Time, Buttermere. The scene of water birds and rooks returning to their overnight roosts, before the dark sets in, will become a familiar sight to any artist trying to capture the mountain scene just after the sun has gone.

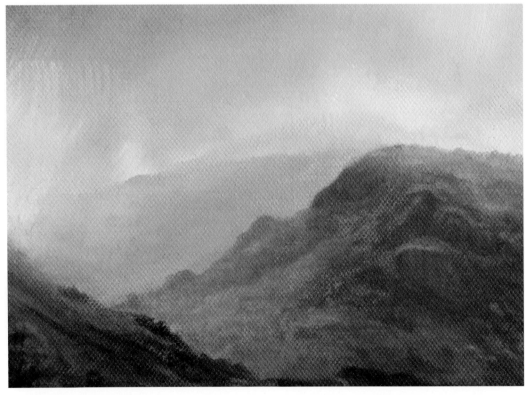

Blue shadows: Look at this detail of a painting of Ullswater from Silver Bay, looking towards St Sunday Crag. The Ultramarine Blue glaze contrasts with the rich orange brown of the slopes and gives form to the crags and woodland.

mountain flanks, and mountains cast shadows on the valleys and lakes below. These shadows follow the contours, and reflect the texture, of the material onto which they are cast. The detail from *Walk on the Shoreline, Buttermere* includes several cast shadows: from the trees; the people; the dog and the rocks. Be careful to make shadows consistent, but be wary of monotonous repetition. Shadows should not appear like a row of dark bars.

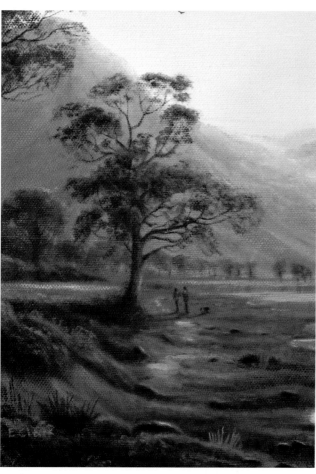

Cast shadows: *Walk on the Shoreline, Buttermere*, detail. The shadows should be consistent, but not monotonous. Allow the other forms to distort and scatter them. In this painting, notice how the shadows from the people and the dog are more defined at the point where their feet meet the ground, and then become more diffuse as they spread out over the grass. This painting portrays a walk late in the day, so the shadows are long, and they tell you that the sun is well down in the sky.

COMPOSITION AND LIGHT: GUIDING THE EYE

I hope, by the end of this chapter, that you will have tried your hand at painting a variety of different lighting conditions on the mountain landscape. As you become more confident, try to create opportunities in which light is used to guide the eye. Ideally, the most intense points of light should lead the eye across the mountainscape from all sides of the canvas, from foreground to mid-ground to a point (often at eye level) in the distance. Beware, though, of creating a simple line of light into the distance, or of making the composition symmetrical by having light points exactly opposite one another, right to left.

In *Misty Fells, Ullswater* the eye is led into the composition by the bright lines of the ripples hitting the reeds, and the splash of light in the foreground. Most of the bright lines are short, and none cut right across the picture. Notice one or two small outliers, for instance the one on the small rock on the front left of the picture. These help the eye to encompass the whole composition while the dark areas push the focus back inwards. A small white sailboat and its reflection in the distance catching the light, balanced by a white ripple to the right of the island, lead the eye into the V-shaped valley bottom of Patterdale, where the mist is most intense. The dark birds and trees also help to steer the eye back round onto the focus of the composition, the mountain range.

It is helpful, in the early stages of a composition while sketching, to make notes on your sketch to remind yourself of the direction of the most intense light source, areas of dark shadow and any features that are particularly reflective and might be helpful as guides to the eye. Also being aware of the direction of light at a specific moment is important because a sudden change, such as cloud cover, can make a nonsense of the composition – creating anomalies and a lack of coherence.

Tonal mapping

The painting at the end of this chapter, of the Buttermere Valley, is pictured in black and white. It is easier to analyse the tonal breakdown of the painting *Buttermere Basking in Sunlight* without the distraction of colour. The slopes forming a V-shape in the foreground are the deepest in tone, and the highlights on the sheep, the boulders and the vegetation contrast strongly with the darker shadows. As the ridges line up along the lake edge on either side,

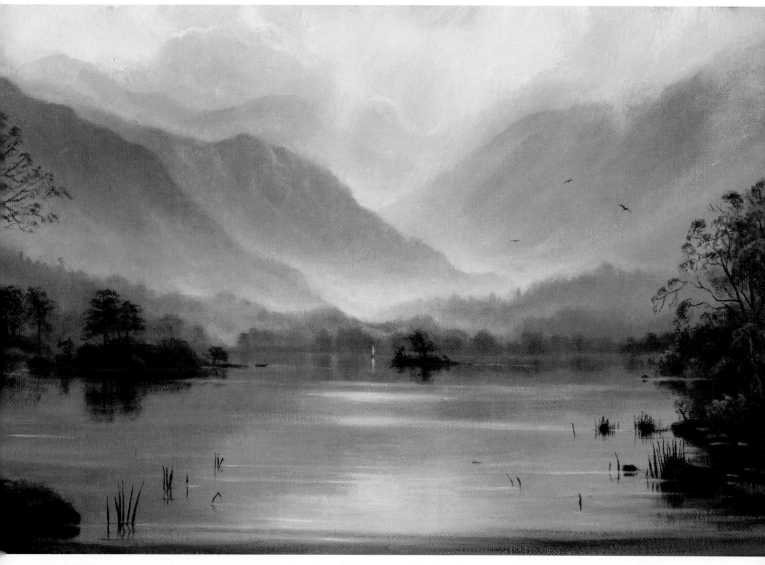

Misty Fells, Ullswater, eastern Lake District. In this painting, the points of light are created by the disturbance in the water and by the rays of sunshine hitting the mist in the valley bottoms.

recession is emphasized by the lightening of tone and the decrease in contrast between light and shadow. Notice, though, that the pure whites appear to hold on to their intensity well into the distance, whereas the deeper and mid-tones fade as they recede.

Looking again at the colour version, it is possible to see that the tonal progression combines with the change of colour (from rich greens and browns to a light blue) to create a sense of distance. This change in colour (caused by the atmosphere acting like a filter, allowing some colours through and muting others) is a feature of mountain painting that has been recognized by artists for centuries, and

a brief online trawl through the Old Masters and famous landscape painters will demonstrate this. You will, most likely, have made some initial explorations in your studio piece in Chapter 3.

In this chapter we have looked at light both as a definer of form and as a storyteller. We have explored the importance of the direction of light. We have studied how light can transform detail and colours, and how it can be scattered or break through in shafts onto the mountain scene. We have noted that light can be affected by many other factors such as the season or time of day, and also how the study of shadow as light's 'other half' is a vital part of our

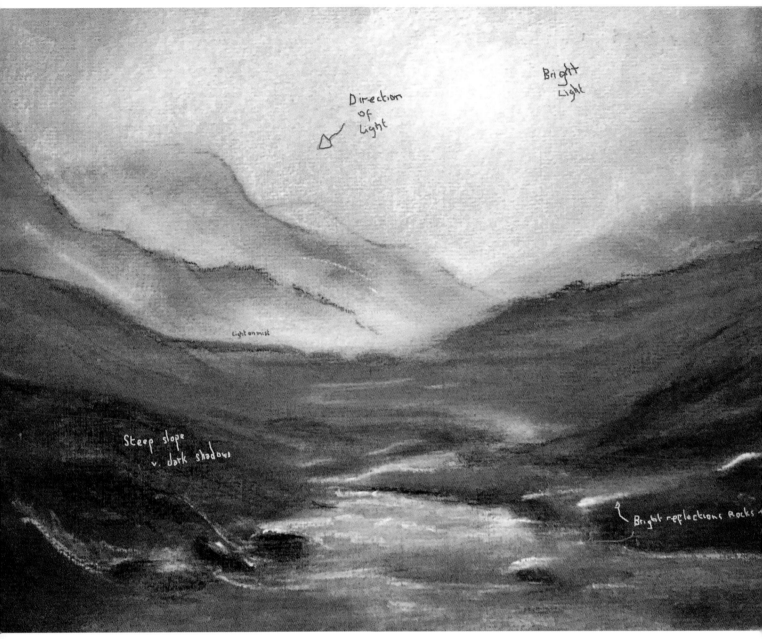

This is a pastel sketch for the painting pictured earlier in this chapter, *Crossing the Beck, Honister Pass*. Here, the most important elements of strong light and shade have been noted. You might find it useful to be more detailed if you are relying on only your sketch and memory.

skill. Also, for the mountain painter, light is undoubtedly a wonderful tool with which we can capture the attention of the viewer, and lead them from the foreground, across the mid-ground, and on to the summits.

I would like to make one last point in this chapter, which I believe is particularly important, about studying the use of light in mountain painting. It can, of course, be particularly useful to know 'the rules' and there are guidelines and tips to be found in just about every instruction manual, but it is important to avoid becoming a slave to them. Looking at those artists who have been praised for their use of light (the title of 'Painter of Light' was given to Turner), it is obvious that they have concentrated not on the rules, but on helping the viewer experience their own perception and love of light. I hope that you can find lots of instances where the light on the mountains inspires you to think, 'This really must be painted'. Enjoy it. Light really is everything.

Buttermere Basking in Sunlight, converted to black and white. Having access to a computer and suitable graphics software, in order to convert a photograph into black and white, can be an especially useful tool. Successful contrasts are much easier to identify in the work, as are areas where tone and contrast needed to be stronger or more varied.

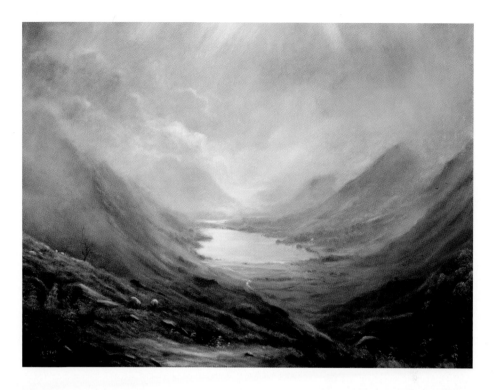

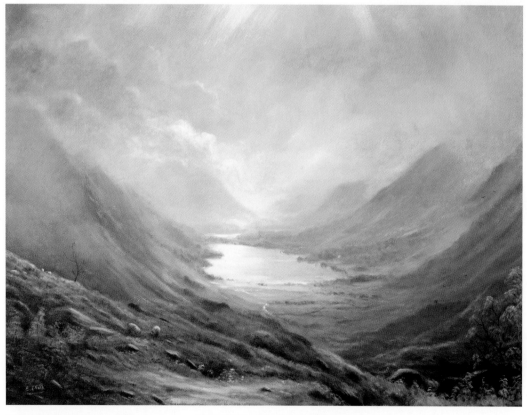

Buttermere Basking in Sunlight, oil on canvas. This view from the slopes of Haystacks takes in two of the most beautiful and unspoilt stretches of water in the UK's Lake District – Buttermere down below, stretching on towards Crummock Water in the distance. The sun moves westward, lighting up the water and the mountain slopes that run down on either side to the lake edge. Eventually it sets on the Cumbrian coast – which is often visible from the fells, especially on a fine summer's day like the one in the painting. This is a popular view for both painters and photographers for good reason. It offers a sense of distance and openness, but at the same time the viewer is aware of the imposing mountain ranges which flank these lakes. Directly behind the viewer, the slopes lead up to the small mountain lake of Blackbeck Tarn, then on towards the high central fells of Great Gable and Scafell Pike.

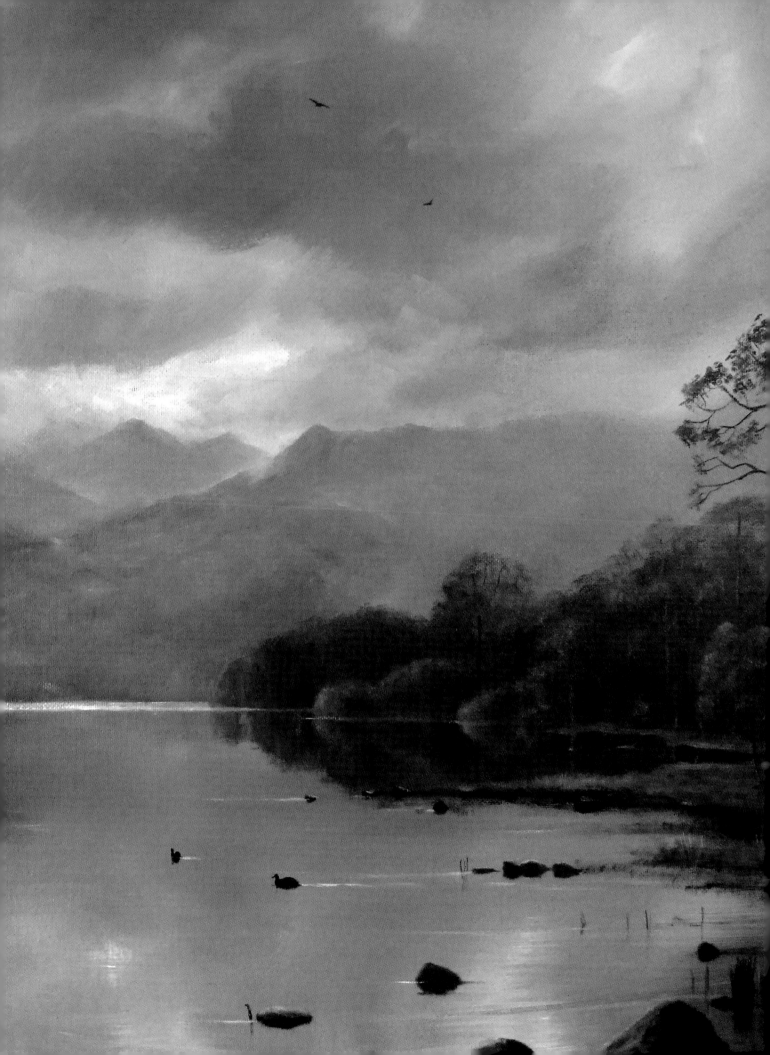

The Sky

Be comforted, dear soul!
There is always light behind the clouds.

LOUISA MAY ALCOTT

It is tempting to think of the sky in a painting as somehow a separate entity to the rest of the composition. In mountain painting, even more than other genres, this should not be the case. The guidelines which govern lighting, perspective and composition apply just as much to the sky as they do to the other features of the painting. In certain weather conditions, the sky and the mountains are so intimately related in colour and tone that it becomes impossible to distinguish between the summits and ridges, and low cloud. On other days, the mountains stand out strong and sharp against a clear sky. In both cases, however, the amount of light and the colour of the sky profoundly change the hues and tones of the land mass.

Ratios: sky versus land and 'the rule of thirds'

When artists and photographers feel unsure about how to construct the proportions of their artwork, they often fall back on the 'rule of thirds'. This is an artistic principle that has been employed for centuries. It is a simple guideline which works by dividing the composition equally into nine rectangular sections using two horizontal lines and two vertical lines. The main focal points should, according to the rule, sit on the intersections of the lines. This avoids the temptation to place the focal points in the centre of the composition, and thereby accidentally divide it in half.

Some landscape painters use this as a rule of thumb, and interpret it as either a one-third sky versus two-thirds land, or two-thirds sky versus one-third land. For the mountain painter, this poses difficulties. Where does the sky end and the mountains start? Are the distant faded-out mountains part of the sky or the land section? Does the dividing line pass through the base of the mountains or the tops? There are no hard and fast rules about exactly where to divide the composition, but within limits these basic divisions can be helpful as a rough guide.

Think about the function of the sky in your painting, and ask yourself the following questions: How important is the sky to the composition and the overall tonal contrast? Which areas of light and shade do you want to be dominant?

Have a careful look at the painting *Into the Mists, Derwentwater*. It is clear that it is divided roughly into thirds horizontally. The most obvious dividing line is where the lake meets the base of the mountains, and the mountains and the sky sit above this line and constitute roughly two-thirds of the composition. The tonal values of the sky and the mountains are very similar, with the bulk of the slightly darker tones sitting underneath the lower horizontal line, comprising the reflection in the lake (were this line to divide the composition in half, the effect would appear artificial). Dividing the composition in this way accomplished two main aims: firstly, the intentional blurring of the sky and mountains, as the outlines of the summits were lost in the mist; secondly, the creation of a light backdrop, which produced a sharp contrast between the dark trees and the tiny figure on the promontory.

◀ *In a Quiet Water'd Land, Ullswater*, detail, oil on canvas.

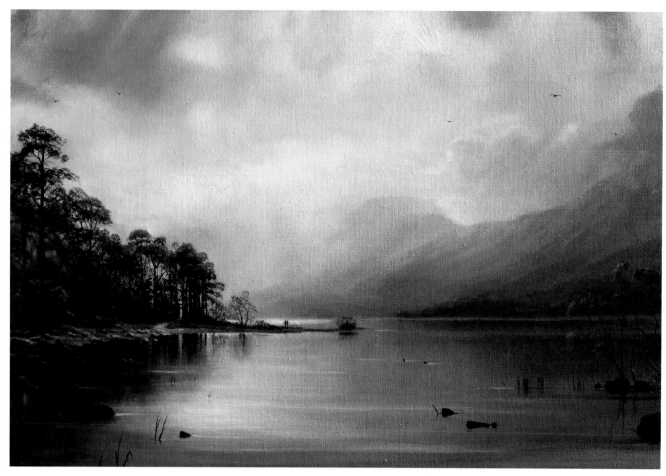

Into the Mists, Derwentwater, oil on canvas. The Lake District fells are often swathed in mist, as in this picture of the southern end of Derwentwater. This was not a dull day; in fact the sky was quite bright with a great deal of diffused light reflecting off the water droplets and the lake. The light sky plays a significant role, as it contrasts with the dark trees and the tiny figure on the promontory – which is an important focus of the composition.

Avoiding over-emphasis

I invariably decide on the role of the sky before I begin the composition, and it is the first area to be painted. Some artists become so enamoured with painting skies that they move on to concentrating entirely on large canvases, depicting wide and wonderful cloudscapes. However, if mountain painting is your chosen path, remember that over-emphasizing the colours and contrast in the sky can be dangerous. It can detract from the subject matter and fight for the attention of the viewer. The mountains can appear diminished. Dramatic brushwork and high contrast in light and shade can enhance a mountain painting, for instance when painting a storm (*see* Chapter 6 for a step-by-step demonstration), but it must be a 'part of', not separate from the mountain scene.

Eternal Summer, The Langdales, detail. The profiles of the Langdale Pikes rise up at the head of the Great Langdale Valley in the central Lake District. They have a strong characteristic shape and are very well known and loved, therefore it was important to be as true to their shape as possible. This detail is from a painting that attempted to capture the rich green pastures of the valley. It was important that the sky should not detract from the mountain scenery, but instead should add to the atmosphere of tranquillity. The light clouds complement the shapes of the Pikes and are softly blended with the blue fair-weather sky.

THE FAIR-WEATHER SKY

There are some weather conditions in which the sky is completely blue and cloudless down to the horizon, but in others, even in fair weather, there is often a mist or fog lying in the bottoms of the valleys. Sometimes, there is a hazy band hanging across the sky above the natural horizon. In the afternoons on fine days 'puffball clouds' form and very quickly dissipate, or there may be a low cloud bank which sits on the horizon all day without changing.

For the mountain painter who wants to show the characteristic shapes of the summits, clear skies may be essential for at least some of the time. The skies of the Lake District in England, where I complete most of my work, are rarely clear blue or cloudless for a full day. It is possible, though, to find times (when the pressure is high in summer and winter) when the profiles are clearly visible.

Most blue fair-weather skies have some variations in tone and hue. 'Atmospheric perspective' usually means that the intense blues above our heads fade as they recede towards the horizon, and in *Eternal Summer* in the distance the lighter colours have a yellowy tinge. Avoid

painting a block of uniform, intense blue. This is likely to appear unnatural and may well make the mountains look like cut-outs against the sky. Carefully observe the point at which the sky meets the outline of the mountains and the transition between the two. As the sky recedes, the boundary between sky and mountain will become softer and, depending on light conditions, sky colour will filter through the vegetation on the ridges. I always paint the sky first, and never leave it blank to 'fill in at the end'. This avoids artificial divisions and lack of integration.

The sky is usually the lightest part of the composition and is likely to set the breadth of tone in the painting. If initially the sky tones are too dark, creating the correct mid-tone and the shadow variation in the rest of the composition will be more difficult. Begin painting the sky with a thin layer, and remember that colours often appear lighter on the palette than on the canvas. For the next step-by-step demonstration, you may decide to use the photograph of Crummock that I have used as source material, or you may prefer to find your own view – in which case, try to choose a sky which is blue, but recedes into a lighter colour.

Blending a Cloudless Sky

This exercise could be completed in one go; it could be dried quickly if you use a quick-drying medium or quick-drying oils. The demo does involve a lot of blending, however, and you may decide to use standard oils, which will allow you to take the process more slowly. (On other occasions this has its drawbacks. For the oils to dry enough to proceed, even when thin, may take several days at least, whereas quick-drying mediums or paints can shorten the time to a couple of hours or less.)

YOU WILL NEED

- Quick-drying oils or standard oil paints (I am using standard oils):
 - Underpainting White (not necessary if you decide to use a tinted panel)
 - Titanium White
 - Ultramarine Blue
 - Prussian Blue
 - Winsor Yellow
 - Alizarin Crimson
- Walnut Alkyd Medium (using this will mean that your standard oil paints will dry much more quickly)
- A support: I am using a small, smooth, tinted panel for practice purposes
- Palette for mixing
- 1in flat brush (for un-tinted panel)
- 3 fan brushes: large, medium and small
- 2 or 3 round brushes (small size 2 approx., medium size 4 to 6)
- Chalk or soft pastel
- Brush and equipment cleaning materials: paper towels, white spirit for oils, or soap and linseed oil

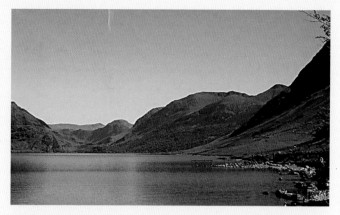

Photograph of Crummock. This view of Crummock Water looks south-west towards the Buttermere Valley. Red Pike and High Stile rise high above the water. This was a rare day in the English Lake District when there was a cloudless sky right down to the horizon.

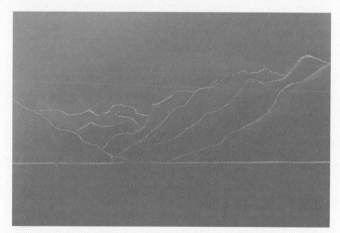

Step 1: Mountain outlines. Using chalk, pastel or soft pencil, very lightly draw in the outlines of the mountain tops. Try to complete all the following steps without allowing the paint to dry.

Step 2: Mixing the blue. Mix three or four shades of blue going from dark to light, using Titanium White and Ultramarine Blue. Adding a very small amount of Alizarin Crimson or Burnt Sienna will create a purple tone. Adding Prussian Blue will move the shade closer to cyan.

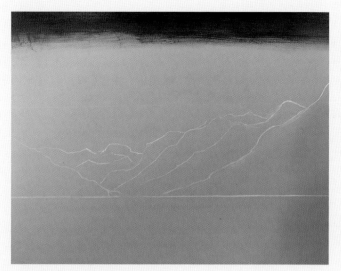

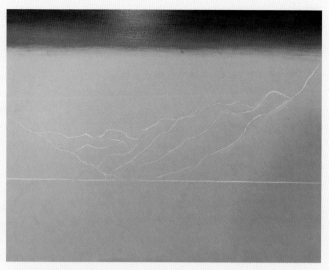

Step 3: Horizontal strokes. Using a large soft fan brush, paint in a horizontal strip of dark blue at the top of the board. Use parallel, even horizontal strokes as much as possible.

Step 4: Blending the blue. Paint in the next band of mid-blue tone with a fan brush. Using a soft, clean medium fan brush, blend the margin of the two colours with smooth horizontal strokes in parallel across the canvas. Try to avoid over-blending, as this will create one single block of colour.

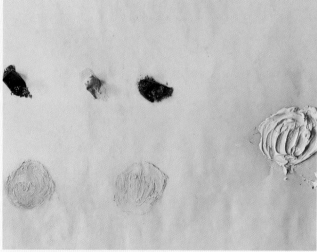

Step 5: More blending. Repeat Step 4, but this time using the lightest blue rather than the mid-blue. Avoid introducing the darkest blue to this area of colour. The idea is to create a smooth transition from dark blue to light.

Step 6: Mixing the whites. Try mixing tinted shades to use in the remaining half of the sky. For example, mix Titanium White with a very small amount of Burnt Sienna to create a warm white shade (pictured bottom, centre). Then mix Titanium White with a very small amount of Burnt Sienna, Winsor Yellow and Alizarin Crimson (bottom left). The intention here is to tint the white, not overpower it.

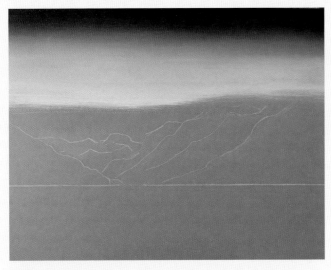

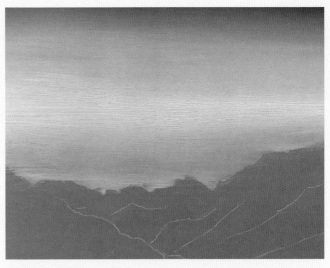

Step 7: Blending the white. Using a medium or large fan brush, paint a strip of the white/Burnt Sienna mix and blend with the previous light blue band. Repeat this using pure Titanium White and blend the colours using a clean, soft, medium-to-small fan brush. Try to keep paint strokes horizontal.

Step 8: Sky and mountain margins. Paint in the final area between the sky and mountains using warm, tinted white tones as mixed in Step 7. Use a medium-to-small round brush (size 2 to 4) to fill in the area. Then, using horizontal strokes, blend with the Titanium White.

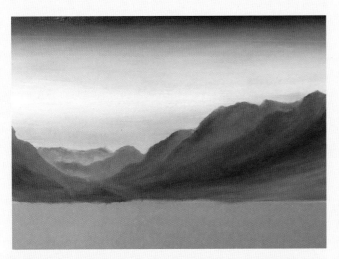

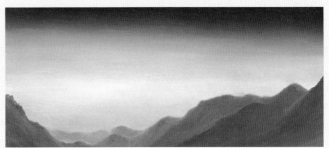

Step 9: Mountain shapes. Add a little Burnt Sienna to the light blue tones on your palette, which you created to paint the mid-tones of the sky. Add a very small amount of Burnt Sienna to add warmth. Use this tone to block in the basic shapes of the mountains. Use slightly darker shades for the foreground ridges. Darken shades which are already on your palette by adding a mix of Ultramarine Blue and Burnt Sienna.

Step 10: Softening or strengthening the margins. Use a small soft fan brush to blend the margins of the mountains and the sky. Apply the brush very gently to avoid over-blending. If this occurs and the definition is lost, use a round brush to gently define and darken the edges. As you develop the mountain highlights and colours, the soft edges defined at an early stage help to avoid unnatural transitions between the sky and mountains. Mountain profiles are something which can be strengthened further as you progress if using oils or acrylics . This is a point which I have emphasized throughout the book and which I feel is important to the mountain painter.

THE CLOUDY SKY

Some artists find painting clouds daunting to begin with. Much of the difficulty comes from two main misconceptions. Firstly, that clouds are two-dimensional flat objects, and secondly that the whole of a cloud's edge is clearly defined. Traditionally, landscape artists like John Constable produced sky studies as part of their regular practice. If you do the same, you will discover that clouds are enormously variable in just about every aspect.

The first and most important task in a cloud study is to work out the position of the sun. This is essential, as the sun dictates the pattern of light and shade in the whole composition. Try to think of clouds as three-dimensional objects, with shadowed areas. They often cast shadows on the mountains, on each other and even on themselves. They are multicoloured and hardly ever simply white, and the edges are anything from sharply defined to softly merging into the colour of the sky behind. The edges of clouds are likely to be the softest edges you will come across when painting natural forms.

Chromatic greys

When painting the clouds in the sky, avoid reaching for black or grey from a tube. Mix 'chromatic greys' instead. These are colours which are not formed by mixing black with white. Black is not used, but instead complementary colours are mixed and lightened with white to form grey. Traditionally, the complementary colours are red/green, yellow/purple and blue/orange. A perfect grey is made by mixing the primary colours red, blue and yellow in perfect balance and then adding white. Complementary colours are a combination of a primary colour, like red, and a secondary colour, like green. If the complementary colours are not perfectly balanced, they will produce a grey which leans towards the colour which is richest in the mix. These subtle warm or cool greys are particularly effective when painting the various deep, rich shadows on a mountainside, or indeed the darker areas of the sky. Carefully study the chromatic greys that make up the darker areas and shadows in the clouds.

Cloud study in oils. This study of storm clouds was painted using five colours which I use over and over again in various combinations: Titanium White, Ultramarine Blue, Burnt Sienna, Winsor Yellow and Alizarin Crimson. The strong shapes and contrasts of the cumulonimbus clouds combined with the warm shades create a sense of drama.

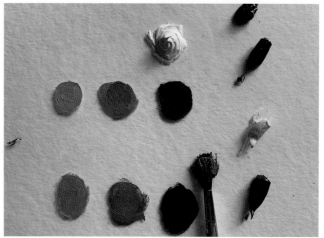

Chromatic greys. Try mixing chromatic greys to paint the shadows in the clouds. Use Ultramarine Blue with orange to create a warm tone. Burnt Sienna, which is an orange shade when mixed with blue and white, creates the same effect. Be careful when using yellow or green to mix grey shades, as using too much yellow or green can create unnatural green colours in the sky.

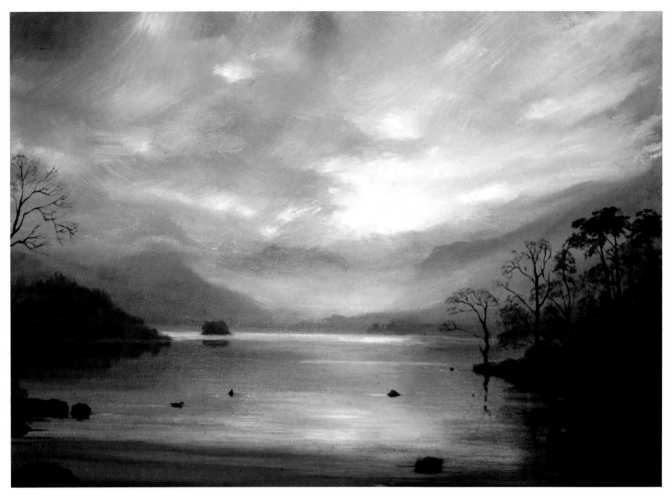

Derwentwater, oil painting. The clouds in this painting form strong vanishing lines that lead the eye to the patch of bright sunshine which is the main focal point. Here the sun is breaking through. The sky is a strong aspect of the picture, and the other features are largely in silhouette. Notice also that the composition adheres quite closely to 'the rule of thirds' – the sky representing roughly a third of the canvas and the rest two-thirds. The overall effect, including quite strong brushwork in the sky, is one of quickly moving clouds and fast-changing light.

Look also for the highlights on the outer edges of the clouds. These are rarely white, but instead they reflect the other colours in the sky. Sometimes stratus clouds (which are veil-like clouds over the whole sky and often look like fog in the mountains at low levels) produce a halo of light as the sun shines through. At other times, the sunlight breaks through the clouds as 'crepuscular rays' (*see* Chapter 4, page 66, for a mini demonstration on painting these).

As well as studying the subtle variations of light and colour in the clouds, it is helpful to be aware of linear perspective. Just as the mountains conform to the rules of linear perspective, so the clouds also become smaller as they approach the horizon. The tops of the clouds become more visible in the distance, whereas the bases of similarly sized clouds close by are larger and wider.

Painting the Clouds

This exercise is not limited to one particular cloud type. It is often the case that two or three different cloud types appear in the mountain sky at the same time. For instance, low cloud or mist may be sitting in the valley, while above the ridges cumulus clouds have formed (caused by rising moisture) and above these, perhaps, mid-level or high-level clouds – either broken or in a veil. The demonstration is based around a view of the mountains at the north-east end of Wastwater. You may decide to use either a photograph or sketch of your own for this exercise, but if you do, try to choose one with similar cloud cover. This is not a stormy sky, but there are clouds building over the mountains with light coming through the breaks. When completing this mini demonstration, try to apply the lessons learnt in the previous exercise regarding colour recession and blending.

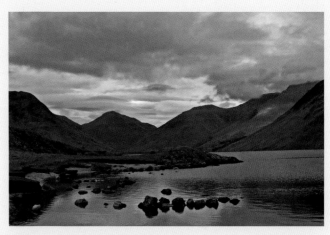

Clouds over Wasdale, photograph. Clouds are building in this scene, looking up Wastwater towards the peak of Great Gable in the centre. To the side, Scafell Pike is obscured.

YOU WILL NEED

Please see the list contained in the previous mini demonstration, 'Painting the cloudless sky'. However, you may also need Sap Green or yellow for Step 5.

I would recommend the use of quick-drying oils, or a quick-drying medium like Walnut Alkyd Oil Medium, to hasten the drying time between steps. Unlike the previous demo, there are a number of steps which produce better results if the paint is dry.

Support: Use either a medium board or canvas. I have used a Winsor and Newton medium-size canvas. It is pre-prepared with a white acrylic and does not need an extra layer. I have not primed this with a ground and am painting on white, in order to illustrate the use of chromatic greys more clearly.

Step 1: Mountain outlines. Very lightly sketch in the mountain outlines using a soft pencil or pastel. Be careful to avoid a heavy application of pencil which might colour the oil paint, especially Titanium White. I use a 2B pencil or a very light pastel when using a white base, and I press very lightly on the canvas.

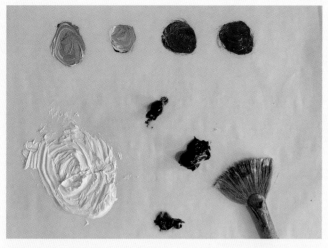

Step 2: Mixing the blues. Mix three or four tones of blue, using Ultramarine Blue, a small amount of Prussian Blue, Titanium White and a very small amount of Burnt Sienna. If in doubt go lighter, using more Titanium White. Use a very small amount of the Walnut Alkyd Medium to thin the paint and to decrease drying time and increase flow.

Step 3: Establishing sky texture and tone. Paint in the top area of the sky. Use a medium/large fan brush to create a variation in texture and tone, to evoke broken cloud. Blend the colours using a soft small fan brush. At this stage colour contrasts should be low and edges should be soft. There will be opportunity later to produce greater contrasts and definition.

Step 4: Painting the receding sky. Using a small fan brush, paint in the remaining area of sky, adding slightly warmer areas as the sky recedes. Do not forget that the breaks in the cloud will be more compressed and frequent in the distance. Also, colours become less intense and contrasts reduced. Soften any edges using a small/medium fan brush. At this point the aim is to create a fairly neutral base on which to build the cloud shapes in the following steps. With a small/medium round brush, paint lighter tones as the sky meets the mountain outlines.

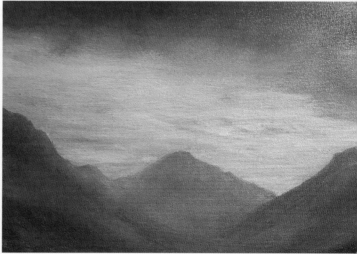

Step 5: Blocking in mountain tops. The darker and mid-tone mixes that you created earlier for the sky can now be used to block in the mountains (you could add a touch of yellow or green to enrich the colours of the nearby mountain slopes, ready for later development). Darken the tones with a mix of Ultramarine Blue and Burnt Sienna if necessary. Blend the edges very gently using a clean, soft, small fan brush, and redefine the mountain outlines with a small round brush if they become too indistinct. This is a good time to establish some soft edges at the margins of sky and mountain.

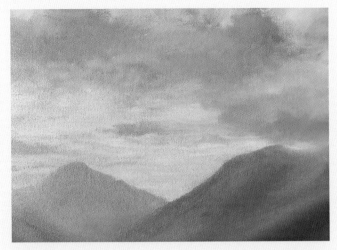

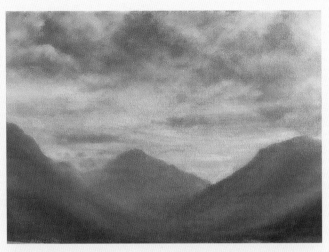

Step 6: Cloud shapes. Using a small-sized round brush, paint in some of the cloud shapes in the foreground, distance and mid-ground. Choose mid-tones and lighter shades from your colour mixes. The intention here is to create a variety of shades and to avoid uniformity. An army of similar clouds marching into the distance will look unnatural. Remember, the cloud colours will fade as they recede. Soften the edges with a clean, small/medium fan brush. Allow the paint to dry before you go on to the next stage.

Step 7: Light on the clouds. Keeping in mind the position of the sun in the sky, paint in the lighter areas of the clouds. Use a small to medium round brush, a mix of Titanium White, Ultramarine Blue and a tiny amount of Burnt Sienna. Do not try to paint each cloud exactly as you see it, and do not be afraid to vary brushstrokes to create texture. Try to give the impression of varied light on the areas which would be catching most light. In this case the sun was coming through the clouds high up on the right.

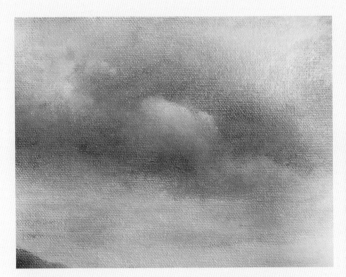

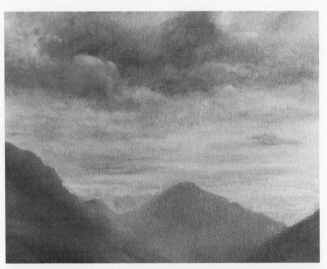

Step 8: Chromatic greys. Mix two or three chromatic greys using Ultramarine Blue, Alizarin Crimson, Winsor Yellow (or Burnt Sienna, which is an orange shade) and Titanium White. Using a small round brush, paint in a thin glaze over some areas of shadow, choosing mid-tones. Some of the greys you have already painted will be chromatic greys, because you mixed blue with Burnt Sienna. Do this very sparingly and blend the shadows with a small, soft fan brush. Try to find areas where the shadows will contrast with light. Look for areas where clouds cast shadows on themselves and other clouds.

Step 9: Blending the cloud. Use a small fan brush to blend some areas of the clouds with other areas of clouds and sky. You do not need to blend all of the edges, and if you over-blend them, redefine them using a small round brush. Some edges should be left sharper than others. There are rarely very sharp edges in clouds, however. Have a careful look to see if there are any remaining sharp, unnatural lines between the dark and light areas. Use a small, soft fan brush to blend any areas which need a softer transition. Be careful not to over-blend; you do not want to create a sky that is an almost uniform grey-blue.

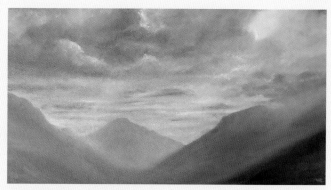

Step 11: Painting the highlights. Try to locate the points at which the cloud edges reflect most light from the sun. Use a small round brush and a mix of Titanium White, tinted slightly with Alizarin Crimson and Winsor Yellow. Pick out the highlights using small strokes, but do this sparingly. Thick paint can be effective on highlights, but not if it is spread too far. Look for areas which are the brightest in the sky. Using a small fan brush, gently stroke the lighter shades, or even pure Titanium White, downwards to suggest light spilling on to the clouds lower down in the sky. Finally, use a small round brush to pick out any highlights caused by the spreading light.

Step 10: Deepening the shadows. Now is the time to deepen shadow areas. You can do this by using one of the darker chromatic greys mixed in Step 8 as a thin glaze. This should be kept to a minimum. Avoid creating large dark blocks. Limit the deep shadow areas to a few in the sky. Remember, they will be unlikely to be as deep as the shadows in the mountains and in reflected water. Gently blend them if necessary. Allow the paint to dry before going on to Step 11.

Choosing the right brushes is an important factor when painting a mountain sky. I nearly always use fan brushes throughout the process, to either produce texture or smoothly blend different areas. The brushstrokes used will radically alter the general appearance and impact of the painting; for instance, it may be visually distracting if the mountain areas are all smooth and blended, whereas the sky is roughly textured, or vice versa.

SKY AND THE CREATION OF ATMOSPHERE

Understanding the visual appearance of different mountain skies and how to capture them using particular paints, hues and brushes is of course vital, and will improve enormously with practice. It is equally important, however, to consider the overall impact that the rendering of the sky will have on the whole painting. If your purpose is to create an atmosphere of peace and tranquillity in the mountains, the energetic use of rough brushwork and intense colours will be out of place. An over-lively sky will detract from the features, such as ancient woodlands and warm-coloured fellsides, which are likely to reinforce a sense of serenity. Similarly, a delicately blended sky in pastel shades will do little to evoke a sense of the drama present in a stormy mountain scene.

As you worked through this chapter, you may have noticed that I have omitted the study of two particular types of sky which have a special place in mountain painting. This is because they both deserve closer examination. The next chapter, Chapter 6: 'Storm in the Mountains', covers the formation and appearance of storm clouds. It also includes a step-by-step demonstration of a finished piece, which involves the use of strong brushwork and high contrast for dramatic effect. The other type of sky which is notable by its absence in this chapter is the sunset. The sight of a glowing, red sun casting its light through the sky and around the mountains is surely one of the most breath-taking sights the painter can hope for. Burnt Sienna is a colour that is particularly well-suited as a warm, rich base for many sunset scenes, and for this reason I decided to include a section on mountain sunsets in Chapter 10, 'The Burnt Sienna Palette'.

Much of this chapter has been given over to technical advice on sky painting, however in practice you will no doubt find that mountain skies are stunningly beautiful, and you can learn a great deal by simply watching them as often as you can on your travels. I find that sketching and photographing them is of course useful, but spending time committing them to visual memory as they change in front of my eyes is both pleasurable and a vital part of the learning process.

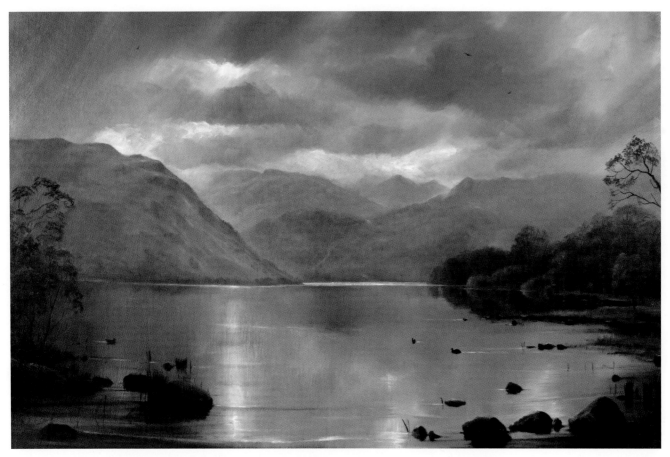

In a Quiet Water'd Land, Ullswater, oil on canvas. In this painting of Ullswater (one of the larger lakes on the eastern side of the Lake District), typically broken cloud moves slowly across the skies of the lakes. The sky does not cover a large area here, but the light from it plays an important role in the composition. Remember, if water is included in your composition, the effect of the sky is amplified. For the mountain painter, studying the appearance of water in all its many forms, such as lakes, streams, waterfalls and pools, is essential, but is too large a topic to be included in this chapter (*see* Chapter 8 for much more). The reflections in this painting of Ullswater are not perfect, but there is clearly very little wind and only slight disturbance on the water. On a fairly still day such as this one, the imperfectly reflected light and hues of the sky and mountains allow a pleasing harmony between background, mid-ground and foreground. On some days, when there is no breeze at all to disturb the surface, water, mountains and sky seem to become one.

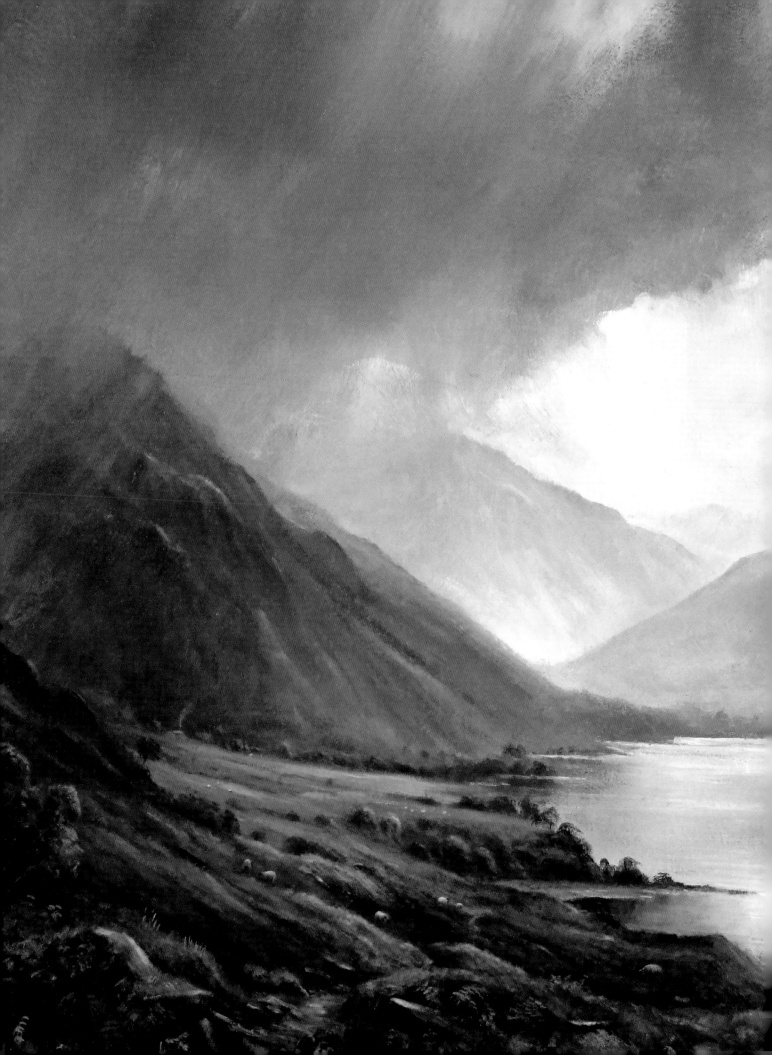

Storm in the Mountains

Flying, and rainy vapours call out shapes
And phantoms from the crags and solid earth.

WILLIAM WORDSWORTH, FROM 'THE EXCURSION'

On visiting the main art galleries in London and other UK cities (and probably elsewhere in the world), it is not unusual to see a visitor transfixed by a great work of art, perhaps a John Martin or William Turner, featuring a storm in the mountains. Philosophers and art historians have developed many theories about what came to be referred to as 'the sublime', in an attempt to explain why these dramatic and dangerous scenes are for many of us both frightening and awe-inspiring, but also absorbing and enchanting. They tried to understand how beauty and 'the sublime' related to one another and often they drew a line between the two.

In the eighteenth and nineteenth centuries, as the Grand Tour of Europe (involving a trip to the Alps) became popular, some artists developed and explored the sublime in their mountain paintings. Of course, tempests, with their strong light contrasts and sense of danger, perfectly fitted the bill. I think it is fair to say that our twenty-first-century ideas about art do not usually insist upon a strong division between the beautiful and the sublime. For most of us, as we stand in front of one of these masterpieces or try to capture for ourselves the stunning spectacle of a storm over the mountains, there is little discomfort in the idea that their power and their beauty are one.

Personally, I am always delighted at the prospect of painting a piece based on a storm. As mountain painters, tackling a storm scene gives us the opportunity to experiment with more expressive brush strokes and strong contrasts between light and shade. The portrayal of the sudden and unpredictable changes in the sky, and its effects on the mountains, allows for a greater freedom of interpretation. Laborious, particular and smooth brushwork is unlikely to convey the energy and power of thunder, lightning and tumultuous clouds over a craggy summit. Keep this in mind when you try the step-by-step demonstration later in this chapter, and do not be afraid to be adventurous in your approach.

THE STORMY SKY

Mountains and the formation of storm clouds

The winds in a thunderstorm do not come from one particular direction, so the clouds can appear very turbulent and changeable. Incoming cold air forces the warm, moist air in strong updrafts up the mountainsides and creates a very unstable and energetic sky, which can pave the way (invitingly for many of us) for some lively and sweeping brushstrokes. Thunderstorms are much less prevalent in the winter, when storms are usually caused by the meeting of two different air masses, producing a variety of wind, large amounts of rain and snow. Portraying a winter storm is likely to be more difficult, not only because of the weather conditions, but also because often much of the mountain scenery is completely obscured.

◀ *Crack of Thunder, Wastwater*, detail, oil on board.

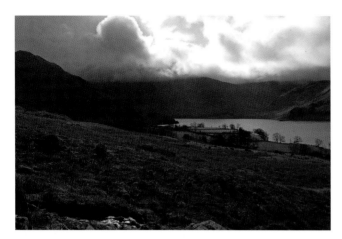

Storm forming over the Western Fells, Lake District. The highly recognizable shape of a cumulus cloud is highlighted here as the remaining sunlight catches on its edges. Behind this, the dense dark cloud base contrasts with the bright tops.

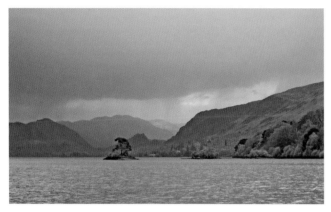

Heavy cloud base, Borrowdale. Here, a heavy cloud base has formed over the mountain tops and light is seen in the distance underneath it. Showers which fall from the base of the thunderclouds often appear in blurred columns. Including these dark shafts in a painting can help to link the sky to the mountain range, without losing the strong outlines of the peaks.

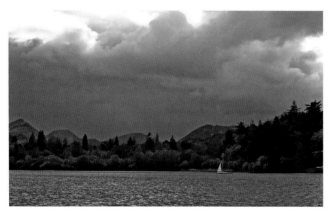

Cumulus gathering. The cumulus clouds have formed right down to the mountain tops here, and the only sunlight shines over the top of them. This scene would be a challenge to paint as there is no light on the ridges and summits, and little colour differentiation. It would probably be worth waiting until shafts of light come through the clouds and create more interest.

Because storm skies are so volatile, taking photographs of storms in the mountains from a safe vantage point at every opportunity is a good strategy. A very basic understanding of the formation of storm clouds in the mountains is helpful too, giving clues as to when the most impressive cloudscapes will appear, and how to recognize and depict their characteristic shapes and distinctive patterns of light and shade. It is useful to briefly study the development and appearance of the cumulonimbus clouds that often accompany a mountain storm, especially in the summer.

Cumulonimbus clouds

In the warmer months, the dark rocks and woods – such as coniferous woods – on the mountain slopes heat up during the day and water condenses as it rises into the cooler air. It is then channelled upwards along ravines towards the mountain tops, often obscuring some of the summits. Most of these storms occur in the afternoon or evening, as it can take much of the day to build up. Early in the day the small 'puffball' cumulus clouds can either melt away quickly or build upwards into the familiar columns of cumulonimbus clouds – which have shapes that look similar to cauliflowers, with a dark, flat base.

As they gather and grow, 'turrets' are formed at the top, and tuft-like shapes appear on the sides. When they grow to full height and reach the upper winds of the

STAY SAFE!

Please stay safe. The following list covers points to remember – just in case, in your enthusiasm to paint a wonderful mountain storm, you forget just how dangerous storms can be. Climbing manuals remind mountaineers of the following:

- Get to know the weather patterns in the area you are visiting. Storms can build up and be right on top of you very quickly in the mountains.
- Lightning is a particular danger in the high mountains. Avoid isolated objects, such as lone trees, which are vulnerable to lightning strikes. Wet ropes and metal objects (such as a metal easel!) are also good conductors.
- Although the view from a summit or ridge may afford great opportunities for the artist, they are also the most dangerous places to be in a thunderstorm. Avoid being the highest object in your immediate vicinity.

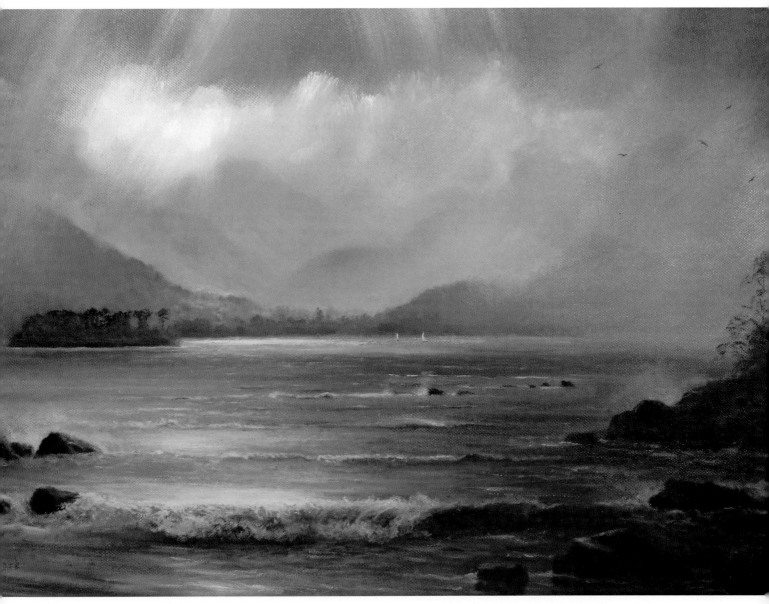

Riding the Storm, Derwentwater. This medium-size painting is an oil on canvas of a view across Derwentwater. The strong downwards brushstrokes in the foreground of the sky suggest the dark blue base of a storm cloud; the light breaking through is reflected on the edges of cumulus clouds which hang over the mountains in the background, and also in some of the valleys where mist and cloud have gathered. The low cloud obscures some of the ridges, so that the sky and the mountains are not clearly delineated.

atmosphere, they form an anvil shape and spread out at the top. Cumulus clouds, which are lower, have sharp defined edges – but as they rise, develop and form ice clouds, they appear more diffuse and with spikier edges. The cumulonimbus tops block the light from the base, which appears dark. As more and more clouds form, the bases join together – either above or right down to the mountain tops, and can appear very dark indeed.

Light effects on the mountain scenery

Choosing a storm scene in which light either spills through, over or under the storm clouds is likely to be more successful than a fully darkened sky. Look carefully to see where the mountain edges are more defined and where they are obscured. Often, when the cloud base is above the ridges, they will appear darker with light behind. When the cloud is down to ridge level, the summits will often be shrouded with cloud, and light may flow over the top of the cloudbank.

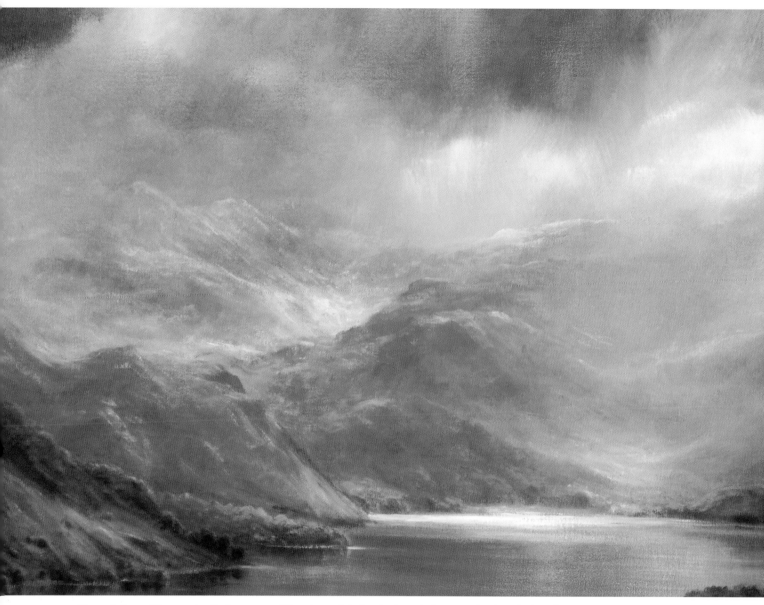

Mountain Storm, Ullswater, detail, oil on canvas. When the sunlight breaks through the storm clouds in the late afternoon or evening, it often produces orange tones which reflect onto the mountain sides – particularly if they have some snow cover. Here the cloud mass is heavy, but with some breaks. The main colours used were Burnt Sienna, Ultramarine Blue, Ivory Black, Titanium White, and Sap Green for the lower ground. The highlights are picked up using this slightly orange tone, and the blue/purple shadows of the ravines and crags fade as they recede into the distance. Notice also that the green promontory in the mid-ground catches the light and seems vivid. Often, when the sky is dark and heavy, the greens of the grass and trees seem luminescent if they catch the limited sunlight.

The time of day also plays an important role in determining the effect of storm light on the mountains. A high sun behind the clouds will most likely produce high contrasts and dark blue/purple clouds, whereas the lighting in a storm occuring later in the day, as many do, will be different. As in the case of a sunset, the orange colours will be more visible while the blue light (shorter wavelength) is scattered and less apparent. It is important to remember, too, that what is happening in the sky will be reflected by damp or light surfaces on the mountainside, and particularly so by snow and water.

Choice of colour palette

Choosing the right colour palette does of course depend upon the mountain scenery you have chosen as subject matter. If this is your first attempt at painting a storm in the mountains, you will find controlling the light, shapes and brushwork much easier if you limit your palette to

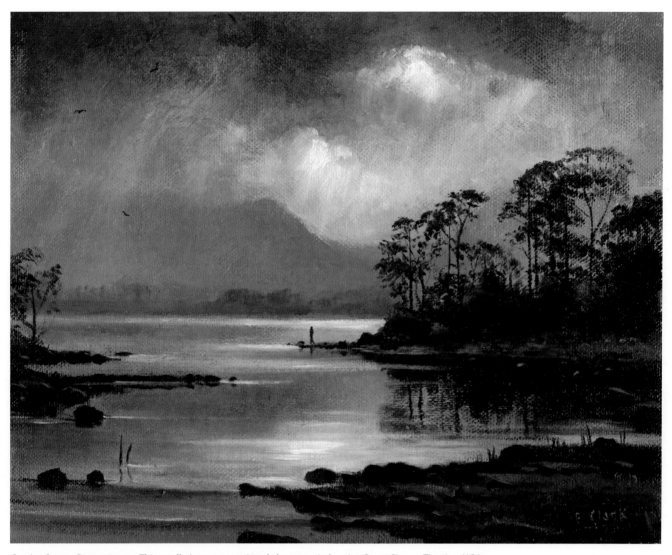

Coming Storm , Derwentwater. This small picture was painted almost entirely using Burnt Sienna, Titanium White, Ultramarine Blue and a little Sap Green. A very tiny amount of Cadmium Yellow and Alizarin Crimson were added to the highlights. As is often the case with a storm painting, it relies on strong brushwork and high tonal contrasts. The mountains, veiled in storm clouds, reflect the colours of the sky, as does the water.

a few colours. For instance, using colours based around Burnt Sienna, red, yellow, white and a limited amount of Ultramarine Blue and black (to darken shadow areas) will suggest a low sun shining through the storm clouds. Trying to use a large range (unless you are experienced) can result in muddied colours and a lack of cohesion.

The colour that I buy most of is Titanium White. It is essential to all my paintings, including storm paintings. As well as mixing it with main colours to lighten them,

it is effective when used as a very thin layer. Using a soft medium fan brush, Titanium White can be very lightly dragged over the darker tones of the ridges, in order to produce the impression of low cloud or mist spreading downwards. Allow the darker tones to dry before you paint over with the white, and start using it very sparingly to begin with. You can add more later to intensify the effect. Be careful not to use too much, as the lightening effect may be difficult to remove once applied.

Crack of Thunder, Wastwater, detail. A close look at this detail reveals how a light, varied layer of Titanium White allows the blue of the mountain ridge to show through. Putting the paint on neat (using very little thinning medium) will create a rougher, more varied texture – as with this example.

Gathering Stormclouds, Crummock, detail. A closer look at the detail demonstrates how the brushstrokes often oppose one another and are varied in their tone, but at the same time occasionally blended to avoid over-sharp edges.

Gathering Stormclouds, Crummock, detail: using brushstrokes to create energy. The dark blue areas of the sky and mountain ridges in this painting (which features a view across Crummock Water similar to the one in Chapter 2, *The Old Jetty, Crummock*, but from further away) were painted in first on a ground. Then a blend of Titanium White and Ultramarine Blue was applied, using a small fan brush swept across the sky area, creating movement in various directions.

Creation of energy

Finding a way of evoking the energy of a storm in the mountains is important to the painter, and it involves three main aspects when using oils or acrylics:

Layering: Prime the support with a colour that works for your chosen subject as you would normally. This creates cohesion. Following this, a fairly thin first layer of colour can be laid in with some varied brushstrokes. This creates a mildly textured surface throughout. Further layers can be added to increase colour and tonal variation.

Strong brushwork: Using strong brushwork, including 'impasto' (thick paint laid on the surface so that brushstrokes or palette knife marks are visible, and paint can be seen lifting up from the support), creates a sense of

movement. Remember though, the rule of painting 'thick over thin' is important. If you use very thick oil paint, because thick layers will dry much more slowly, this can cause cracking as the 'curing' process progresses. This applies especially to slow-drying standard oil paints. Some artists always adhere to 'the rule of thick and thin'. However, whatever the thickness you choose, it is important to pay attention to drying times (*see* Chapter 1 for more about drying times and mediums).

High tonal contrast: High tonal contrast suggests sunlight coming through the dark clouds, and emphasizes the sense of drama as the light rapidly changes on the mountain landscape during a storm.

When completing the step-by-step demonstration in this chapter, try to keep these key areas in mind.

It may be difficult to complete a storm painting en plein air if you intend to use layers, unless you use a fast-drying medium. Even acrylics, if used very thickly, will take time to dry, and you may well run out of time as storms are frequently accompanied by rain showers. Watercolour painting often offers a quicker solution for either sketching

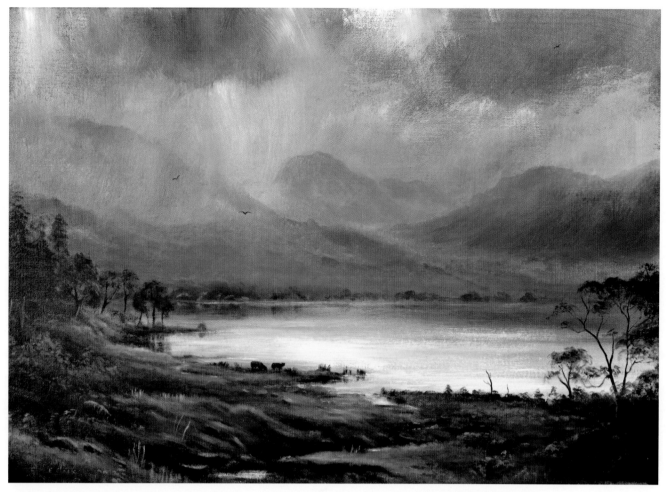

Rain Showers on the Lake, Crummock, oil on canvas. This oil on canvas was begun on a blustery day looking over Crummock Water towards Gale Fell, Red Pike and High Stile, and then finished in the studio. The sky was energetic and darkening over the mountains as a storm was building. The winds were blowing in a number of directions on the tops. Capturing this relies on the curved visible brushstrokes in the sky and over the mountains, and the strong tonal contrasts. These were built up over a red/brown ground, using a number of thin layers of paint including a tinted Titanium White. Areas of light breaking through the clouds are essential here, to accentuate the shadows.

or a finished piece of work, but will be more limited if you want to concentrate on paint texture and thickness to create energy. A compromise is to arrive with a pre-prepared support that has been primed with an appropriate colour. Broad areas of light and shade can be quickly sketched in, along with accurate outlines of mountain and cloud shapes. Taking photographs of the scene provides enough information so that detail and further layers can be added in the studio.

Painting freely

One of the most difficult challenges for any painter is to paint 'freely'. If you hear an artist speak of a painting as being 'free' it is usually a great compliment to the originator. We all tend to fear departing from the safe, slow strokes and careful work that might have brought us success in the past. My advice when painting a storm in the mountains would be to try to use larger brushes than you would normally use, and concentrate as much as possible on the larger strokes that you make to convey the changing light and unstable sky. As you progress through the step-by-step demonstration which follows, give yourself permission to experiment as you sweep the brush across and round the canvas. This is a small painting, so a small brush was needed for details (I used a size 2), but the sweeping textures were created with a size 6 round brush and medium fan brushes. If you decide to paint a bigger picture, try choosing larger brushes.

Storm over Borrowdale

- Medium- and small-size fan brushes (fine) for acrylic or oil paints
- Size 2 and size 6 round brushes for acrylic or oil
- Acrylic or oils (I am using Duo Aqua Oil, by Holbein):
 - Sap Green
 - Ultramarine Blue (Light and Dark)
 - Ivory Black (black can have a deadening effect; use it very sparingly, mix complementary colours if possible to create deep shades)
 - Burnt Sienna
 - Titanium White
 - Lemon Yellow
 - Naphthol Red
- A support (I am using Ampersand Gessobord, 12 × 16in, which has an acrylic gesso finish)
- Palette for mixing
- Medium for thinning (water for acrylics or quick-drying linseed or alkyd walnut oil for oils)
- Brush and equipment cleaner: water for acrylics; either white spirit for oils or specialized brush cleaner if you dislike or can't tolerate the smell and fumes; or you may want to use oil and soap to clean brushes by an alternative method, as outlined in Chapter 1
- Lint-free cloth or kitchen roll (paper towels)
- Retouching varnish (Winsor and Newton produce a professional retouching varnish, which I use)

I have chosen a smooth board for this exercise, and will use paint layers to create texture. Most of this exercise is completed using these brushes.

- A pre-primed board or canvas would be appropriate here. Have at least two or three fan brushes as well as round brushes at the ready, as you may not want to wash off colours between uses, especially if you are using a white glaze. Notice the small, well-used one in the centre of the three fan brushes in the photograph. Sometimes you will find that familiar, older brushes will allow effective, rough textures – do not automatically throw them out

This demonstration is based on a view of the southern extreme of Derwentwater in the Lake District, which is aptly named 'The Jaws of Borrowdale'. The steep slopes of the Borrowdale Valley, with the dark wooded Castle Crag standing in the base, create an inviting choice for a storm painting. As warm air flows upwards onto the surrounding summits of Grange Fell and Glaramara and on to the higher mountains behind, great dark storm clouds can form over the woods and crags. Pictured here are a number of photographs that I have taken of the area, and a sketch in preparation for the painting.

Ferry passing under Castle Crag. Even on a fine day, low cloud and mist can obscure the ridges and summits. Here the ferry from Keswick, which travels around the lake several times a day, passes under Castle Crag.

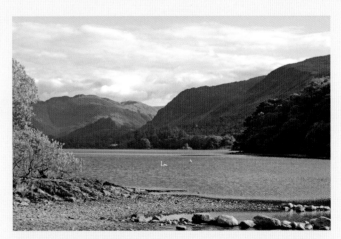

The Jaws of Borrowdale on a sunny day is one of the most famous views in the Lake District and takes on quite different moods, from peaceful to dark and threatening. I often take photographs on fine days for cloudy day paintings. It always helps to know what is under the clouds...

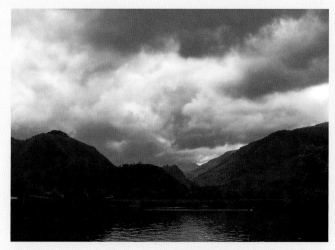

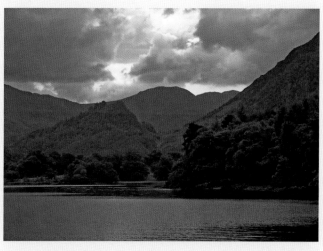

Building storm, Borrowdale. The heavy clouds were gathering over the tops on this day, but this view, although extensive, did not allow a complete view of Castle Crag – a feature which I wanted to include in my stormscape.

I chose this view of Castle Crag and the surrounding fells. The crag, which is wooded, has a strong dark shape and provides an effective central point in the composition.

Borrowdale Storm, sketch. This is a quick sketch made before the rain came in, using tinted charcoal pencils, 2B pencil and chalk (the tinted charcoal pencils are made by Derwent; I enjoy using these as they blend easily and have some colour).

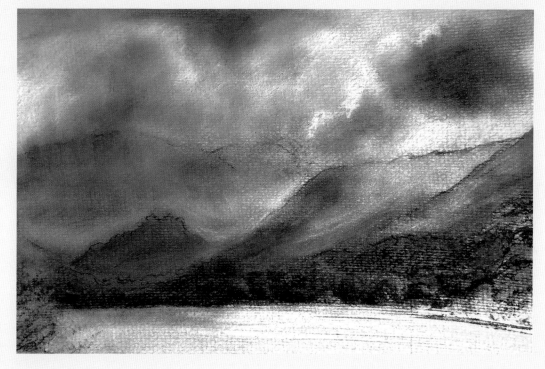

Thunderstorm, the Jaws of Borrowdale, the choice for this step-by-step demonstration, was drawn up and completed in the studio – unlike *Rain Showers on the Lake* featured earlier, which involved working outside in the initial stages. Try to gather together a library of images of the scene as I have done (I have not included them all here, of course) to provide the information you need when back indoors.

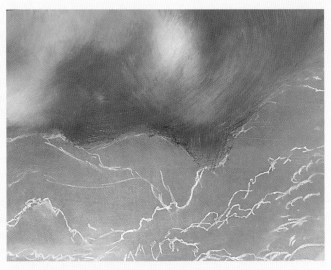

Step 1: Drawing in composition lines. Transfer your basic composition lines onto the pre-primed canvas or board. I have primed this board with a thin layer of an orange shade made by mixing Burnt Sienna, Titanium White, a very small amount of Ultramarine Blue and a little red and yellow. I have used chalk to outline my design (normally this would be thinner and lighter, but I have thickened the lines to make them clearer for this demonstration). Whatever you use to draw out your composition (pencil, oil pastel or charcoal), be careful that it does not tint or damage the main medium.

Step 2: Blocking in cloud shapes. Paint in a simple layer of sky colours. I have used Titanium White with a mixture of Ultramarine Blue and Burnt Sienna (add a little Ivory Black to darken if you prefer). Mixed and free brushstrokes, with a medium fan brush, will create texture. Try to suggest the shapes of storm clouds, but remember that this is an initial layer. You are not yet ready to paint exact shapes and details. This should be a thin layer, and the colour of the ground will be visible in places.

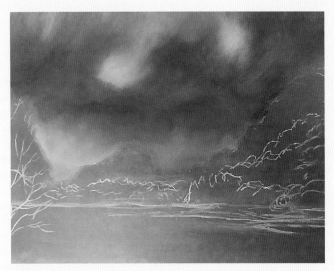

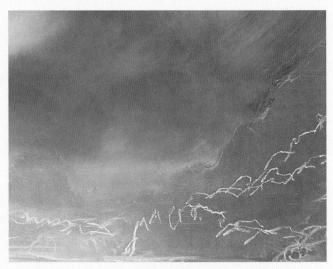

Step 3: Working downwards, distant fells. Paint the basic outlines of the distant fells while the sky colours are still wet. It is unlikely, in a storm painting, that you will want the outlines of distant fells to be sharp. Painting them with a softened outline will leave your options open for later in the composition. Notice that, as is so often the case, there is little difference between the colour of the sky and the distant fells, which are only slightly darker than the sky.

Detail, Step 3. Create a transition to a lighter colour at the base of the distant fells using added Titanium White. Use a soft, clean fan brush to blend colours. Sharp, defined edges are not appropriate at this point.

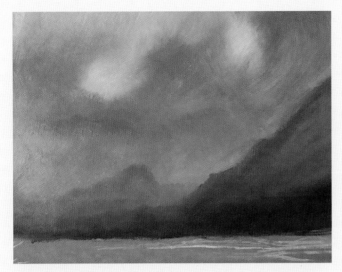

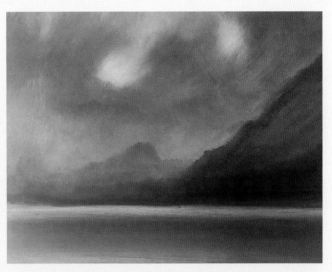

Step 4: Mid-ground colours. Using a size 6 round brush and small fan to smooth, block in the mid-ground areas including the near fell, crags and woods. The mid-ground colours are mixed by progressively adding in a little Sap Green to the dark colours used in the sky and mountains. Yet again, it is worth remembering that colours usually become more saturated as you come towards the foreground. Paint the mid-ground woods as suggested shapes only at this point, and add a little extra green to the area which borders the lake – that being the nearest.

Step 5: Painting in the foreground lake. Paint in the small foreground area of the lake using a small fan brush with horizontal strokes. As the lake is reflecting the colours of the fellside and sky, use the same colour mix. Paint a strip of lighter water (caused by rougher water reflecting the light in the sky), using Titanium White to lighten your mix.

Step 6: Sky highlights. Mix a little Titanium White with a very small amount of Burnt Sienna to pick out the edges of the cumulus clouds, which are catching the light breaking through them. Avoid painting a simple outline, as the intensity of light will vary depending on the angle of light and distance from the viewer. Suggest the shapes, rather than trying to paint a whole cumulonimbus. Add a little more Burnt Sienna to the Titanium White (only a little as you must avoid a strong orange colour here), and use this as a thin layer to give colour to the brightest area of the sky.

Step 7: Adding tonal details. Using a slightly lighter tone than previously used on the higher mountains (behind Castle Crag), and a size 2 brush, paint in the areas of the crags that are catching the light. Do the same with the shaded areas, using a slightly darker tone. Contrasts should be muted, as you will want to add highlights later. At this point, you should be trying to give shape to the crags and ravines while avoiding high tonal contrast. With the size 2 round brush, add definition to the mid-ground shoulder and Castle Crag in the centre of the composition. Use a mix that is darker and more saturated than the mountains behind.

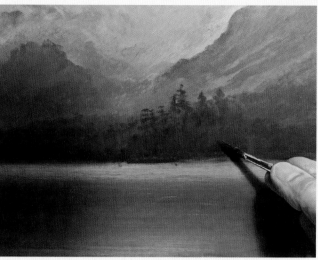

Flattening your brush. Prepare to paint in the mid-ground woods by flattening out the round 6 brush into a wedge shape. Do this by stroking it in the paint on one side and then the other, or simply pinch it between your fingers if you don't mind the mess! You can use this to paint in varied shapes of the woods with the sharp edge of the wedge. Alternatively, use a smaller brush if you find this too hard to control. Mix a shade or two darker than the mid-ground shoulder, crags and woods.

Step 8: Mid-ground woods. Use your flattened size 6 brush to pick out shapes of the woods that are the nearest in the mid-ground. Make small, varied vertical strokes to fill in the area. As the woods come nearer, you will need to add a little more Sap Green to darken them. Notice that the woods behind are catching a little light, but are less saturated and have a blue tone.

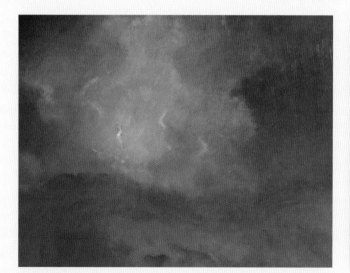

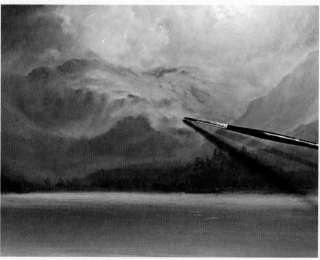

Step 9: Defining the sky. Now that you have built up a key layer of the colours, tones and shapes, you can go on to develop these using thicker paint, more texture, stronger contrasts and more saturated colour. Returning to the sky, use a mix of Titanium White and a small amount of Burnt Sienna to enrich the brighter areas. Use a smaller brush (approx. size 2) for these highlights. Adding a little Naphthol Red and Lemon Yellow will add a richer orange tone to the sky (be particularly careful to add in very small amounts to gauge the effects). Also, strengthen the shapes and colours of the darker clouds.

Step 10: More light on the mountains. Use a size 2 or larger brush to build up the intensity of the light on the mountainside. Pure Titanium White will create too much contrast. Tone your white down with the other colours used to paint the mountainside, and a tiny amount of Burnt Sienna to reflect the sky colours. Try not to create simple blocks of light colour. Light on the fellside does not reflect evenly, and the sharp edges of the crags (especially if wet) will reflect more light.

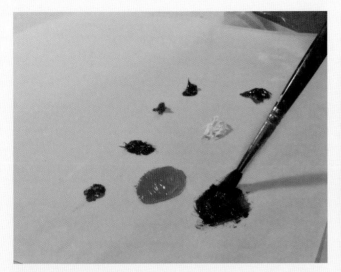

Paint mix for the woods. The woods are painted predominantly with a mix of Ultramarine Blue and Sap Green, with a little Burnt Sienna, and Titanium White added according to the desired colour and tone. As you progress towards the foreground, add a little more green to the mix. Use a mixture of Ultramarine Blue with Burnt Sienna and Sap Green for the shadows (use a tiny amount of Ivory Black to darken the colours if you wish, but use it very sparingly). Lighter areas can be mixed from the main woodland colours, but with more white and Burnt Sienna added.

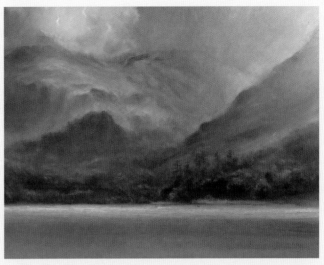

Step 11: Deepening the mid-ground woods. Having built up the tone and colour on the sky and mountains, you are ready to give the mid-ground woods definition. As in Step 8, use vertical strokes with a size 6 brush to deepen the shadows and add highlights. Use a smaller brush if you feel unsure when tackling more intricate details on the trees. At this point, do not try to accurately paint any individual trees. You should, as is often the case, be 'suggesting' the woods and the patterns of light and shade.

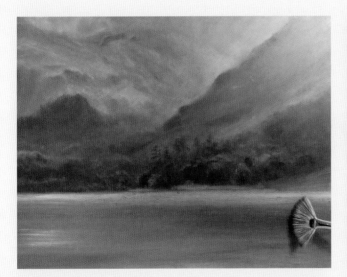

Step 12: Developing the water. Use some of the paint mixes that you have used to paint the mountains and woods to colour the water. Use a fan brush in parallel horizontal strokes across the canvas to create areas of colour that reflect the landscape and sky above. This is not still water, so do not attempt to paint a perfect reflection – and avoid simple blocks of one colour only. Again, you are suggesting the colours reflected in the water. The focus of the composition is on the storm, not the water. Enhance the areas that were left light with a mixture of Titanium White and a very small amount of Burnt Sienna.

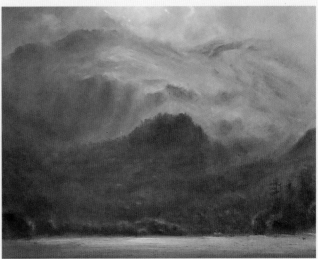

Step 13: Mid-ground checks. At this point have a close look at your mid-ground contrasts – especially the light on the mid-ground woods. Add more highlights if they appear to be flat, but make sure they are not too bright. They should not draw the eye away from the lightning in the sky, which should draw most attention.

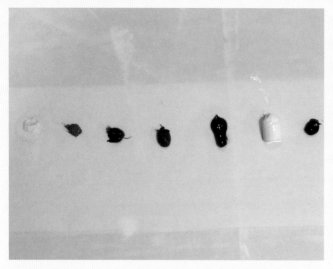

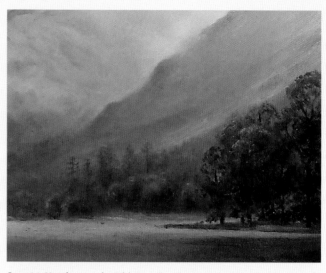

Colour refresh. You are now ready to move on to paint the nearby trees and foreground, which in a storm will probably be mainly dark and contrast strongly with the background. It is a good idea to refresh your palette to avoid losing control of colour mixes. I usually do this when I know that my colour mix will be stronger, or there will be a change in colour balance.

Step 14: Nearby woods. Add more Sap Green to the colours you used in Step 8 to produce a richer colour for these nearby woods. They should also be darker. Foreground woods will normally be richer in colour, and you will need less Ultramarine Blue for the foliage. Use a smaller brush (size 2+) to paint individual trees at this point, but remember that they will usually merge into one another, unless they stand alone.

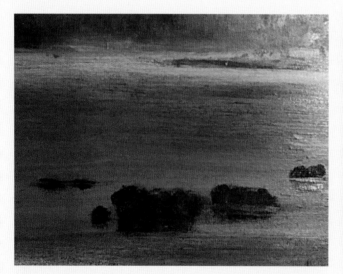

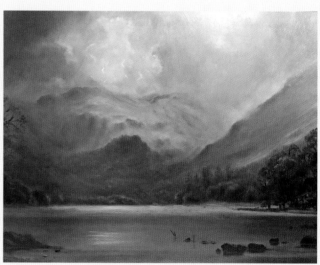

Step 15: Foreground detail. Paint in some basic rock shapes to create foreground interest, using a mix of a little Burnt Sienna, black and white, and using a small brush (review Chapter 4, 'Mini Demonstration: Light on Rocks and Boulders' for more detailed tips on painting light on rocks). Use a similar colour, to suggest a reflection in the water underneath the rock.

Step 16: More foreground details. Paint in some more details, including the small beach in the foreground to balance the composition, but keep them simple and be careful not to overcrowd the area. The focus should remain on the storm clouds and lightning.

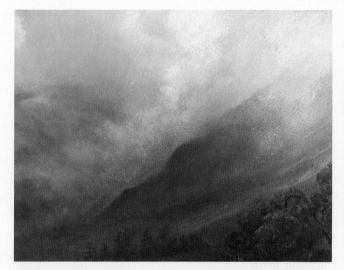

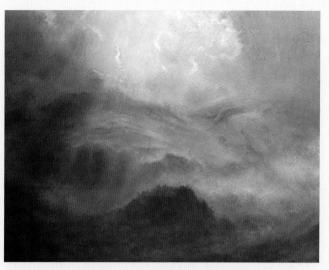

Step 17: Using Titanium White. Use a size 6 brush and Titanium White to suggest thin low cloud in the mid-ground, which is catching light in the sky as it lies on the slopes of the mountain. The colours underneath the white should show through. Do not attempt to apply thick paint. Use the paint very sparingly to create this impression, with circular and sweeping motions. It is at this point when any texture that you have built up in previous layers pays off, as it helps to create energy in the sky and it should be visible as it grips the paint. Use a lint-free cloth or kitchen roll to wipe off paint if you have used it too thickly (technically, using Titanium White as a thin layer is not actually a 'glazing' process as Titanium White is not transparent or semi-transparent, but it creates a very similar effect).

Step 18: Sunrays. Using Titanium White with a very small amount (a really tiny touch) of Burnt Sienna suggests light rays emanating from the flash of light in the sky. Use a small fan brush to pull the paint very lightly and gently from the clouds onto the mountains and woods below (review Chapter 4, 'Mini Demonstration: Crepuscular Rays in the Mountains' for tips on painting light coming through clouds onto the mountains).

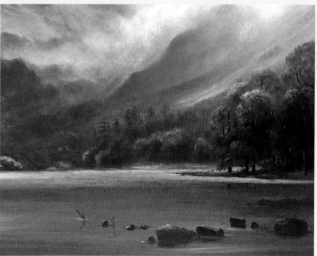

Step 19: Final adjustments, colour. This is the most dangerous moment in the painting process! The temptation to 'overwork' is very strong. This is the time to stand back and look carefully. If you are satisfied with your use of colour at this point, then leave it alone. If you feel that some of the colours need intensification, try a little glaze on a small area to gauge the effect. I used a little Ultramarine Blue glaze on the shadow area of the mountains and woods and the sky to emphasize the storm colours.

Step 20: Final adjustments, tone. Again, if you are satisfied with the values of the tones in your painting then leave it alone. However, you can, if you feel that you have not produced a strong enough tonal range, intensify your deepest shadows and lightest lights at this point. I have lifted the lights just a little on the rocks, trees and mid-ground woods, and darkened the shadows on the water and in the trees and sky. Be very careful, though, at this stage. It is a good moment to add these shades as you have the whole picture, but nerve-wracking because it is easy to overdo it and the painting is so close to completion.

Thunderstorm, the Jaws of Borrowdale portrays an early afternoon storm in the summer and the predominant colours are blue and green. Burnt Sienna is used sparingly. Have a look at the painting pictured in full at the end of this chapter, *Crack of Thunder, Wastwater*. This is an autumn storm that occurred later in the afternoon and the colours are warmer; the storm light emphasizes the glow of the vegetation. Sap Green is used along with Burnt Sienna. The use of Ultramarine Blue is limited. The highlights are intensified using small amounts of Alizarin Crimson, Lemon Yellow and Burnt Sienna added to Titanium White. These appear even brighter than the warm highlights created using Titanium White with only a touch of Burnt Sienna.

The next chapter explores the mountains in a very different mood, one in which they seem to offer peace and refuge. However, before you move on to Chapter 7, in which the quietness of the hills is such an important feature, enjoy the opportunities that painting a storm offers. Experiment with different colour palettes and light effects. Conveying the energy and beauty of an unstable, rapidly changing sky over the ancient and enduring mountains is often a real challenge for the artist, but I think you will find that it is one of the most rewarding.

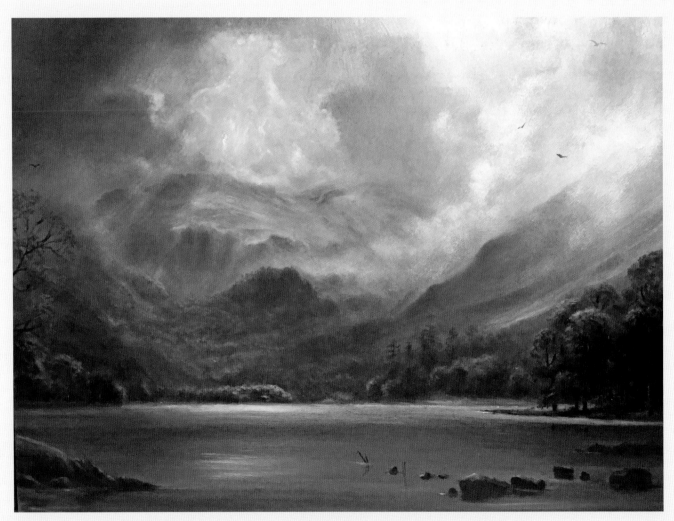

Thunderstorm, the Jaws of Borrowdale, drying and varnishing. When the finished painting is touch-dry you may decide to use retouching varnish. This is not a final varnish (which is appropriate after approximately six months), but one which can be used for recently finished paintings and is especially useful as a temporary protection. It is also helpful if you want to create a glossy finish in areas of the painting where the paint has sunk and gone dull. Retouching varnish will also often enrich the contrasts and colours.

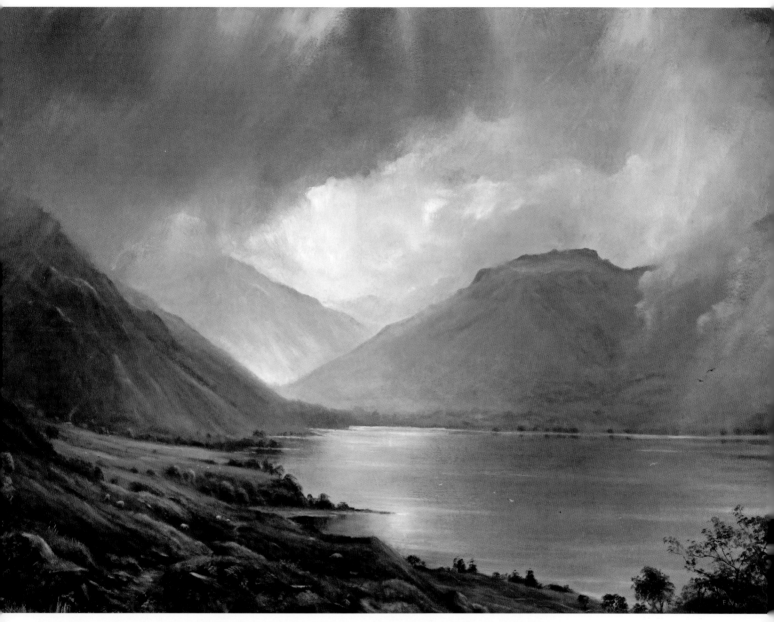

Crack of Thunder, Wastwater, oil on board. The valley of Wasdale sits on the western side of the Lake District, and the lake of Wastwater lies in its base. There are two roads which lead into the area, but none leading out at the north-eastern end. Driving, walking or cycling into the valley, the view of the Wastwater screes lies in front of you – falling 2,000ft into the lake, which is itself the deepest lake in England. It is an awesome sight, and as you look towards the head of the lake you see the great profiles of Great Gable, Lingmell, Yewbarrow and Scafell Pike (standing at 3,210ft and England's highest mountain). If you were searching for the 'sublime' in the Lake District, this valley would certainly be the place to find it. Storms over Wastwater can be extremely dramatic, and provide irresistible subject matter for the mountain painter. This painting was inspired by a day when great clouds were building over the high mountains and occasional sunlight was breaking through, lighting up the lake and fellside as the storm moved in from the west.

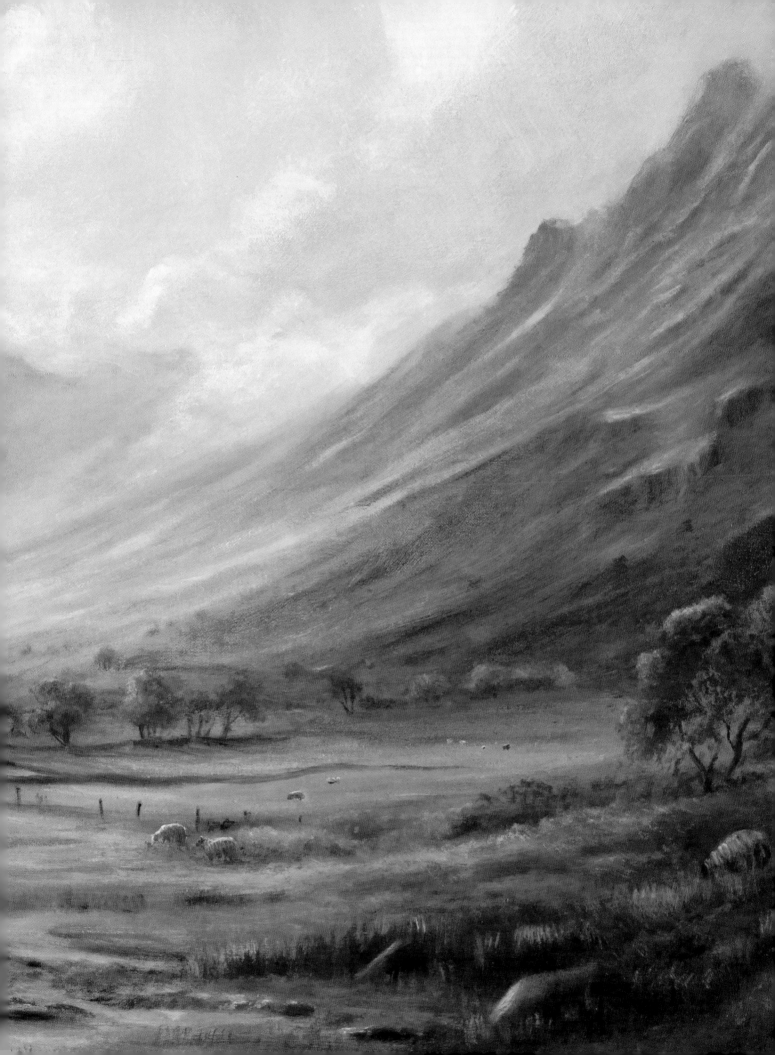

Peace and Refuge in the Mountains

The butterfly counts not months,
but moments and has time enough.

RABINDRANATH TAGORE

Artists who are frequent visitors to the mountains, along with residents, climbers and walkers, will probably experience a moment when it seems – quite inexplicably – that a great sense of peace, quiet and well-being settles over the entire mountain scene. It is usually ephemeral, but I think it is true to say most people find such a brief experience quite profound. Historically, painters as diverse as Claude Monet and Alfred de Breanski Senior seem able to evoke something akin to these transitory feelings through the subtle use of colour, lighting and composition.

In Chapter 6, we examined the role of the sublime in a stormy mountain painting. Creating a sense of peace in the mountains – rather than excitement – requires a different approach. This is especially relevant in the use of contrast, hue and tone. I cannot claim to know all the secret ingredients that will produce this emotion in the viewer, but hopefully this chapter will highlight some of the most important.

USE OF COLOUR: THE GREEN AND BLUE PALETTES

Handling the colour green is an essential skill for the mountain painter. It is easy to fall into one of the two major traps: either the greens seem garish and the hues clash with one another; or they appear too similar, in which case the areas of grass or heathland appear blocky and flat.

Be careful if you intend to paint using strong premixed greens that are from different parts of the spectrum. For instance, you might choose a green/blue shade, like Cobalt Turquoise or Viridian, along with a green/yellow shade, like Prussian or Sap Green for use in a painting. A safer

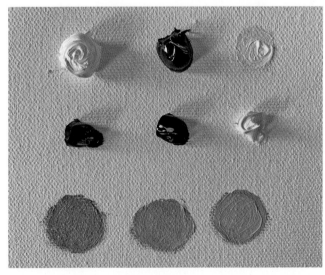

Practise mixing greens, using Sap Green as the base. Use Lemon Yellow, Ultramarine Blue and Burnt Sienna to produce three or four shades that harmonize.

◀ *After the Rain, the Langdale Valley*, detail, oil on canvas.

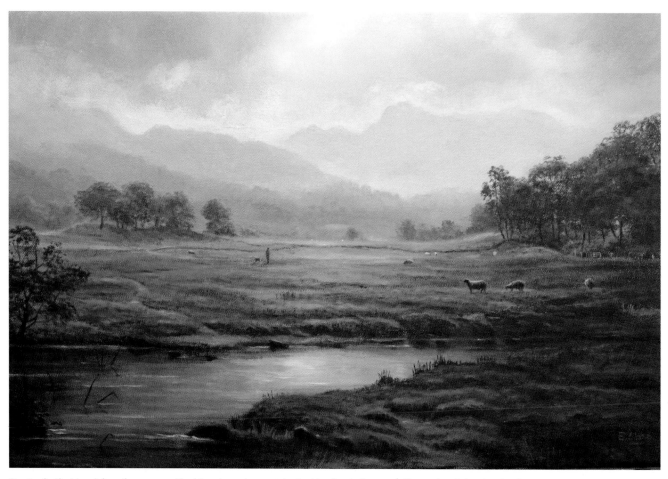

Passing by the Langdales, oil on canvas. The blue sky and mountains in this oil painting are deliberately subdued and soft, as the emphasis is on the foreground and mid-ground features. Notice how the trees, reeds, bushes and grasses all differ just slightly in hue and tone. Try to develop a range of greens that are close in hue and tone, but differ enough to create an effect of lushness.

choice would be a single green colour (in my case it is nearly always Sap Green), mixed with other hues, using a limited range of colours. In this way, you can control the colour contrasts and avoid unpleasant, garish and discordant effects.

As with the use of green hues, limit your palette to one particular blue. Use this as a base to develop a harmonious effect throughout the composition. Be particularly careful mixing blues for the sky area. A bright Prussian Blue sky with Viridian mountain slopes will certainly be colourful, but it will need exceptional skills to evoke peace and serenity when used in this combination.

THE HUMAN ELEMENT

Including man-made structures such as cottages, farms and stone walls in the mountain landscape can create the sense of a comforting, human presence. These features suggest that the landscape, while it is sometimes inaccessible and vast, offers areas of peace and sanctuary. A tiny, white cottage shining out in the sunshine at the base of a mountain shoulder not only produces a sense of security, but is compositionally powerful. As well as providing a sense of scale to the viewer (who will naturally perceive the size of the mountain by referencing a known quantity – the building), it also provides a bright point, which leads the eye into the scene.

If you do include buildings and walls in the composition, try to concentrate on harmonizing the structures with the landscape. The shadows and the lights on the buildings will reflect the colours of the vegetation around them, and wet roofs often reflect the colours and brightness in the sky. Painting a building standing out alone, separate from the scene, is likely to look false, as in the mountain landscape buildings are nearly always obscured by trees and bushes. Also check that you have not neglected the shadows that surrounding vegetation casts on the walls and the roofs.

A word of warning is necessary at this point. If the cottage is large and prominent in the composition, it is likely to become the main focus of the painting. Try to make a decision as to the importance of the building early on in the information-gathering stage. Are the mountains a backdrop to the cottage, or does the cottage enhance the view of the mountains?

Sometimes, you will come across a viewpoint in which a particularly iconic building seems to be so perfectly placed that it demands particular attention, as in the painting *Woodsmoke, Blea Tarn, The Langdales*. Here the mountain scenery, the trees, stream and sheep are significant features, but the beautiful, old, white building takes centre stage.

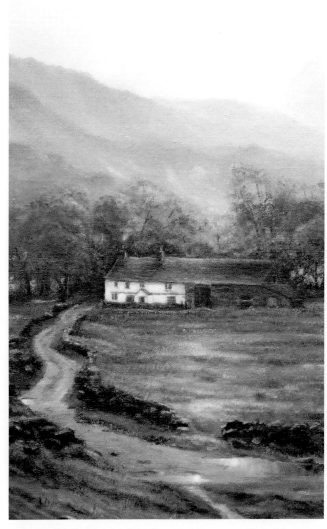

Little Langdale Cottage, detail. In this scene, the stone walls and the wet footpath lead the eye into the composition. The old farmhouse cottage sits easily in the landscape, and it is far from geometrically perfect. A wisp of smoke moves attention on to the shoulder of the mountains behind, and is a reminder of the many open fireplaces which have been burning in these landscapes for centuries. The leafy, green tones of the dark trees behind the cottage are incorporated into the roof and the adjacent barn.

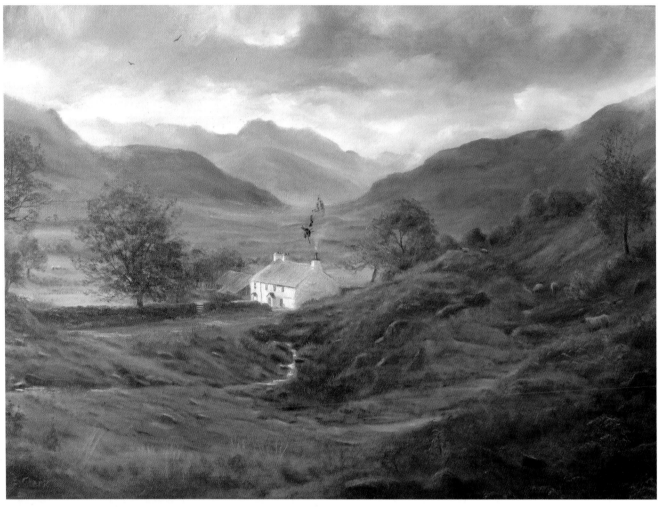

Woodsmoke, Blea Tarn, The Langdales. Blea Tarn House, pictured here, stands by itself in this hanging valley, and attracts many painters and photographers alike. It is a Grade 2 Listed Building and it is owned by the National Trust. From this angle, with the profile of Bowfell behind, it is the natural central focus for the composition.

You may recall that in Chapter 2, one of the paintings featured was entitled *Under Clearing Skies, Blea Tarn, The Langdales.* Take a look, and you will see a small white building on the right of the composition. This is the very same building, Blea Tarn House, but from a very different angle. Here, it contributes to the scene, but the emphasis is on the sweeping lines of the hanging valley that lies between Greater and Little Langdale.

The human figure

A human figure included in the mountain landscape will draw the eye. As soon as the figure is noticed, even if it is small, it will attract attention – sometimes too much. Including figures can, however, have advantages. They can, like cottages, emphasize the height of the mountains and the distances involved. The direction of travel of a walking figure will steer the eye towards his or her destination. In addition, the gestures and attitudes of the figures will contribute to the atmosphere of the painting, and many walkers and climbers will be able to identify with a moving figure in the landscape.

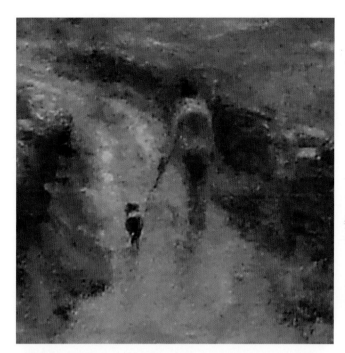

A Day in the Fells, Stonethwaite, Borrowdale, detail. The figure and the dog in this painting (pictured in full in Chapter 1) are painted using the same tones and hues as the surrounding stone walls. Simple details, such as the hint of a rucksack, imply that this person is heading through the village for a walk in the mountains.

Snowmelt, Helvellyn, detail. The two figures and family pet were included in this commission piece on request. They are painted using brown landscape hues and are almost in silhouette. They are not the main subject of the composition, but instead their head positions are tilted to suggest that they are looking across the tarn, towards the melting snow on the peaks, the central focus of the painting.

I nearly always paint small figures that blend as much as possible into the scenery. If you want figures to be noticed, but not to be the main subject matter, avoid bright colours and use the blues and browns and light shades on your palette. A perfectly detailed, sharp figure is unlikely to harmonize with the surrounding textures. Practise painting tiny figures using small, simple and suggestive brushstrokes. Remember, a single brushstroke will change the apparent direction of travel or attitude of the figure.

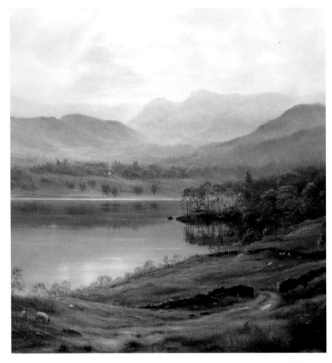

Perfect Day, Windermere, detail. The sheep in this composition, and the pathways that they and the farmers create, provide mid-ground and foreground interest, and also the opportunity for points of light which track downwards towards the lake.

Sheep Study in oils. Along with the sheep tracks, of course, you find the inhabitants who make them. Often, their backs and their brindled white fleeces catch the light. Try to integrate them with the surrounding vegetation, allowing some part of their backs or feet to be hidden in the shadows, or overlapped by leaves and ferns.

Crossing the Beck, Honister Pass, detail. Sometimes including sheep or deer can contribute to a sense of movement and narrative, as in this painting, which was featured in full in Chapter 4.

Pathways, sheep tracks and other features of the mountainside

In the initial stages of a composition, look out for pathways – whether these are created by humans and lined by stone walls, or are 'sheep tracks' through the rough ground. They are a gift to the mountain painter. Use paths that disappear into the distance to create convincing perspective, and to add texture, light and shade which might otherwise be missing.

Luckily for a Lake District artist like myself, sheep tracks are to be found nearly everywhere, and on damp ground they reflect light and break up areas of grass, ferns and heather. Herdwick sheep are considered by many to be part and parcel of the English Lake District. These sheep are what is termed 'hefted', meaning that they are left to roam, at least in the upland areas, where they develop a sense of belonging. It is worth considering sketching and studying any creatures that are evocative of the area of mountain scenery you have chosen. Be aware, though, that large, detailed studies of deer, sheep or other animals are likely to relegate the mountain scenery to 'backdrop' status.

After the Summer Rain, the Langdales

YOU WILL NEED

- Quick-drying oils or standard oil paints (I am using Holbein Duo Aqua oil paints):
 - Underpainting White
 - Titanium White
 - Burnt Sienna
 - Burnt Umber
 - Carbon or Ivory Black
 - Sap Green
 - Ultramarine Blue
 - Lemon Yellow
 - Naphthol Red
- Walnut Alkyd Medium (using this will mean that your standard oil paints will dry much more quickly)
- Palette for mixing
- 1in flat brush
- 3 or more fan brushes (preferably more if you have them): large, medium and small
- 2 or 3 round brushes (small size 2 approx., medium sizes 4 to 6); for most of the detailed work towards the final stages, you will probably use sizes 2 to 4
- Support: use either a canvas or board which is ready primed with a gesso layer. I am using a Winsor and Newton fine-grain canvas, 24 × 18in. This is slightly wider than standard landscape format, as I wanted to encompass the width of the valley, including mountain ridges on either side. This surface has been pre-prepared with white gesso. I have applied a thin layer of Underpainting White mixed with Burnt Sienna and thinned with Alkyd Medium, to create a warm ground
- Chalk or soft pastel
- Brush and equipment cleaning materials: paper towels, white spirit for oils, or soap and linseed oil
- A roll of strong kitchen paper or a lint-free cloth: this will be necessary when you come to the wiping-out stage of glazing
- Spray can of retouching varnish (optional)

I chose this subject for a demonstration piece as it provides plenty of scope to work on the challenges discussed in this chapter. It is based around a view across the Langdale Valley towards the central mountain range that includes Bowfell, The Band and Pike of Stickle on the left, with Wall End Farm in the mid-distance. In the summer months the fields, sometimes wet after rain, appear lush and they produce rich pasture for the grazing sheep. This provides lots of opportunities for reflected light on vegetation, buildings, sheep and pathways. The old farm building, framed by aged trees, is not over-dominant or out of place. You may decide to use this view as the basis for the exercise, or you may decide upon a composition with similar features, and follow through the main stages set out in the exercise.

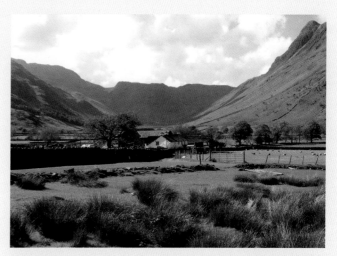

Photograph of the view across Langdale Valley, with Wall End Farm in mid-ground.

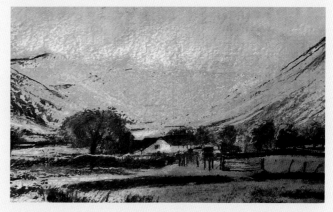

Sketch in mixed media, *Wall End Farm*. The farm, although it is not the main subject, will play an important part in the composition. The trees around it and the light falling on the white sides of the building are worth studying.

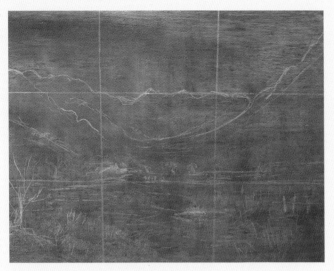

Step 1: Outline sketch on colour base. On the pre-prepared surface, use chalk to sketch in your composition lightly and roughly. I have deliberately emphasized the chalk layer here, but would normally use it very lightly. Notice that I have 'pushed' the farmhouse slightly further back into the mid-ground. I have also lightly sketched in a grid which divides the painting into thirds (*see* Chapter 5 for explanation of 'rule of thirds').

Step 2: Basic sky tones and hues. Mix some basic sky tones and hues, using Titanium White, Ultramarine Blue and a small amount of Burnt Sienna. Use a medium-size fan brush to sketch in the sky area (refer back to Chapter 5 if you need any reminders on this). Remember, this is an early stage of the painting and you are using a fan brush to suggest simple areas of cloud and sky. Keep colours light and contrasts low.

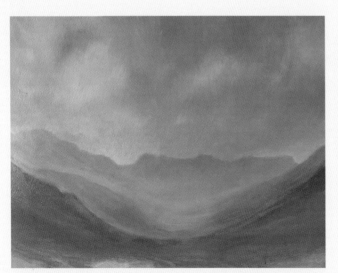

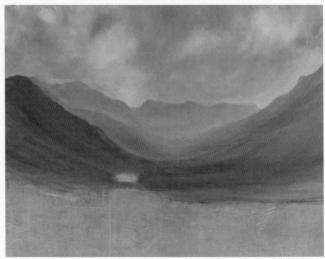

Step 3: Painting in the basic mountain shapes. Paint in the mountain shapes, using either a small fan brush or a size 6 round brush. Mix Ultramarine Blue with Titanium White and a little Burnt Sienna. These shades should be close to sky shades, just a little darker. Try to keep the sky–mountain margins soft at this point. Use a small fan brush to soften the edges if they seem too harsh. Paint in some of the nearer ridges, adding a little Sap Green as you move forwards in the composition. If possible, preserve these mixes for use later on in the exercise.

Step 4: Establishing the mid-ground. Leave a small gap without paint, so that you know where the cottage is situated in the composition. It is an 'anchor point'. It is sometimes helpful to choose a particularly obvious feature that is a clear, small, bright area. Left without paint for a short period, this can provide a useful reference point to work around (be careful though not to allow this to become a problem area as the paint builds). Add more Sap Green and a little Burnt Sienna to your mix as you paint in the far fields and move into the mid-ground.

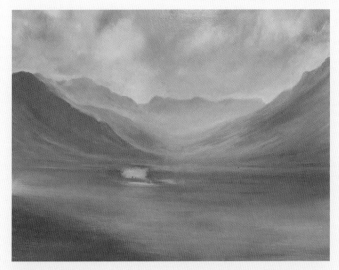

Step 5: Foreground hues. Mix three or four green hues and tones, using Sap Green, Burnt Sienna and Ultramarine Blue. A medium fan brush is perfect for filling in the mid-ground and foreground. Greens nearby, in the foreground here, are richer in hue and closer to a yellowy green – as they so often are. Create some texture and variation as you do this, which you can build on later.

Step 6: Defining the clouds. Mix two or three lighter shades for the clouds. Use Titanium White, a little Ultramarine Blue and a tiny bit of Burnt Sienna. Start to define the lighter areas of the clouds, using a size 4 round brush. Do not add any dark chromatic greys to the sky in this painting, as strong contrasts in the sky will affect the overall harmony. This is not a storm sky as in Chapter 6, and so any greys should be muted.

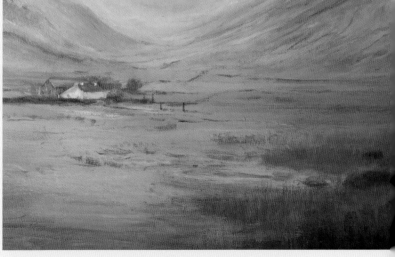

Step 7: Creating the basic lights and shades on the mountains. Use a size 4 to 6 round brush for this stage. Mix deeper shades for the darker shadow areas of the mountains by adding a little more Ultramarine Blue and Burnt Sienna to your original mixes created in Step 3. Adding a little red will create more purple tones for greater contrast with green highlights. To create warm, highlighted areas use Titanium White tinted with Burnt Sienna, and tone down with a little Ultramarine Blue, if you want to make them cooler. Add a little Sap Green very sparingly for the lower slopes. Beware of over-sharp edges.

Step 8: Developing mid-ground and foreground. Using a size 4 round brush, develop the texture and the range of the greens and browns in the mid-ground and foreground, to develop the various shades of the grassland and vegetation. Mix some lighter and darker shades using both Sap Green and Burnt Sienna. You could add a little Ivory or Carbon Black to the mix, or preferably darken it using Ultramarine Blue and Burnt Umber. Roughly sketch in the white cottage and the walls in the mid-ground in a simple form.

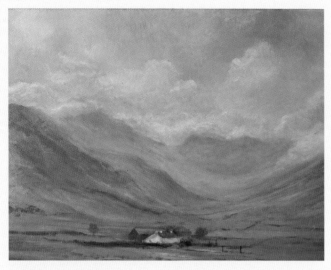

Step 9: Back to the sky. At this point nearly all the compositional elements are in place, and so it is time to add more details, highlights and shadows to the picture. Start with the lights in the clouds, and, as before, avoid any heavy, dark shadows. Use a size 4 to 6 round brush and a small to medium fan brush to blend any unnatural edges.

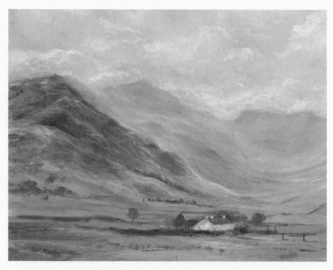

Step 10: Emphasizing mountain lights and shades. Having strengthened the highlights in the sky, it is time to emphasize the lighter and darker areas of the mountains. In Steps 3 and 7, you mixed mountain colours which now can be darkened to create deeper shadows, using a varied mix of Ultramarine Blue and/or Burnt Sienna, Burnt Umber, Sap Green and red. Look back to Chapter 5 for hints on using chromatic greys. If you prefer using a black to darken shadows, do so very sparingly as it can have a deadening effect. Lighten some of the shades developed in Step 7 by adding Titanium White and then paint in the areas where the light is catching. Add a little Burnt Sienna to the warmest light areas.

Step 11: Getting down to detail: the vegetation. Use a size 4 round brush to paint in tree shapes and vegetation in both mid-ground and foreground (the strongest highlights on vegetation will come later). Mix Sap Green with a little Ultramarine Blue, and Burnt Sienna and Titanium White, using different proportions to create a variety of shades. Mixing Sap Green with a little Lemon Yellow and white will enrich the greens in the foreground. Try to create variations in the tone and texture of the vegetation. Look for areas where the ground is rough and areas where the light catches. Use a medium/small fan brush to paint in the reeds, and a size 2 to 4 to paint in sharper details.

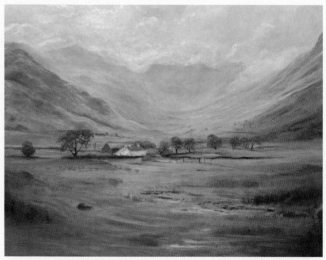

Step 12: Glazing to add warmth. This step and the next one are not essential in this exercise, but if you are feeling courageous it is a good chance to have a go at using a simple Burnt Sienna glaze over the colours you have established in the mid-ground and foreground. Before applying a glaze, make sure the paint is completely dry. This is essential in case you use too much and need to remove it. Use a thin mix of Burnt Sienna and a tiny touch of Naphthol Red. Thin this with a medium like walnut oil and paint a very thin layer onto the foreground and mid-ground areas. The colour should be very weak, almost like a tint. Paint this on very gently with a soft fan brush.

Step 13: Wiping away. Do this while the glaze is wet. If you have used a glaze and your paint underneath was thoroughly dry, it is possible to gently wipe away some of the glaze, with a very soft cloth or strong paper towel. When the paint is removed from the lighter areas, highlights can become more intense. Be very careful when you remove some of the glaze. Do this gently so as not to scrape or remove paint from the layers underneath. The effect should be subtle with no strong areas of the glazing colour obvious. Gently wipe away any areas that appear too strong.

Step 14: Developing mid-ground and foreground shadows and details. If you are happy with the amount of detail and the depths of the shadows in the foreground and mid-ground, then leave these areas as they are. If not, use a size 4 to 6 round brush to deepen the shadows with a very thin glaze of Ultramarine Blue. Tone the blue down with Burnt Sienna, Burnt Umber or Sap Green to produce darker shades if the blue is too intense. Use a size 2 round brush to paint in detail, such as the finer strands of the reeds and vegetation. Mid-ground and foreground areas will usually display characteristic vegetation, and these will vary according to the region you have chosen to paint. Use your knowledge and sketches of the mountain foregrounds to add interest to your composition. Be careful, though, as over-working is a danger at this point.

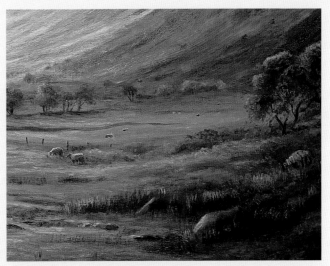

Step 15: Highlighting the vegetation and buildings. Pick out the highlights on the tops and sides of the trees with Titanium White tinted with a tiny amount of Burnt Sienna or Sap Green – a size 2 brush is suitable here. Using a similar mix, and adding a little yellow for extra brightness, pick out areas in the mid-ground and foreground vegetation that are catching the light. Try to maintain consistency in the direction of the sunlight and the shadows. Use points of colour and light to guide the eye from the foreground, across the mid-ground, to the high mountains in the distance. In this painting, the light is coming from the upper left-hand side of the composition, catching on some of the side of the farm building and vegetation.

Step 16: Painting in the sheep. Again, this step is not essential, and depending on your composition may cause over-crowding. If you do decide to include these inhabitants, try to place them so that they do not detract from other elements such as the cottage. Use tinted Titanium White to paint the light which catches on the backs of the sheep, as you did with the vegetation and trees. Notice that they cast shadows and are sometimes partially obscured by grasses or shrubs. I always leave the painting-in of sheep or figures in the composition until close to the end, as they are such a wonderful, moveable feast, and sheep are rarely in one place for very long.

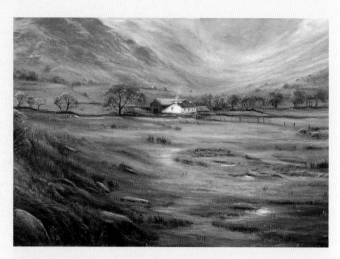

Step 17: Stand back and final touches. Stand back at least a few feet from your painting at this point, and consider the whole composition. Working from the sky downwards, lift any highlights that you feel are important in drawing the eye into the composition – for instance, the light area on the sheep track in the near mid-ground of this composition needed more light. Do this sparingly. Apply small strokes and use small round brushes to avoid creating unnatural blocks of light. Titanium White mixed with a tiny touch of Lemon Yellow, applied very carefully, will create effective highlights. When finally assessing your painting, you may well see a glaring error, for instance a stray bright brushstroke. Do not despair. Oils and acrylics are very forgiving, and you can overpaint areas that look odd or out of place. A word of caution, though: try to avoid 'fiddling' with areas that are already satisfactory, as over-working can ruin good work so easily.

PREPARING YOUR WORK FOR FRAMING

If you have chosen standard oil paints, the paint will usually be ready to varnish between two to six months later for very thin layers. This varies, however, and for very thick paint this can take up to two years. The time will be shorter if you have used quick-drying paints or mediums. Do not attempt to varnish the picture with a standard varnish until it is completely cured. If you need the painting for an exhibition, a retouching varnish can be used after a couple of weeks, but only if the painting is touch dry. This varnish is useful for temporary protection, and also it will restore gloss to areas that have gone dull compared to the surrounding paint. Retouching varnish can be removed eventually, or a final varnish can be applied over the top after about a year.

Choosing the right frame for a mountain landscape, whether it is for a stormy or a peaceful scene, is very important. If you can strike up a relationship with a thoughtful and professional framer for advice, do so. I have certainly found this invaluable. A serene mountain landscape is more likely to succeed if the tones and style of the frame harmonize with the overall impression of the scene. Some artists paint and tint their own frames and inners to suit the landscape colours. This can be very effective but is time-consuming, and depending on the framing materials it can be difficult to maintain a good finish. Natural, muted wood frames along with neutral inner frames can be very effective.

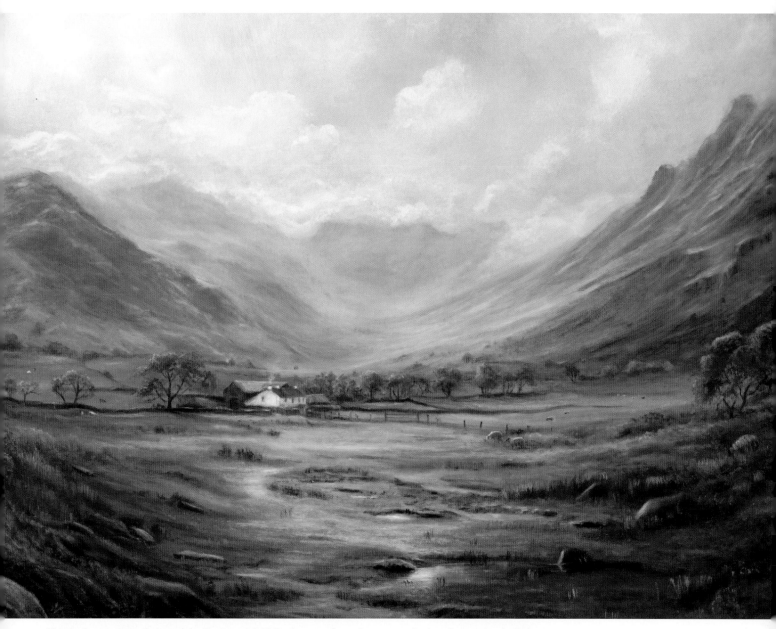

After the Summer Rain, the Langdales. The Langdale Valley is a great favourite amongst both walkers and rock climbers, particularly in the summer months. Despite the fact that it is one of the most visited places in the Lake District, it is relatively unspoilt. Whether you are walking or climbing on a warm, quiet summer's day, the valley has a powerful atmosphere. The sweeping slopes and outcrops formed by glacial erosion have stood there for millennia. Within the human timescale the valley has seen many activities, from the Neolithic inhabitants who fashioned sharp axes from the green rock, to slate miners and of course the sheep farmers, whose Herdwicks wander across the valley and onto the mountainsides. In the valley bottom there are a few farmhouses, often painted white, which catch the sunlight and stand out against the green fields. Sheep tracks criss-cross the landscape, and after heavy showers in the summer small pools form and then quickly drain away. The farmhouse in the mid-distance below the high peaks is a symbol of the peace and refuge to be found in the mountains.

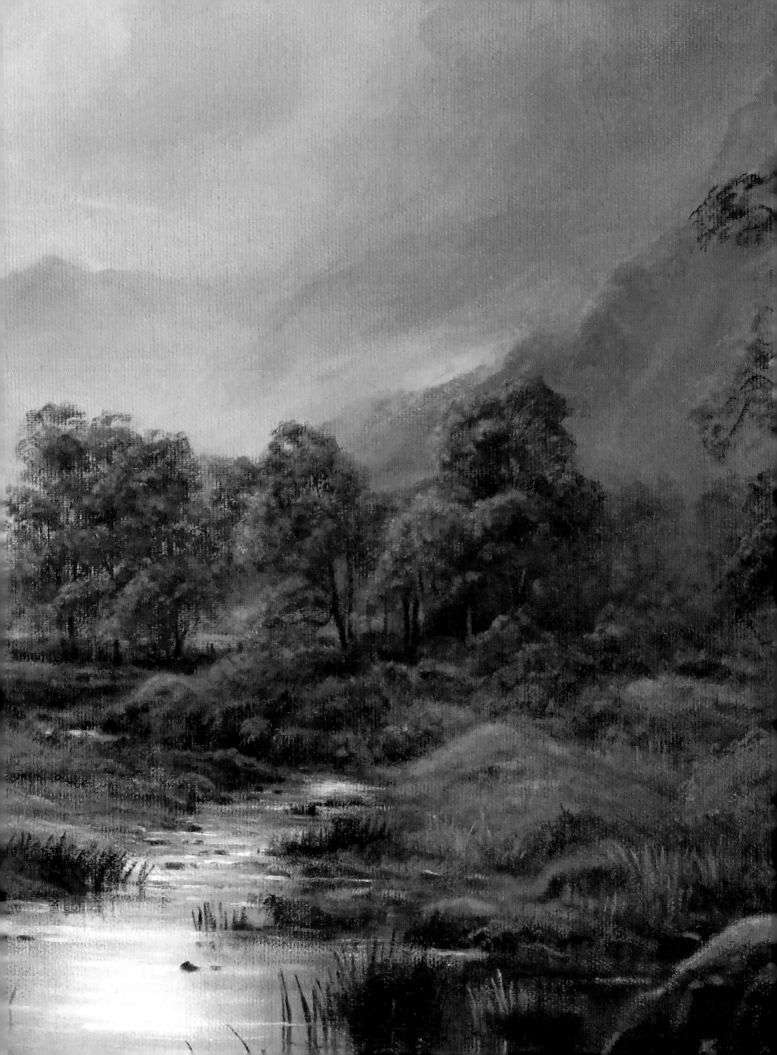

Water: Lakes, Rivers, Waterfalls, Snow and Ice

I hear lake waters lapping with low sounds on the shore.

W. B. YEATS

Water transforms the mountain landscape. Often, both the land itself and the water in it have evolved together, and are therefore intimately related. The grassy sloping banks of the streams have been undercut for thousands of years by fast-flowing water. Mountain rain pouring down from the heights has eroded deep ravines in softer rocks and exposed hard, igneous outcrops. Lakes lie in the valleys ground out by glaciers and rocks.

Some artists avoid painting water, believing it too difficult to achieve a naturalistic effect. Please do not take fright at the prospect of a fast-flowing stream or a broken reflection in a lake. Mountain landscapes, rich in lakes and streams, provide some of the most stunning and rewarding views you could possibly find. This chapter explores some important but surprisingly simple techniques that will hopefully significantly improve your skills when incorporating water into the landscape. In particular, we will examine the role of brushwork, tonal contrasts and the use of Titanium White.

When water is included in the composition, because it has special properties it opens up a new range of possibilities. Points of light on a stream can steer the eye across the composition. Mountain reflections bring unity to tone and hue. Uninteresting blocks of mid-ground or foreground can be broken into various shapes and colours when light reflects on rainwater pools and wet ground.

Try to sketch or take photographs in different weather conditions, in various seasons and times of day. You will notice that changes in these conditions, particularly in the movement of air, will dramatically alter the appearance of the water and its reflectivity. Even within a few yards, there can be significant changes in the colours and texture of the water. For instance, as you approach the lee of an island or promontory, suddenly the water will be calmer and reflections clearer. Creating a small library of these images for reference, as you may have done with the sky and other features of the landscape, is very worthwhile. Skills learned from practising lake painting are often, at least partially, transferable to the painting of rivers and streams, and vice versa.

LAKES

On some occasions, you will see what appears to be a mountain perfectly reflected in a lake (actually, because the angle of view slightly distorts the image, it is not an exact mirrored image). Careful observation of angles is needed. I would not recommend these 'perfect' reflections as subject matter, unless they are in some way divided by an island or promontory – and even then, there is the danger of the water looking flat and lifeless. More interesting to the artist are the lake surfaces partially covered with or broken by reflected light. These offer many more opportunities for mid-ground and foreground highlights, and also for variation in tone. Be aware also that choosing a lake that is uniformly 'choppy' is likely to create a monotonous block in the composition.

◀ *Song of the Beck, Buttermere*, detail, large oil on canvas.

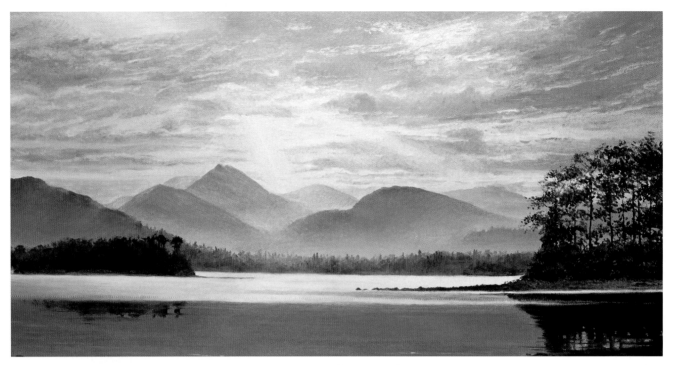

Late September, Derwentwater, detail. The pattern of light seen in this detail of a painting of Derwentwater is very common. In breezy conditions the water in the distance, which is disturbed, will catch the light. In stretches closer to the shore – in the calmer water – the trees, mountains and sky will be reflected. Notice the broken reflections of the island treetops on the left of the composition. These trees can only be reflected where the water becomes less disturbed in the foreground. The clearest, strongest reflections are to be found where the water is at its deepest and is still. Further out in the distance, shafts of sunlight will reflect off the disturbed water, creating a bright band.

Mountain reflections

The following tips for painting a mountain reflection are not hard and fast rules. Do not obey these rules unthinkingly, especially when your eyes and your artistic senses tell you something different.

Colour saturation and tone

Colours that are reflected, for instance the blues and greens of mountain slopes, are less saturated than the originals. The general rule is that in reflections, dark colours appear lighter and the light colours appear darker – but this is not always reliable or preferable. Observation here is key. It would be a mistake to believe that reflected colours should always be painted using lighter or darker tones. For instance, although colours may be more neutral and slightly lighter when reflected, areas under the woods and trees can sometimes appear darker, simply because the light does not reach them at all.

Details and definition

As water recedes it can become more reflective, so in the distance reflections on undisturbed water often look very clear. Close by, however, the colours frequently appear more olive and more mixed. Shallow water is less reflective, and when rocks and reeds break the surface the patterns become distorted and complex. Details are often lost when the reflection is nearer to the viewer, so reflections of mountains close by are often areas of colour that overlap and blur. Where light from the sky catches on the water, light lines cut across the reflection. Use soft fan brushes and horizontal strokes to blend areas that reflect the margins of the mountains and sky.

The reflected sky

Water may be darker than the reflected sky, and the blue less saturated. Light areas breaking through the clouds often form broken patches and changing lines across areas of colour. If the sky lightens as it recedes, so does the reflection in the water. A nearby reflected blue sky can be darker and more neutral than the actual sky, whereas in the distance tending more towards a purple colour. However, if the sky becomes warmer in the distance, so will the reflection beneath it.

Wooded Shore, Ullswater, detail. Ullswater is one of the region's largest lakes and is on the eastern side of the English Lake District. On much of the western shore there are no roads, and the mountains fall steeply to the lake. Trees and woodland line the banks, and on calm days the slopes and trees form varied reflections in the water. Notice how the tree reflections are slightly more defined than those of the mountain slopes. The blue, green and brown shades nearer to the viewer are broken by lines of reflected light, and the colours sometimes merge into one another.

Riding the Storm, Derwentwater, detail. Stormy weather over Derwentwater can create breaking waves known as 'white tops'. Notice how the brightest points of light occur where the water is breaking. Patches of brightness can also be seen reflected from the areas where the sun is breaking through the clouds. A fine mist is produced when the wave hits a group of rocks in the foreground. This mist is painted using a very thin layer of Titanium White, softened at the edges using a lint-free cloth before the white is dry. Notice also how the white lines of the 'white tops' become closer together as they recede.

Elongation

Water that is even slightly disturbed distorts reflections. This applies particularly to light objects, which often appear elongated. A sun setting behind a mountain shoulder will form a column of light on the water, which spreads downwards from a bright reflection in the distance. The column can broaden and often fractures as it approaches in the foreground. A bright white cottage on a lake shore will often be reflected as a thin white column much longer than its height. The same effect applies to bright areas of sky.

Waves and ripples

Water and ripples often reflect the colours from both the light and dark areas in the landscape and sky, and so are often dark on one side and lighter on the other. The turbulent water in the *Riding the Storm* painting, where waves are breaking, strongly reflects the light. Use short, lively strokes and small brushes to paint the points of light. Painting blocks of continuous light, using a large brush, will make the water appear static and solid. When the water hits a rock or reeds, or when a bird crosses the lake, a ripple is formed. This leaves a fine trace of reflected light. Suggest this using a fine brush, but avoid thick lines, and fade the lines out towards the middle and end.

Painting a Mountain Reflection

I have chosen a section of a view of Crummock Water for this exercise. The shapes and tones of the mountains are fairly simple. This enables us to focus on brushwork and the control of the hue and tone in the reflection.

YOU WILL NEED

- Quick-drying oils, standard oil paints or acrylic paints depending on your preference (I am using standard Winsor and Newton oil paints):
 - Underpainting White
 - Titanium White
 - Ultramarine Blue
 - Sap Green
 - Burnt Sienna
 - Winsor Yellow
 - Alizarin Crimson
- Walnut Alkyd Medium (using this will mean that your standard oil paints will dry much more quickly)
- Palette for mixing
- 1in flat brush
- Fan brushes: 3 medium and 2 small (having several of these clean and ready to use is very helpful)
- 2 or 3 round brushes (1 × small size 2 approx., 2 × medium size 4 to 6)
- Small round brush for fine detail, size 1 to 2. (Having several brushes of each kind, clean and ready to use, reduces the chances of inadvertently mixing colours)
- Chalk or soft pastel
- Brush and equipment cleaning materials: paper towels, white spirit for oils, or soap and linseed oil
- Support: use either a pre-prepared board or canvas, coated with a layer of warm coloured ground (I am using a fine-grain canvas, primed with several layers of white gesso; I then applied a coat of warm ground, mixed from Burnt Sienna and Undercoat White)

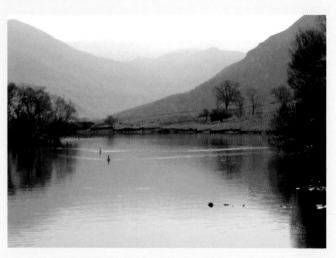

'Crummock Reflection' photograph. You may decide to use only a section or the entire scene as a basis for this exercise. If you use your own sketches or photographs, try to choose a similar scene with simple shapes and darker mid-ground and foreground vegetation.

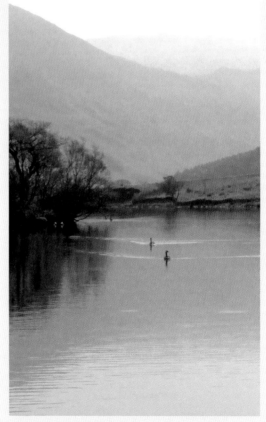

I have used this detail from the photograph 'Crummock Reflection' as a basis for this mini demonstration.

Step 1: Guidelines. Draw in simple guidelines, using a chalk or a light pastel on the pre-prepared warm ground. I have painted in a little of the sky tones around the chalk marks to demonstrate the process of filling in around the guidelines.

Step 2: Blocking in sky and mountains. Mix some light tones for the sky and the mountains. Tint some Titanium White with a little Ultramarine Blue and, using a medium fan brush, paint in the sky. Add a very small amount of Burnt Sienna to the mix and paint in the ridges. Blend any strongly delineated sharp edges. Then add a hint of Sap Green to the mix to gently define the nearest ridges. Save any mixes you have left for Step 3.

 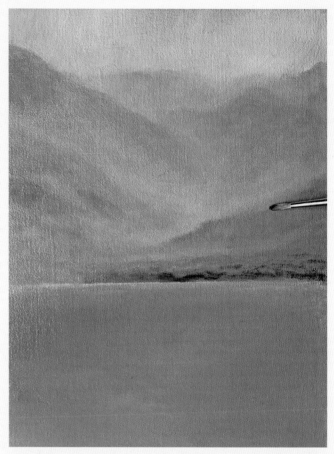

Step 3: Colour base for the water. To create the reflection, use the corresponding tones previously mixed for the sky and the mountain, but make them very slightly more neutral in colour, in other words less saturated and closer to grey. Paint in all the areas of water using horizontal strokes. Blend the areas so that there are no strong divisions; a soft medium-size fan brush is the best choice for this. Go over the whole area using roughly horizontal strokes. You should now have a colour base on which to work on the more subtle areas of light and shade. Allow the paint to dry before going on to Step 4. It is possible to work 'wet on wet' throughout this whole exercise, but this method makes it harder to correct errors and can get very messy.

Step 4: Mountain slopes and peaks. When the paint is dry, work on the mountain slopes and peaks. Pick out the highlights using Titanium White, which has been tinted with Ultramarine Blue, and add a tiny touch of Alizarin Crimson to create a more purple hue for the most distant peaks. For the closer ridges, tint the white with Ultramarine Blue and Sap Green, and Burnt Sienna. The mid-ground bank should be warmer in tone and so add a little more Sap Green, Burnt Sienna and Winsor Yellow to the mix. The mountain colours in this scene are muted compared to the foreground. The contrasts are low, and the hues are not saturated, so the highlights and shadows should not be strong.

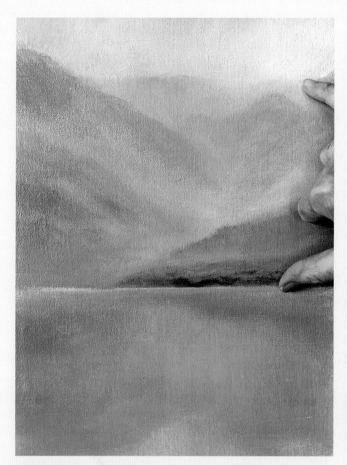

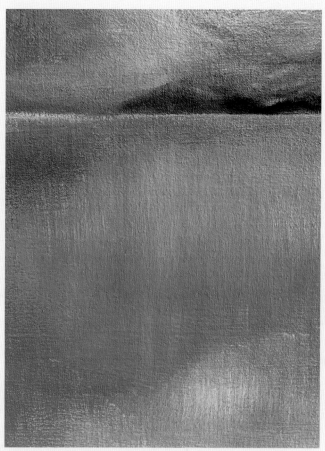

Step 5: Colour and tone gradation. Check that you are happy with the colour and tone gradation, from the top of the reflection to the bottom. Add a little Titanium White to lighten areas if necessary, or an Ultramarine and Burnt Sienna mix for darker shades. Blend any unwanted divisions. These should be subtle differences, as contrasts in the mountains are low. I often use the span of my hand to estimate the proportions of the reflection, and to decide where the main transitions between the subtle hues and tones occur. Try to establish these before you go on to Step 6, and allow the paint to dry again. Step 3 and this step are important as they establish a base on which to build the patterns of light and shade on the water later on in the exercise.

Step 6: Vertical strokes. Using a medium-size flat brush or a fan brush (I always use a fan brush in my selection for water painting) paint over your base to emphasize the gradations you identified in Step 5. Try, as a general rule, to use the mountain colours that you have mixed for Steps 2 and 4. The aim is not to paint a perfect reflected image. Instead, use downward strokes to pick up variation in areas of tone. Pay particular attention to the point where there is a subtle contrast or boundary. The margin of mountain and sky should be one of these areas.

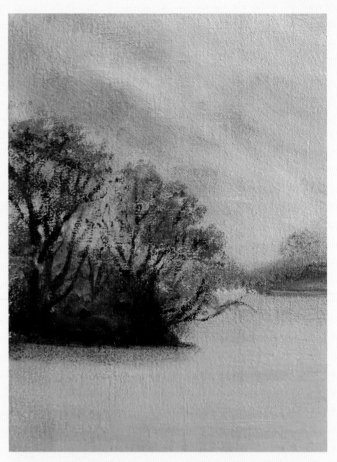

Step 7: Horizontal strokes – ripples and reflections. Look again at the photograph. Notice that the ripple effect is the most marked in the foreground. Further away in the distance, it becomes almost invisible, and instead there is a soft merging of colours. Try to create a ripple effect in the water. Do this by gently dragging the brush across the wet vertical strokes of paint, so that some of the colour is pulled into a nearby different colour or tone. Add a little more white, or colour, where necessary. Use a medium fan brush to achieve this striated effect. Occasionally, turn the brush on its side and pull a thin line of light paint into a slightly darker area of colour. The same effect can be achieved with a very fine-tipped pointed brush. The paint strokes do not have to be rigidly horizontal as water ripples take many different tracks. Do not overdo this process as the wave effect will be lost.

Step 8: The small island trees. The darker reflections in the composition are easier to manage once the lighter areas have been at least partly established. Paint in both the small island trees, which are in the middle ground and foreground, and the darker areas of the bank. Use a mix of Burnt Sienna and Ultramarine Blue for the trunks of the trees. For the leafy areas, use a mix of Burnt Sienna and Sap Green, lightened with white or a little Winsor Yellow if necessary. A size 2 to 4 round brush is suitable for the fine details of the branches and leaves.

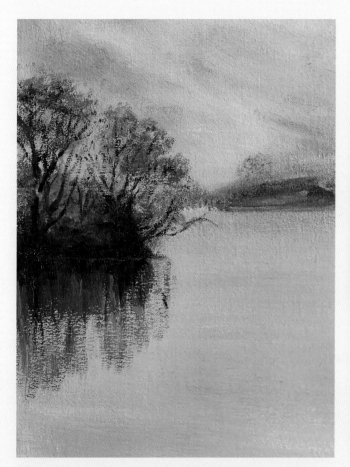

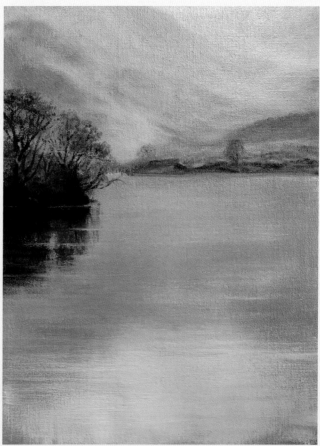

Step 9: The reflected trees – vertical strokes. It is possible to paint in the tree reflections wet on wet, but this can get very messy and errors are hard to correct. I usually allow the paint to dry on the light areas of the mountain reflection. The nearby vegetation is a considerably deeper tone than the mountains, and so the reflection of the trees should contrast with the light tones behind it. Use a small round brush (approximately 2 to 4) to paint in the strokes, but be very sparing to begin with. Complete the next step (Step 10) before the paint dries.

Step 10: The reflected trees – horizontal strokes. Make sure that you use a completely clean size 2 to 4 round brush. Carefully pull it across the wet, vertical strokes painted in Step 9. Try to pull some of the darker paint across into the lighter areas, to give the impression of ripples. As the reflection comes closer, it should appear more broken. Adding one or two fine light streaks to dark areas will also help to create a ripple effect. Again, add these very sparingly and randomly, otherwise they will look like an unnatural structure on the water.

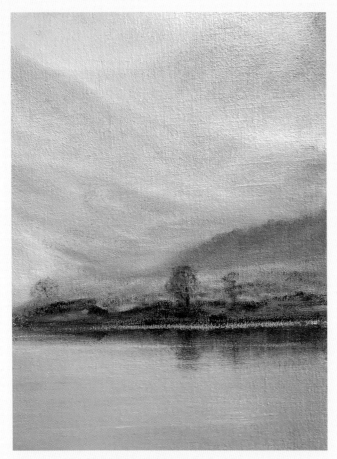

Step 11: The mid-ground bank reflection. Look carefully at the reflection of the bank, and the small bush in the mid-ground. Notice how the very thin area of reflected colours of the eroded bank close to its borders are dark, but the colours fade quickly as it extends towards the viewer. Similarly, the small tree on the bank has a reflection which fades as it extends outwards into the water – again, a familiar pattern which you will observe when you study reflections. Paint in these features using a size 2 to 4 round brush. Do not forget to paint in the tiny strip of light visible at the boundary of the water and shore. It is common for these boundaries to be marked by a bright, sharp, thin strip.

Step 12: Birds, reeds and stones. Allow the paint to dry before you try painting the sharp details of the birds and the nearby rocks and reeds. Use a small size 1 or 2 brush for this step. Mix some Burnt Sienna with Ultramarine Blue to create a rich dark grey for the birds. Mix a similar tone for the reeds using Ultramarine Blue and Sap Green with a little Burnt Sienna (you can pick out any light areas on the reeds or birds using a tinted shade of Titanium White, but this may be unnecessary detail if you are already happy with the effect). Add a little Ultramarine Blue and white to your mixes to create a shade for the reflections underneath the birds. Paint these in very sparingly.

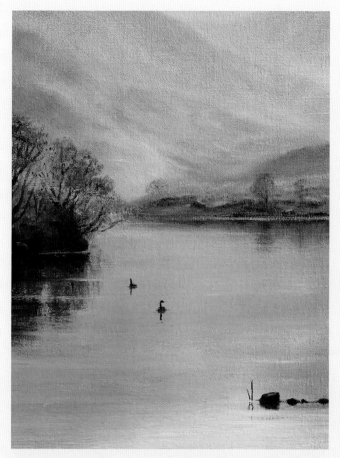

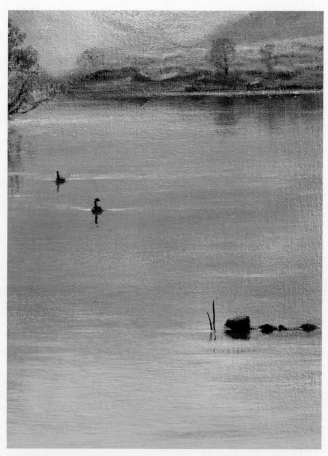

Step 13: Fine lines. While the paint is still wet, take a clean size 2 brush and carefully flatten it between your fingers to create a thin edge. Pull the fine edge across the division between a bird, a stone or a reed – to mark the division between the object and the reflection – and only very slightly extend it into the water. Do this very carefully to each object with a clean brush. It should be delicate and faint. Heavy lines will look unnatural. Here, the important thing is to hint at the division.

Step 14: Traces on the water. Make sure that the paint is dry. Using pure Titanium White and a size 1 round brush, paint in the fine white traces in the water. These are left behind where the water is disturbed by a moving bird, or where it meets with a rock or reed. The white lines are usually very thin initially and then they broaden and fade as they move away out into the water. Carefully soften the extreme edges of the lines using a clean cloth or brush.

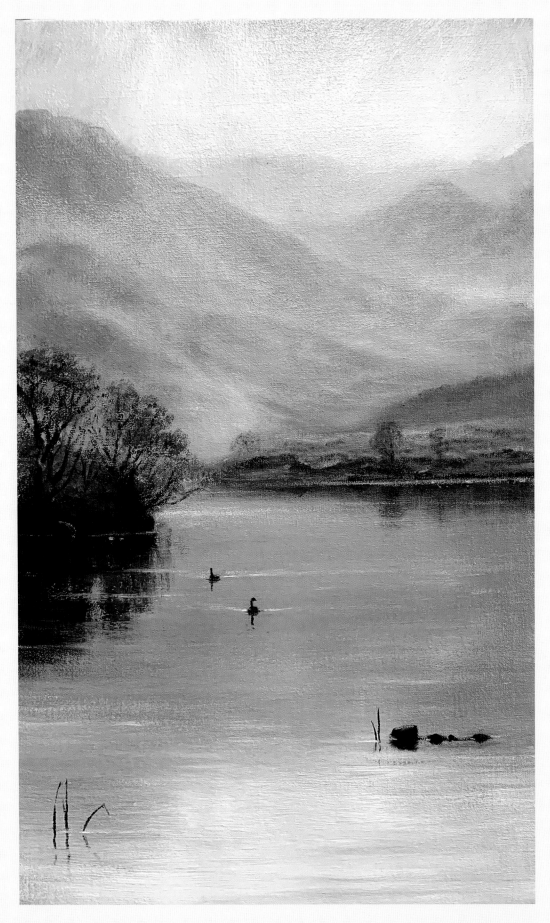

Step 15: Final touches.
Step back from the picture to see where highlights and darker shadows might be needed. You may need a little extra Titanium White in the foreground to accentuate the light catching on the front of the wavelets. Try to remember: if you intensify any strong highlights or shadows on an area, highlight the corresponding area in the reflection.

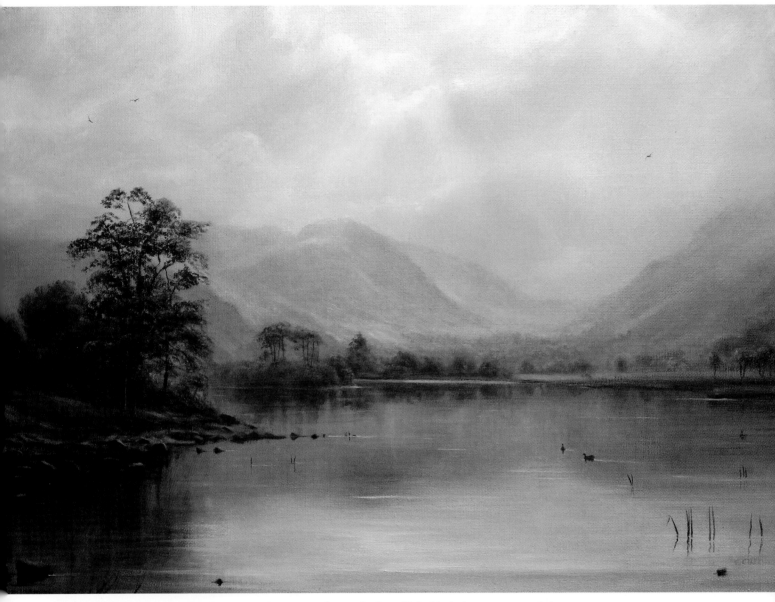

Gentle Grasmere, oil on canvas. Grasmere Lake and Grasmere village in the Central Lake District have strong associations with the Romantic Poets. The lake itself is one of the smaller stretches of water, and the name Grasmere is believed to have originated from the Middle English term, 'Grassy Lake'. Many people who visit this area perceive it as a peaceful sanctuary. The surface of the lake often seems to be calm. The view here is from Red Bank, looking north-north-west. The warm light of Helm Crag and Seat Sandal are reflected in the surface, disturbed only by a tiny breeze. Grasmere Island, beloved by William Wordsworth, is visible in the middle distance on the left of the composition.

Reflections and tranquillity

Reflections which are calm and only slightly distorted are a bonus for any artist trying to create a feeling of tranquillity. In the last chapter – Chapter 7: 'Peace and Refuge in the Mountains' – I referred to Alfred De Breanski Senior. My experience of his work is that he is able to evoke a profound sense of peace, and often he paints the warm light of high mountain slopes reflected in calm lake water. It is really worthwhile searching for mountain painters whom you find personally inspiring. Learning from them is not 'cheating', but instead is an essential part of progress.

RIVERS AND MOVING WATER

A river or stream which winds its way into the distance makes composing a mountain scene much less challenging. This is because it acts on a number of levels: points of light on the river guide the viewer from the foreground to the background; vegetation and rocks along the riverbank provide foreground and mid-ground variation and create convincing perspective; and the inclusion of moving water can add a sense of energy to the atmosphere of the painting.

The path of a river or stream

In the initial stages of sketching a composition, think carefully about the course which the stream or river takes through the landscape. Look for where it stalls, or becomes rapid, and also for where it twists and turns. At some points rough water will reflect light, whereas in other areas shaded by trees or bushes, deep pools will be dark. Look particularly for drops in height or sudden changes of direction. Most streams and rivers will disappear and reappear as they move through trees and vegetation. Try to incorporate these variations in your composition, and avoid stretches of water which form a single straight line and cut the composition in half.

Colours

The colour of the water is often formed by impurities, especially after heavy rain. Look also at the colour of the riverbed and the stones and gravel which may be partially visible, especially in the shallow parts. Much of the colour will be created by hues of the vegetation and sky, reflected by the water and wet rock surfaces.

The riverbank, rocks and vegetation

I always paint the banks and vegetation first. This way, I know what should be happening to the water at each point and where most light will fall. Think carefully about how the stream affects the bank and the vegetation. Has it undercut an area of a grassy bank or has the water deposited stones and shingle on the outer corner of a bend? Often rocks and reeds line the banks, some half out of the water and others just under the surface. Try not to arrange rocks in a regular, even pattern as they are usually found in irregular clusters.

Brushwork

Conveying the flow of water in a stream can be achieved by using the right brushwork for both the water and the surrounding vegetation and rocks. Use smooth strokes for the areas where the river is placid and reflects trees, banks and sky, and more spontaneous loose work to suggest rough water. The contrast between the solid rocks and the moving water is important. Paint the dark rocks with strong edges and planes as opposed to the varied textures of the river. Use thin flicks of Titanium White to suggest the points where water meets rock.

Building layers

I usually build up the tones and hues in the water using layers. Paint in the first thin layer over the entire area of the water using a mid-tone – this is often close to the colour of the sky. Then identify and paint in the mid to darker shades, which are usually close to the colours of reflected trees, banks, bushes and rocks. Next, paint in the lighter areas, where the brighter parts of the sky or banks are reflected. Finally, enrich the darkest areas and pick up the brightest points of light where the water is most disturbed.

Fast-Moving Water

Mosedale Beck, pictured here in a photograph, takes rainwater from the high fells. It is fed by run-offs from some of the most famous peaks in the Lake District: Pillar, Steeple and Red Pike. At this point in its journey down to Wastwater, at Ritson's Force, the beck takes a steep plunge over the basalt rocks. These dark rocks, which line the stream, have been formed from solidified lava and are worn into rounded shapes by the constant passage of water through time. The course of the beck sometimes runs calmly, and then quickly becomes turbulent as it drops and moves along the rapids.

Ritson's Force. I have chosen this section of the main photograph as it provides some excellent practice in tackling fast-moving water. Work as much as you can on a variety of brushstrokes – the building up of tonal layers, the use of Titanium White as highlighter, and the creation of strong contrasts between rock and water. You may decide to use the whole of the main photograph as source, or choose a subject of your own. If you do choose your own, try to follow the main steps set out in the exercise just the same.

YOU WILL NEED

- Quick-drying oils, standard oil paints or acrylic paints (I am using standard oil paints, but with a quick-drying white and Walnut Alkyd Medium):
 - Underpainting White (only needed if you decide to use a plain white surface)
 - Titanium White
 - Ultramarine Blue
 - Prussian Blue
 - Winsor Yellow
 - Naphthol Red
 - Burnt Sienna
- Walnut Alkyd Medium (using this will mean that your standard oil paints will dry much more quickly), or Acrylic Medium (if you are using acrylics or water-based oils, you may need water)
- Palette for mixing
- Medium-size flat brush
- Fan brushes: 2 medium and 2 small (having several of these at hand is always useful)
- 2 or 3 round brushes (1 × small size 2 approx., 2 × medium size 4 to 6)
- Size 4 to 6 filbert brush
- Small round brush for fine detail, size 1 to 2. (Experimenting with different sizes and shapes of brush is particularly important when you first start painting fast-moving water, so I have suggested different varieties here)
- Chalk or soft pastel
- Brush and equipment cleaning materials: paper towels, white spirit for oils, or soap and linseed oil
- Support: I have chosen a small (9in width × 6in height) pre-prepared smooth board, which is already tinted with a colour. This coloured board is available in the UK from Jackson's Art Supplies. If you choose a plain white board or canvas, coat it as usual with a mix of Titanium White, Burnt Sienna and Ultramarine Blue to form a similar light warm base

Step 1: Basic guidelines on coloured base. Sketch in the basic guidelines on the coloured base, using either chalk or pastel. This is only a simple outline, as any careful detail will soon be lost when strong strokes are applied to establish rock faces and moving water. Have a number of fan, round, filbert and flat brushes of different sizes at hand, so you can choose the size you need. If you are painting a larger picture than the one chosen for this exercise, as usual use correspondingly larger brushes than those specified.

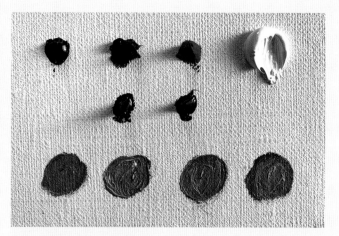

Step 2: Mix some mid-tone greys. Look at the mid-tone greys in the rock surfaces. Mix some greys using Ultramarine Blue, Burnt Sienna, Naphthol Red and Sap Green. Add a little Prussian Blue for a richer tone, but be sparing as it is powerful. Lighten the greys using Titanium White. Choose one or two for the basic mid-tone shades of the rocks, which will be painted in Step 3. This entire exercise could be completed in one go, but it is safer to allow each stage to dry before going on to the next step. If you are using a quick-drying medium or paints, this might mean that you will have to remix the greys, and so it is a good idea to note down the colour mixes.

Step 3: Rocks and vegetation. Using a size 4 to 6 round brush, paint in the areas of rocks and vegetation. Do not try to paint in the exact shape of every single rock. More important is to consider the general shapes of rocks and how this reveals the shape and flow of the water. Overlapping vegetation and strong contrasts will be painted in later in the process. The course of the water through the rocks should be as clear as possible. Look carefully at the shapes of the rocks. In this case they are mainly rounded in shape, having been worn down by the rise and fall of the flow.

Step 4: Defining the rocks, light and shade. Use a size 4 to 6 round or filbert brush (or a smaller brush if you find this more accurate). Mix two or three darker greys, using the same mixes chosen in Step 2, adding less Titanium White. Use these shades to paint in the darker areas of the rock faces. Try to build up the three-dimensional shapes of the rocks, and think carefully about the light source. Have a look at which areas of the water and rocks are catching the light. The brightest lights and deepest shades should be added later, closer to the end of the exercise. Do not try to paint perfect edges, especially around the edges of the water, at this point. Defining the edges is best done after most of the water area has been painted.

Step 5: Painting the water base. Mix a light mid-tone, as a base for the water. Here the mid-tones are reflecting both the sky and the grey/brown/green tone of the rocks and vegetation, and this basic layer will establish a tone on which to develop these. Paint in the area of the water using a medium round brush for the edges, and a medium fan or flat brush for the centre. Do not worry if there is an overlap onto the rocks or vegetation. Sometimes this can be a lucky mistake which looks like water flowing over the rock. It is possible to redefine these edges at a later point if necessary. Look at the entire movement of the water and make the brush strokes match the flow as much as possible.

Step 6: Shadows in the water. Mix greys as in Step 2, but add much less Titanium White to make darker tones. Using both a size 4 to 6 round brush and a fan brush for blending, paint in the darker areas of the water. Include any dark areas where the rocks are just visible underneath the surface. Try to pull the paintbrush in the direction of the water flow, using a smaller brush if necessary. Do not be afraid to experiment with the brushwork. Try a twisting movement with a fan brush and flicking motions with a round or filbert brush. Use a medium fan brush to blend any areas which appear to have unnatural boundaries. Be adventurous and use varied strokes with both the brushes, but make sure that overall they follow the flow.

Step 7: Colours in the water. Identify and paint in more saturated areas of colour in the water. Mix these shades using Sap Green, Ultramarine Blue and Titanium White, with a little amount of Prussian Blue. Mixing in a little Naphthol Red will tone down the green colour, and more Prussian Blue will create a strong aqua hue. Look for areas where the rocks underneath are visible. Paint in one or two of the light brown rocks that are catching the light under the water, but avoid strongly defining these. Some areas of water are more colour-saturated than other areas; be careful not to oversaturate the entire area. Try to paint this stage quite quickly, using a varied brushwork style as in Step 6 to mimic the flow of water – for instance, long flowing strokes or short stabbing motions.

Step 8: Light areas on the water. The lighter areas of the water can be mixed using mostly Titanium White with a limited range of other colours, but save really bright whites for the lightest highlights. Add a little Ultramarine Blue, Sap Green or Prussian Blue to produce two or three different light shades. Light areas of water are very rarely one colour only. Paint in these areas, again noting the direction of flow and level of disturbance, using a size 2 to 4 round brush and a small fan. Do not try to paint in large blocks of light, as this will appear static. Instead, use spontaneous, quick brush strokes to create the fractured light on the surface of the water.

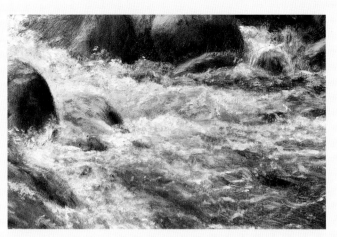

Step 9: Finishing the rocks. Have a careful look at the rocks to locate the highlights, and also the darker well-defined areas. Using a small round brush, define any dark edges that should be clearly marked. Emphasize the light areas, which are noticeable mainly on the edges of the rocks. Use similar tones to those you mixed in Step 3, lightened with white – but keep in mind, lights on wet rocks are rarely as strong as the lights on the water. Too much light on the rocks will detract from the water.

Step 10: The brightest whites on the water. Use either pure Titanium White, or Titanium White tinted with a tiny amount of Lemon Yellow, to pick out the brightest lights on the rushing water. Using a small size 2 round brush, make small flicking or stabbing motions in the roughest areas of the water. As in previous steps, try to follow the flow of the water and to mimic its behaviour with the paint strokes. Thicker paint will help to emphasize the brightest lights on the water. Do this sparingly, and look carefully to make sure that these are the areas which catch the most light.

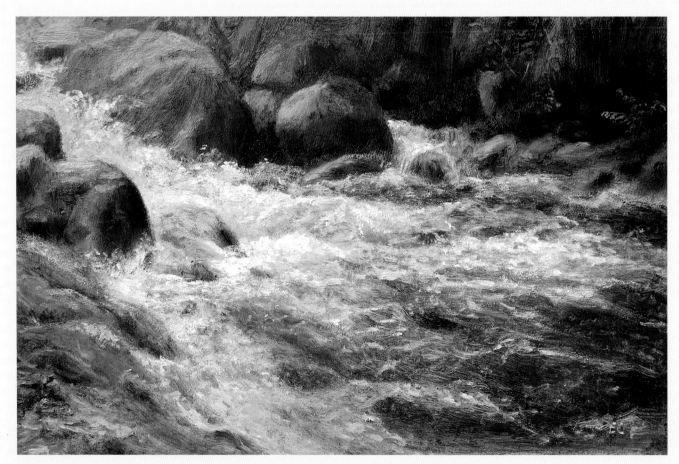

Step 11: Final contrasts. Stand back from the exercise and consider whether or not you are happy with the final balance of the darkest and lightest tones. Beware, as always, of the danger of over-working at this stage. If you are satisfied, leave well alone. If not, use thin glazes of Ultramarine Blue and Burnt Sienna to darken any areas, and very limited touches of Titanium White to emphasize lights. Standing back is not, of course, reserved only for the end of the process; it is helpful at each stage to reappraise the balance of hues and tones in the composition.

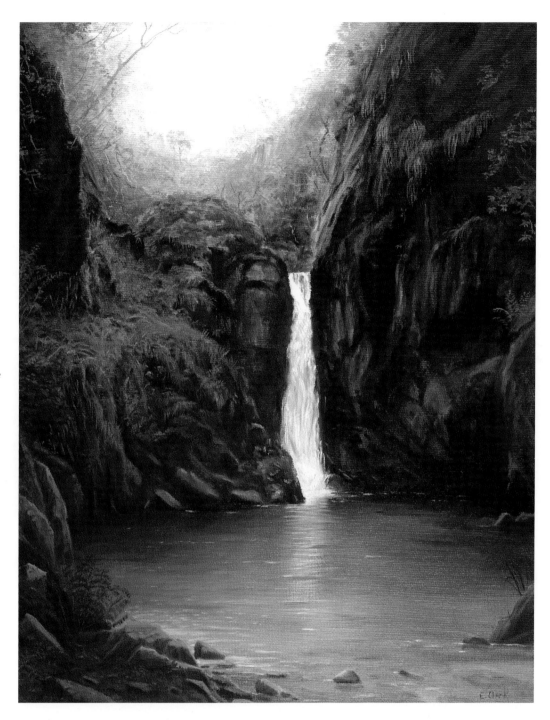

Dalegarth Falls (Stanley Ghyll Force), oil on canvas. Stanley Ghyll Force, pictured here, is sixty feet high and very impressive. It sits in a deep, narrow, wooded gorge. Access is by a precipitous path, which must be negotiated with extreme care. Ferns, bilberry plants, moss, and surprisingly some rhododendrons cling to the sides of the ravine. Notice the contrast between the dark rocks and the bright water. Some of the granite shows through in the dark areas of the waterfall, and this helps to emphasize the strong flow from the top to the bottom of this single drop. The brightest areas are picked out with Titanium White near the top of the Force, where the water changes direction, having squeezed through the gap. The sharpness at the top of the Force gives way to softer areas at the base, where the water falls into a deep bowl. At this point a light mist reduces the definition.

WATERFALLS

Rivers and streams have 'mini waterfalls'; painting these is good preparation for painting more substantial falls, as the same general rules apply. The contrast between the stongly defined, dark shapes of rocks and the flowing water is often even more marked in a larger fall. Carefully trace the entire flow of the water. If the direction of the flow changes, it is likely that the colour and tone will also change. This is particularly important when tackling more complex falls. Do not forget that areas in the shadows cast by rocks and trees will no longer be white, even though they may appear so. This is because there is a strong contrast with the rocks and the bright water, and in bright sunlight the variations are difficult to see. Also, our expectations are that these areas will be white. Pure white should be reserved only for the areas catching most sunlight.

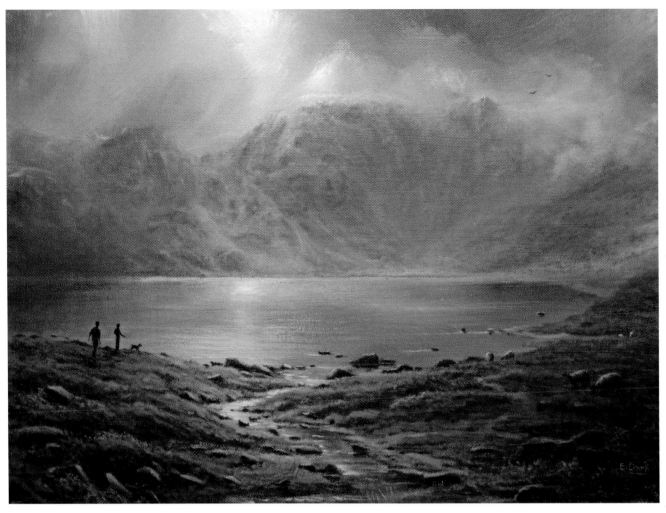

Snowmelt, Helvellyn, oil on canvas. Red Tarn, which sits at 2,356 feet, high on the eastern flank of Helvellyn, was formed when it was scooped out by a melting glacier. Looking up from the tarn, the well-known profiles of Catseye Cam, Striding Edge and Helvellyn rise up from behind the little lake. Often snow on these high peaks remains when all the snow on the lower slopes has gone. When the sun breaks through the cloud that gathers around the tops, the reflected highlights on the snowy ridges are strong.

SNOW AND ICE: MOUNTAINS IN WINTER

Depending on the mountains you choose to paint, there may be either constant snow or perhaps a covering in the winter. In the English Lake District, the snow arrives on the tops as a sprinkling usually in October, builds up to occasionally several inches deep even in the valleys, and usually melts away by April from the mountain tops.

The procedure for painting snow-covered mountains closely follows the same steps that we have already covered in this book: laying down shapes in mid-tones; defining the light areas; deepening the shadows; and finally glazing the deepest shadows and lifting the lightest highlights. There are, however, some important factors to consider when dealing with a snow-covered mountain range. Snow is, after all, a form of water and therefore it is a reflector. Look for colours reflected in the snow such as a cool blue/purple with warm highlights. Even amongst the shadows, you will find that snow can reflect light from either the sky or nearby objects or vegetation. Vivid, sometimes light blue or violet shadows are sometimes apparent in the morning and evening, and the darker shadows appear in the brightest sunshine at midday.

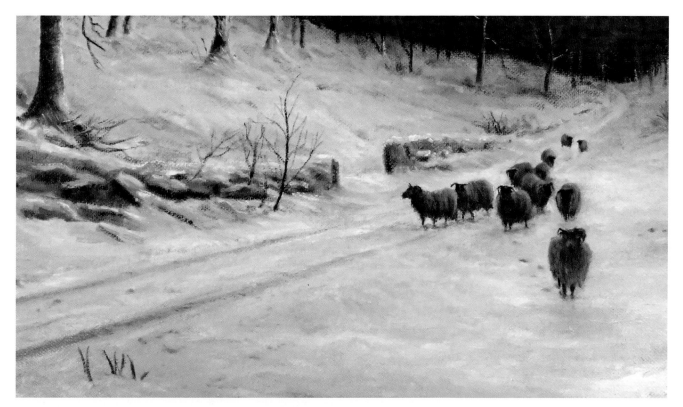

The Woods are Lovely, Dark and Deep, Coniston Woods, detail. When the sun is low in the sky, the snow reflects the warm colours of the setting sun. The shadows are not as dark as they would be in the midday sun, and in these conditions they often have a purple hue. Look at the shadows of the sheep, which are a blue tone, whereas the tracks made by the sheep are deeper and darker and browner in colour. Look out for instances like this where the earth colours show through in places.

Because snow is a reflector, what is going on in the sky is even more important than if there were no snow cover. Planes of snow, formed on rock faces or plateaux, will often reflect the colours of the sky. You will probably also notice that the tonal range (that is, the range from the deepest blacks to the whitest whites) will be less in overcast conditions. A snow-covered peak will have softer features on a cloudy day, whereas bright days, of course, produce sharper contrasts.

Snow Palette

Choosing the colour palette for a mountain snowscape depends very much on the hues in the sky. I often use the shades already on my palette, which were mixed for the sky, to block in the main areas of snow before developing shadows and highlights. Similarly, in the initial stages of the painting, the coloured ground should be chosen to harmonize with the hues that dominate the sky and snow. A warm shade, based on white and Burnt Sienna, is an effective ground when painting a warm sunset reflecting on snow, whereas a toned-down, cooler colour is more suitable for a blue (or colourless) overcast sky.

Look also for the rich, dark tones of features projecting above the snow, such as tree trunks, bare branches, rocks and reeds. These are particularly important, as they contrast strongly with the often subtle, light colours of the snow and sky. Even the shadowy, darker areas of the snow will not be as dark and rich as these tones. Resist the temptation to use a simple black hue to paint these features. Instead, study them and mix deep, dark chromatic greys to add richness to the scene.

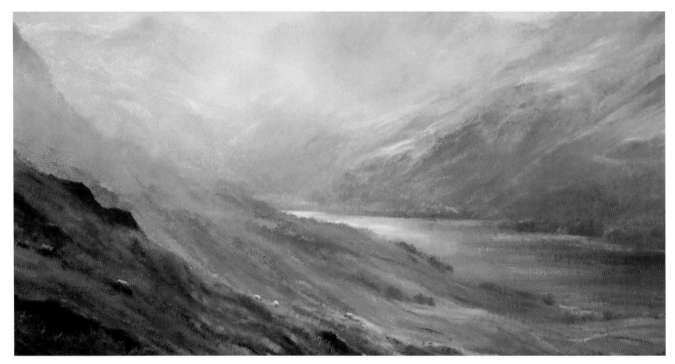

Frostlight, Buttermere, detail. The brown and green hues of the lower slopes of the Buttermere Valley change in cold conditions. Because the sun is low in this painting, the warm, orange tones of sunset are reflected in the cold mist and some brighter areas of the slopes. The colour of the greater part of the shadowed area tends largely towards the blue/purple end of the spectrum. In the initial stages of a composition, try to work out which areas have been warmed by the sun. In some valleys, surrounded by high mountains, there are areas which will never be warmed by sunlight at all during a winter day. Compare the rich green hue of the lower slope in the foreground, which is catching the sunlight, with the mountain range behind.

Warm tones versus cool tones

In frosty or snowy conditions, look for big variations in hue. In the valleys, which are usually milder, the colours will be warmer and usually a mixture of greens, yellows and browns. Higher up, the icy and snow-covered ridges reflect the light from the sky. This means cool highlights in bright midday sun, and warm highlights in the late afternoon to evening and in the early morning. Dark crags, which are in shadow, often range from deep navy to light purple in colour.

Make sketches and take photographs of lakes, tarns, streams and wetlands as often as you can. Beware though, because water is often a moving medium, photoreal-ism is unlikely to be an effective style for catching its

essence – instead, brushwork and control of tone and hue are key skills. If you can, observe how water behaves in as many different conditions as possible. This will help you to capture reflections, and in moving water importantly to recreate the way it flows. Try to develop brushwork which suits the kind of water you are trying to evoke; sometimes this will be visible stabs of paint or smooth blended strokes, and sometimes both of these.

Learning to paint water is something which can be at times frustrating and requires some persistence, but rewards for the mountain painter are many – not least the added bonus of sitting beside a fresh, fast-flowing stream in a mountain gully, or by the shimmering mountain reflection on a clear, cool lake.

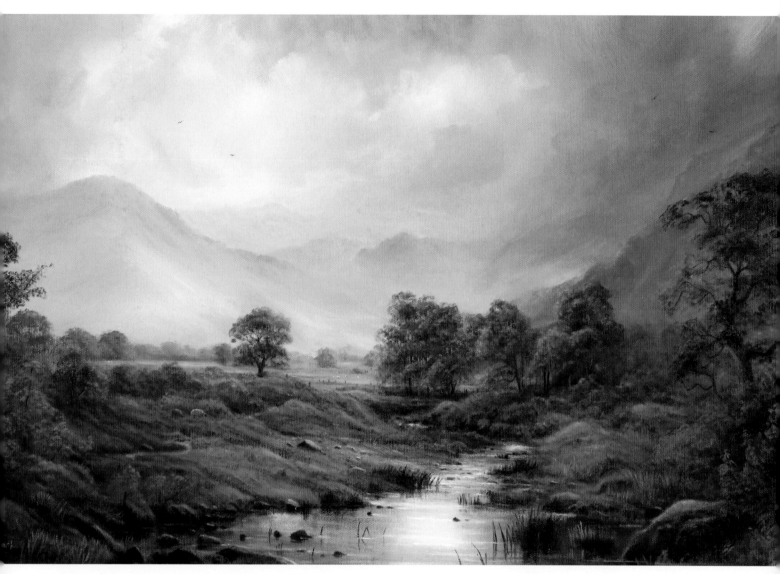

Song of the Beck, Buttermere, oil on canvas. The water in this beck comes down off Haystacks and a high mountain tarn into Buttermere. It travels along the valley in this stream (which is itself fed by various smaller tributaries) and then on into the next lake. A water course that winds its way along the valley, as this one does, creates a powerful sense of distance, even though we can only see its progress into the mid-ground. This stream empties, not far from this point, into Crummock Water, and is typical of so many similar small 'becks' to be found all over the Lake District. Their banks, and even the courses they take, are sometimes changed quite radically after a storm. The amount of water in them varies enormously. The usual, gentle flow of summer changes in the autumn and winter months, when the becks take the full force of the rains, as the water gushes down from the fells in a myriad of tiny rivulets.

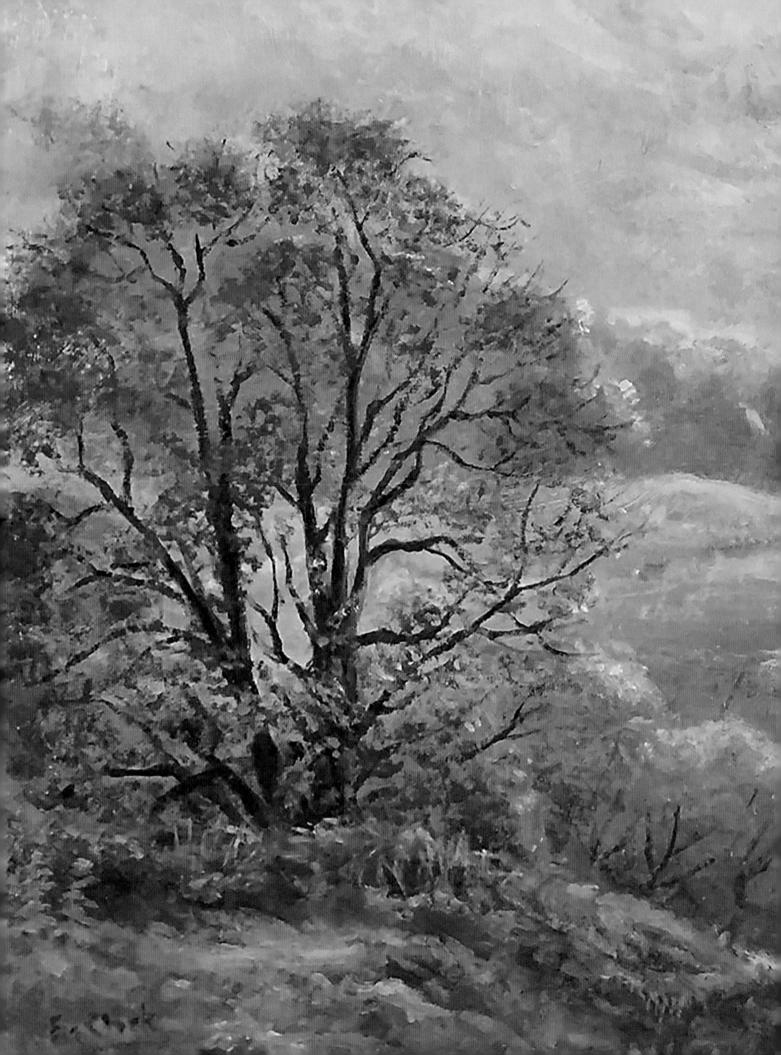

Trees, and Some Special Magic

*There is always something to make you wonder
in the shape of a tree, the trembling of a leaf.*

ALBERT SCHWEITZER

Most mountain landscapes play host to some kind of trees. Their presence often tells us a great deal about the history, weather and geology of the area and so, included in a painting, they can become storytellers.

Look out for the tell-tale signs. Sometimes trees and vegetation are bent over in the strength of the prevailing winds. Some areas of trees, particularly densely planted conifers, are part of a long-term man-made plan, and others are randomly scattered areas of mixed woodland. Single, ancient trees, for example yews, oaks and beech, stand alone or stand well apart on shorelines or by farmhouses – majestic lone survivors from what were previously extensive forests. Some were planted by landowners as part of huge estates. Farming and grazing animals over the years, of course, affect the growth of trees and the patterns of woods. Trees also speak of the climate of a place. Some trees, such as willow and alder, will happily tolerate regularly sodden ground, whereas ash, hazel and rowan hang on in drier habitats.

When painting the sides of the mountains, try to spot the 'treeline'. This is the point at which the temperature, humidity, the extremes of wind and the poverty of the soil mean most of the trees cannot survive. Conifers, which are usually hardier, often indicate the point of the treeline, and for this reason artists frequently see the jagged edges of their tops edging up the shoulders of the peaks. Interestingly, the treeline on north-facing slopes is lower

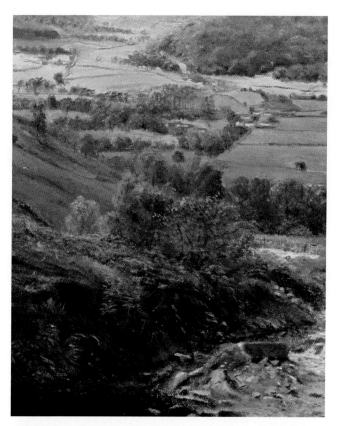

Green Pastures, Borrowdale, oil painting, detail. The shrubs and trees in this detail are those that frequently grow above the treeline in the depleted soil. They are low-growing and survive in cracks in the rocks and run-offs, in small clumps. It is worth exploring areas that include groups or single examples of these small hardy trees, and it is often only a matter of adjusting the viewpoint by a few yards – one way or another – in order to make them part of the composition.

◀ *Sacred Tree, the Langdales*, detail, oil on board.

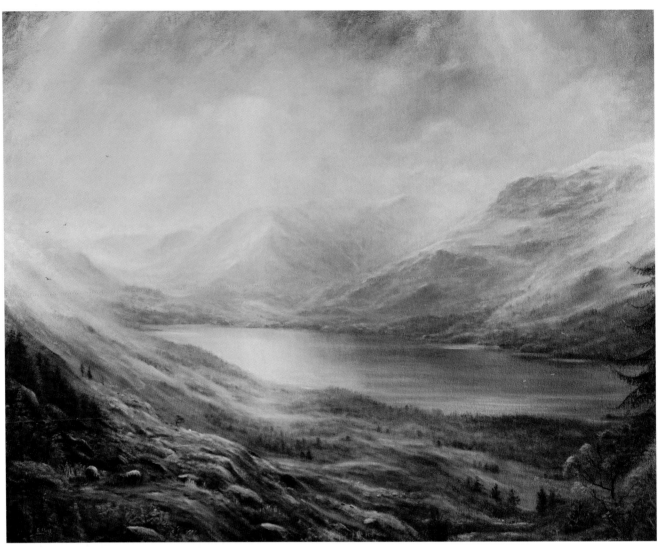

Above the Treeline, the Way to Helvellyn, oil painting. Looking down on Thirlmere, south-south-west from a high vantage point on the way to Helvellyn, the treeline is easy to spot. The thick plantations that line the sides of the reservoir thin out at about 1,300ft and give way to a few clumps of trees and the small shrubs that inhabit the steep slopes above. Thirlmere was not always a single lake. In the nineteenth century, the valley was flooded to form a reservoir, and a dam was built at the northern end. Now, it is often hard to tell that this lake was artificially produced, and these days replanting is mixed coniferous and deciduous woodland. When painting from a high viewpoint like this one, try to locate the point at which the dense plantations peter out. Because it is at a fairly consistent height, the treeline provides clues to the viewer about the extent and height of the mountains. This helps to evoke the experience, familiar to climbers, of looking down from a high remote viewpoint onto a valley or lake laid out below. With thanks to my nephew for the photographic inspiration.

than south-facing slopes, due to the increased shade and shorter growing season.

Some of the smaller trees like juniper and hawthorn can survive in crevices where there is only a little soil. Finding a viewpoint that includes clumps or single examples of small hardy trees or shrubs growing above the treeline provides foreground and mid-ground texture to areas that might be predominantly heather, rocks and ferns.

LIGHT THROUGH TREES

The direction of light, and how it falls on the canopy of the trees in a mountain landscape, can be difficult to portray. (It is worth taking some time observing and practising techniques wherever possible.) The leafy areas of trees are not solid structures that always reflect the light in one direction, but instead they consist of many divided, reflective

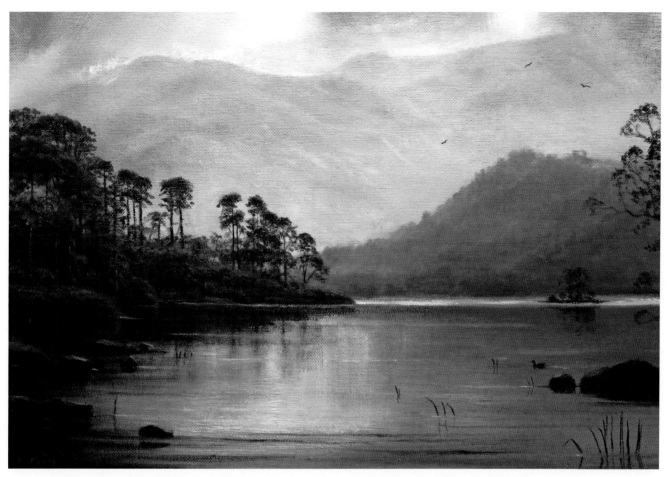

In the Warm Light, Ullswater, oil painting on canvas. When trees sit on a promontory, as these pines do, they provide a strong contrast to the mountain backdrop, especially if warm sunlight is coming from behind them. Some of the trees allow light through and this produces a warm glow, while others remain dark and largely in silhouette.

planes. Sometimes the light bounces off the tops of the trees and the rest of the canopy remains dark; at other times the light diffuses through the leaves, especially as they become thinner towards the autumn. The thicker foliage of some trees blocks the light completely, while other leaves are semi-transparent. Sunlight passing through them often produces a warm glow, which adds richness to the painting.

Compare the two paintings, *In the Warm Light, Ullswater* (above) and *Land of Trees and Water, Derwentwater* (overleaf). Both rely on the contrasts and colours in the trees, which transform from foreground to background to create a strong sense of recession. The reflections of the trees and the mountains in both paintings play an important part in the composition. The colours used are, of course, quite different in each painting. One is based around a warm palette, whereas the other is based around rich blue and green tones.

Including large trees of the valley, which stand singly or in small groups, can be compositionally highly effective. They create a strong sense of perspective and emphasize the height of the mountains behind. This is because they are a known quantity – most people have an idea of the size of an ancient oak or yew. Such trees are often, of course, worthy of being the main subject of a painting. If, however, the central topic of the painting is the mountain scenery, it is usually wise to avoid placing them in a central position or really close to the viewer. As the character of a single tree will undoubtedly have a strong effect on the atmosphere of the painting, choose the tree carefully. The shape is especially important. If the tree is heavily lop-sided or an unusual shape, it will cause imbalance or immediately draw the eye perhaps more than is desirable. Remember, too, that bright foliage and blossom will attract a lot of attention and easily become the focus of the composition.

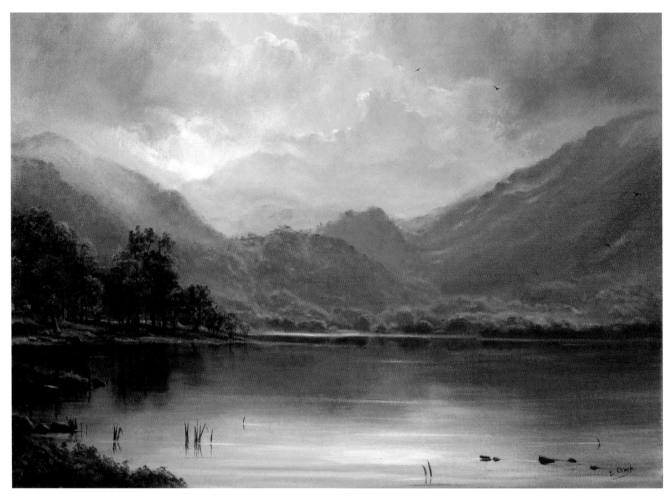

Land of Trees and Water, Derwentwater, oil painting on canvas. You may recognize this mountain range from the step-by-step exercise in Chapter 6, 'Storm in the Mountains'. Here, the mood is one of tranquillity. This view of Castle Crag and the Jaws of Borrowdale is from the eastern shore, rather than the western shore as seen in Chapter 6. The lower slopes of the fells that flank the lake are among the most heavily wooded in the Lake District, with many thick deciduous woods and some ancient oaks which have been there for centuries. Using a variety of saturated green and blue tones helps to evoke the rich colours of the lush mountain woodland.

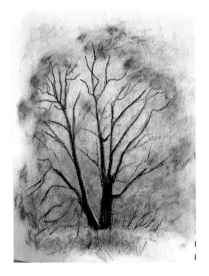

Tree sketch: an alder. If you intend to include a tree in the foreground, or near mid-ground, it is worth trying a couple of quick sketches first. A sketch like this one, in preparation for the following step-by-step demonstration, should take about ten minutes only. Concentrate, not on a perfect finished drawing, but instead on getting to know the basic growth habit of the tree. Look at the shape of the branches and the trunk, and at the way the branches connect to the main trunk. Quickly sketch the basic repeated patterns formed by twigs and foliage, which are often intermingled.

STEP-BY-STEP DEMONSTRATION
Trees in the Mountains

This demonstration is in two parts: Part 1 involves building up the background and mid-ground woods, which in this case are made up of mixed deciduous and evergreen trees. Part 2 involves the inclusion of one large alder tree in the foreground. You may decide to use the photograph of the woods on which the exercise is based, or your own source material. If you choose your own material, try to choose a scene in which there is a substantial single tree with mixed woods, receding and fading into the distance.

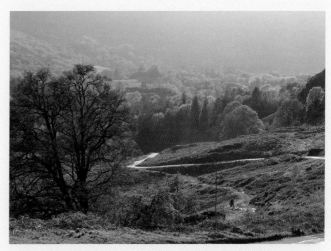

Photograph of woods, Elterwater, Great Langdale Valley. The lower slopes of the Great Langdale Valley in the Central Lake District are at this point heavily wooded, with mixed deciduous and evergreen trees. This view looks from one side of the Elterwater Valley south-west towards High Oxen Fell.

YOU WILL NEED

- Quick-drying oils, standard oil paints or acrylic paints depending on your preference (I am using Holbein Duo Aqua oil paints with fast-drying medium):
 - Titanium White
 - Ultramarine Blue
 - Sap Green
 - Burnt Sienna
 - Lemon Yellow
 - Naphthol Red
- Walnut Alkyd Medium (using this will mean that your standard oil paints will dry much more quickly)
- Palette for mixing
- Medium flat brush
- Fan brushes: 2 medium (as always, having several of these clean and ready to use is very helpful)
- Round brushes: 2 × size 2 to 4, and 2 × size 2 to 6 (it is useful to have a selection of these for this exercise); small round brush for fine detail, size 0 to 1
- Filbert brush: 1 medium size, approx. 4 to 6 (this is not essential, but you may find it useful for painting the trunk and branches in Part 2)
- 2B pencil

- Brush and equipment cleaning materials: paper towels, white spirit for oils, or soap and linseed oil
- Support: I used a Jackson's white gesso panel, 11 × 14in, painting directly onto the white pre-prepared layer without a coloured ground. This board has an acid-free acrylic gesso ground with added Titanium White. Choose a board roughly this size or bigger, with a light texture and fine-tooth surface

Note: You do not have to use Ultramarine Blue or Sap Green for this exercise. These two colours are nearly always my choice when painting the Lake District; however, you may want to try using a different blue such as Prussian Blue or a brighter green. If you do decide to experiment, try to use the same green and blue throughout the exercise. Mixing lots of different blues and greens can become difficult to manage, and they may clash with one another. Also, if you decide to scale up and paint a larger picture, remember to scale up the brushes accordingly.

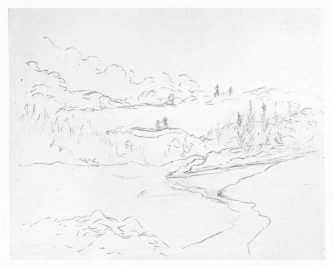

Step 1: Pencil guidelines. Using a soft 2B pencil, draw in a very rough outline of the main areas of the composition. Keep this light, as the pencil will colour the oils. This outline should not be detailed and should suggest the simple shapes of the woods only. The foreground tree should not be sketched in at this point.

Step 2: Background mountainside. Mix a light, cool blue tone using Titanium White, Ultramarine Blue and a tiny amount of Naphthol Red to create the slightly purple hue of a distant, wooded mountain slope. Using a medium flat brush or a fan brush, paint in the far fellside. This should not be entirely uniform, but should vary slightly in tone.

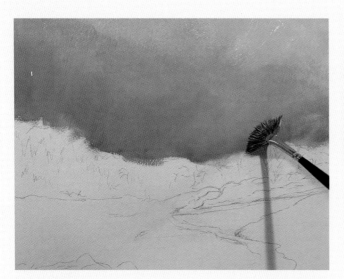

Step 3: Creating a far mid-ground base. Add a little more Ultramarine Blue, and very small amounts of Sap Green and Burnt Sienna to the paint mix – with the usual proviso that woodland colours become progressively greener and warmer as they move from the background to the foreground. Use a medium fan brush to create a little variation in texture and tone. This step involves creating a base on which to build shapes later. Do not try to define shapes or strong colours at this point.

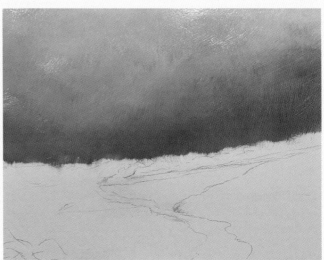

Step 4: Moving nearer. Mix a deeper shade of the colours you used for Step 3. Darken the shades by adding more Sap Green and Burnt Sienna. Again, the aim here is to build a base. Paint in this darker, richer band to mark out the mainly darker coniferous woods in the mid-ground. Use a fan brush or a flat brush to create mainly vertical strokes to build up this area.

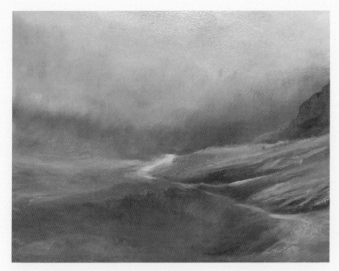

Step 5: Nearby moorland. Use a medium size 6 round brush to paint in the basic tones and colours of the mid-ground to foreground moorland. Mix Sap Green with Burnt Sienna and Titanium White with a little Ultramarine Blue. The open heathland here is a mixture of green and red/brown hues. Save any really pure rich greens for close foreground vegetation and trees. Allow the paint to dry.

Step 6: Suggesting distant woods. Having established a colour base, the next few steps involve using a mixture of tones to suggest the pattern of light and shade as sunlight lands on the woods' outer leaves and branches. The aim is to create the illusion of a wood at a distance. Most individual trees would not be discernible. Mix a few light shades by tinting Titanium White with Burnt Sienna, Sap Green and Ultramarine Blue. Dab in light areas using a size 4 to 6 round brush. Create irregularity by allowing them to overlap in some areas.

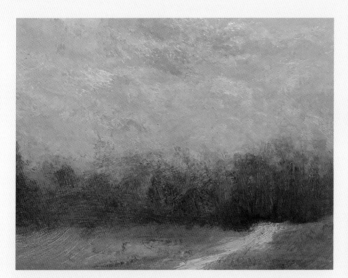

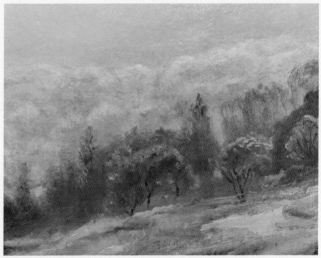

Step 7: Mid-ground coniferous woods. Use a size 4 round brush, or smaller, to paint in the basic shapes of the evergreen trees in the mid-ground. Again, do not try to paint every tree, but instead create the impression of these trees with stronger downward strokes using a darker shade. A rich mixture of Sap Green, Ultramarine Blue and a little Burnt Sienna will create the dark hues of conifers. Add a little white to tone the colour down because the trees are some distance away. Suggest the presence of one or two deciduous trees amongst the conifers by introducing some rounder shapes.

Step 8: Creating definition in the woods. To create more definition in the background and mid-ground woods, use a fine size 2 round brush and suggest a few sharp details at the tops of the coniferous trees. Use a similar fine brush to pick out the highlights on the small mid-ground alder trees. Try to contrast these highlights quite strongly with any dark background, to give the appearance of the sun catching on the outer branches. Do not overdo these details, as only a few are needed to give the impression that these are trees.

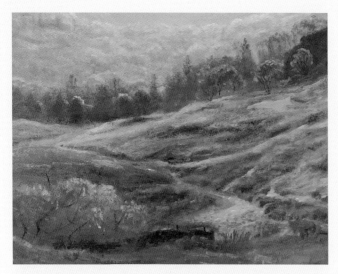

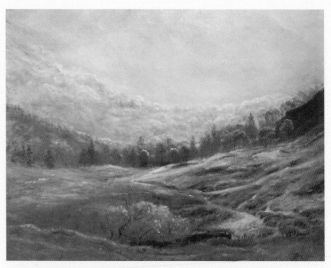

Step 9: Defining the nearby open moorland. This nearby area of moorland should be richer in hue and tone than the background wooded hillsides, as usual, because it is much closer. This kind of open heathland is usually irregularly covered in patterns of light and shade caused by the vegetation and rock formations. Mix a variety of light shades for highlights by tinting Titanium White with Sap Green, Burnt Sienna, Lemon Yellow and Ultramarine Blue. The darker, strong shadows often have a blue tone. A size 4 brush is suitable for most of these details.

Step 10: Emphasizing lights and shades. Allow the paint to dry. Look at the whole composition at this point. Strengthen any areas of contrasts that you feel lack impact. When you become familiar with painting mountain woodland, in fact any mountain scenery, you may find that you are able to work across the whole canvas, balancing the highlights and shadows, and adjusting hue and contrast as you go. Building up layers of paint, so that each area has a strong base is, of course, essential. At the end of this stage, and at the end of Part 2 of this exercise, stand back from the composition and as usual carefully use glazes to darken shadowy areas, and tinted Titanium White to emphasize highlights where necessary. Allow the paint to dry.

Part 2

The tree in the foreground of this exercise is an alder, as are other less mature trees featured in the photograph growing at about the same height. These trees, which are very hardy, will survive in conditions that many others cannot. They have some wonderful environmentally friendly qualities, including nitrogen-fixing, which leaves the soil in a better state than it was before the tree arrived. There are many alders in the Lake District, here growing in the boggy land where water runs off the crags onto the lower slopes. The bark of the tree is a dark grey, often covered in green lichen. Many have two or three main trunks, lots of branches that support thin twigs, and small but abundant leaves.

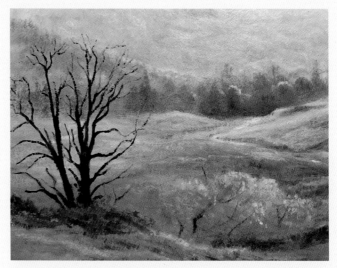

Step 1: Main trunk and branches. Mix a dark grey hue using Burnt Sienna, Ultramarine Blue and Sap Green. Using a size 4 to 6 round brush or a filbert, paint in the basic shape of the main tree trunks. I often find it helpful to pinch the brush between my fingers to form a wedge shape. Alternatively, try using a wedge-shaped brush like a filbert, which you may prefer. This tree has two main trunks. Take notice of the angle at which the branches join the main trunks. Do not attempt to paint all the tiny twigs at the ends of the branches – they will disappear anyway when you paint the leaves. Make sure that you pay attention to the ground around the tree. Here, it nestles in a bed of ferns and a number of alder shoots at the base of the trunk.

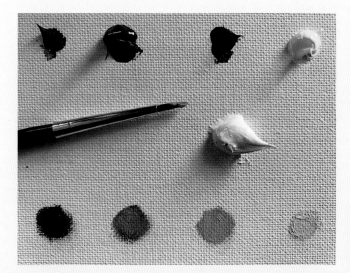

Step 2: Mixing the greens. Mix a range of greens ready to paint the canopy. Try to create a number of shades from a dark shade with a blue tinge to light green with a warmer tint. Use Sap Green and Titanium White as the base and add Ultramarine Blue, Burnt Sienna and yellow to create these hues.

Step 3: Shaded areas of foliage. Look carefully at the light patterns on the foliage of the tree. Using a fine, round brush, size 2 to 4, paint in the darker, leafy areas. Load the brush with a small amount of paint, and dab it on rather than brushing. The leaves on this tree form a delicate pattern. To recreate the delicate tracery, use small strokes. Do not try to paint each individual leaf, but also avoid dragging the brush across the canvas, as large dark blocky areas will look out of place.

Step 4: Mid-tone foliage. Using a mid-tone green, paint in the areas that are not in full shade but not highlighted either. A fine brush size 2 to 4 is about right for these steps. If you have decided to paint on a larger canvas, use a correspondingly larger brush. Create a mottled, delicate texture again by using small dabbing motions, as in Step 3.

Step 5: Brightest foliage. Use a small brush, size 1, to dab on the brightest highlights of the leafy areas that are catching the sunlight. In this case the sun is shining from the upper right of the composition, catching the outermost cluster of leaves on the tops and on the right-hand sides of the trees. Most of the trees here are backlit. Do this very sparingly. Painting in too many light areas will reduce the visual impact.

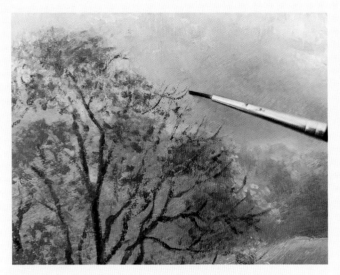

Step 6: Fine twiglets. Look for areas of foliage that appear to be disjointed from the tree. Use a small fine brush to paint in thin lines, hinting at the tracery of twigs. Also paint in some very fine strokes on the outer edges of the foliage, to suggest an overall structure of twigs underneath the leaves. Again, do this sparingly. It is enough to suggest these structures. The viewer's imagination will fill them in.

Step 7: Backlit trunk and branches. In some cases the majority of the trunk of the tree will be lit, so it would be necessary to model the texture and the light falling on the bark. Here the trunk is almost entirely in shadow. Pick out the highlights on the trunk using Titanium White tinted with Burnt Sienna, and a little Sap Green. Restrict these highlights to only two or three areas of the trunk and branches. If all the branches and trunks are highlighted on the sides, this will look unnatural and confusing to the eye.

Step 8: The near foreground. This is the area closest to the viewer; therefore, as is so often the case, stronger contrasts are needed. Use the same colour mixes you used for the mid-ground moorland, but more saturated. Highlights should be brighter and shadows deeper. Add some details such as stalks of grass or ferns. Any details included in the foreground will add to the impression that the background textures are made up of these structures. For instance, a fern in the foreground will suggest that much of the mid-ground is made up of bracken (*see* Chapter 3, 'A Studio Piece', for an example of this).

Step 9: Finishing touches. When completing any artwork there is always the danger of over-working and so, if you are satisfied with the composition, stop while you are ahead. Looking at the balance of this composition, I decided that the large light area on the right invited some simple bird shapes in the distance. I also decided to include a couple of small backlit sheep in the mid-ground. Sheep are ubiquitous to this area and blend easily into the landscape. If you do decide to add details, be careful not to overcrowd your painting.

Not every mountain scene will include trees, some areas being totally inhospitable. In some cases, it is not appropriate to include them as they may distract from a particularly dramatic craggy shape or high summit. Where they do occur, however, standing alone or in small groups or woods, they do provide a valuable, extra dimension to the mountain landscape. Often, their extraordinarily beautiful forms match the changing shapes of the shoulders and ravines, creating intense areas of colour, light and shade. They change with the seasons, transforming lush green slopes to golden hues. Large ancient trees stand like sentinels at the entrances of valleys, over streams and by old cottages, providing a sense of continuity and permanence. Trees in many forms are the living inhabitants of the landscape, who help to tell the story of the mountains. Do not underestimate their power to transform a relatively ordinary scene into something rich and special.

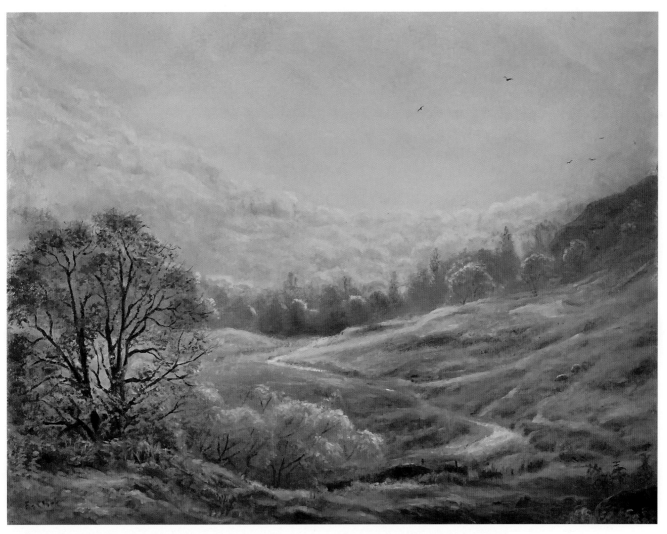

Sacred Tree, The Langdales. These wonderful, hardy alders are found on mountain slopes throughout the Lake District. Some stand alone and grow quite large, others grow in small alder woods or 'carrs' in swampy ground. Particularly loved because they fortify the soil, they also have a special place in tree mythology, and it is believed that these lovely, leafy trees were considered sacred to the Druids and the Picts.

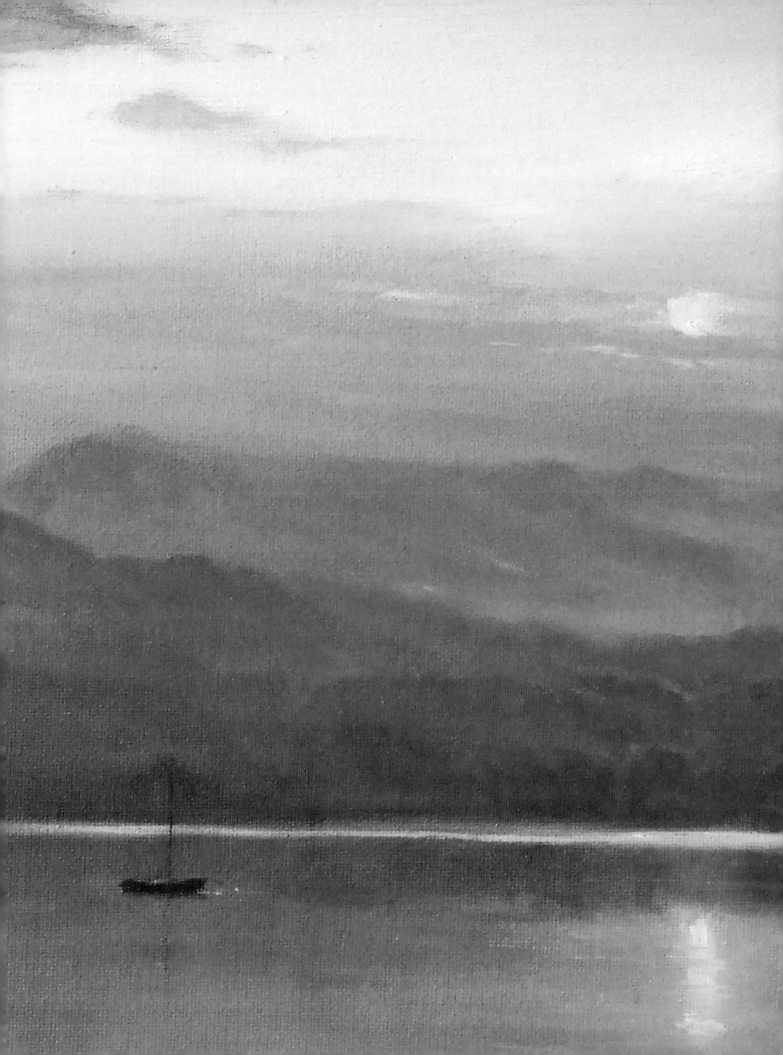

The Burnt Sienna Palette: Sunsets and the Close of Day

Clouds come floating into my life,
no longer to carry rain or usher storm,
but to add colour to my sunset sky.

RABINDRANATH TAGORE

There can be few more beautiful and enchant-ing sights than the moment when a fiery, red sun sets over a mountain range. Sunsets are certainly an inviting prospect for the mountain painter. Beware, though, of the myth of the 'easy sunset', which suggests that a successful sunset painting is attainable by using dark shapes against a brilliant red and yellow sky. Sunsets are so much more complex, subtle and interesting than this.

The colours of the mountains, sky and clouds vary according to many different atmospheric conditions. To complicate matters, they also change radically moment by moment as the sun's light rays are revealed or suddenly lost. Sketching and photographing these rapid trans-formations is difficult. Most mountain painters are not professional photographers – who themselves struggle at times to record the nuanced light of sunsets. If sketching and painting a sunset en plein air, this has to be very quickly done indeed, and it is important to premix some basic paint colours beforehand. You can then refine them on the spot, concentrating on the specific areas of light colour and dark shadows. Details can be developed later, but the subtle colours will be hard to recreate in the studio.

A restricted palette can be particularly effective when trying to capture a sunset in which nearly all cool and green colours are subdued (or missing altogether), and the scene is bathed in a saffron hue. Burnt Sienna is a colour that has many applications in mountain painting, as you have hopefully discovered, but as a base for a rich warm sunset it is ideal. I usually start with a warm Burnt Sienna ground and build up a simple palette of Burnt Sienna or Burnt Umber, a rich red, a yellow, a white, a blue and sometimes, but not always, Sap Green. I have introduced some new colours in this chapter which you may want to experiment with. However, in each composition be careful to limit your choice to a basic range, and try to mix colours from these rather than include many different reds, blues, greens and browns. Two important basic mixes to remem-ber are: blue mixed with red (or a warm tone) and white, to create the purple hues of mountains at sunset in clearer conditions; and yellow mixed with red or rich warm earth colours, effective when you want to make the sky, the vegetation and mountain slopes appear golden.

◀ *Eventide, Windermere*, detail, oil on canvas.

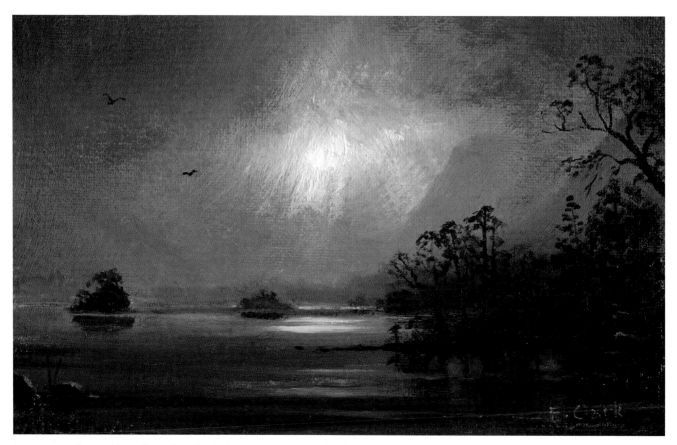

Derwentwater Sunset. This small painting of a winter sunset was composed with a very limited palette. Burnt Sienna was mixed with yellow, red and white for the highlights, and Burnt Sienna mixed with blue to create the deep silhouettes and shadows. When painting quickly out of doors, a small range of colours makes the control of tonal values and hues much easier to manage.

THE TRANSFORMATION AND WHAT TO LOOK FOR

As the sun moves downwards to the horizon, the details on the mountainsides are lost and the hues of the mountain slopes and the sky go through a transformation. As the shorter wavelength blue light is scattered, the longer wavelengths (which are at the red end of the spectrum) are reflected in both the clouds and on the mountainside. Look out for two particular lighting conditions, which provide exciting and atmospheric subject matter for the mountain painter:

When the atmosphere is fairly clear the higher clouds reflect the red and orange light. This is because the clouds are high enough so that the light reaches them directly without passing through dusty or moisture-laden air. On these occasions the clear sky often turns a rich blue/cyan tone. The mountains are almost silhouetted if the sun is setting behind them. Frequently they turn a deep, rich purple/blue shade.

On other occasions, when the air is either dusty or moisture-laden, sunset will produce a misty effect on the features of the landscape. The whole scene will often be bathed in a rich, warm light. The clear, crisp shapes of mountain summits and slopes, along with woods and moorland, will be softened by a saffron haze. Trees in particular, when they catch the golden light, will either be fringed with warm tones or will take on a rich brown colour as the light shines through them.

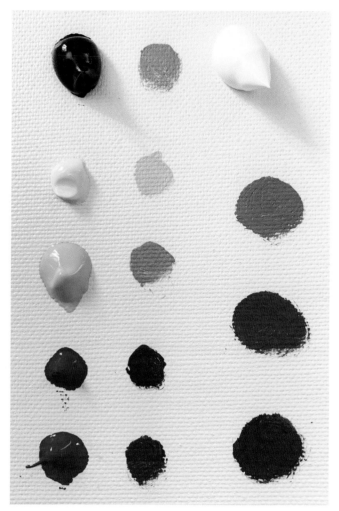

Some warm sunset colours (these are acrylics). The colours from top to bottom (left-hand column) are: Burnt Sienna; Light Bismuth Yellow; Hansa Yellow (opaque); Pyrrole Red Light; Cadmium Red Light. The central column shows the colours produced by mixing these with Titanium White (pictured at the top of the right-hand column). The rich orange hues on the right vary according to the mix of red and yellow. Experiment with the reds and yellows you already have in your collection, or try some new ones.

Some deep shadow colours. The two colours on the top row will be familiar, being the colours used most frequently throughout the book – Ultramarine Blue and Sap Green. The colours pictured in the second row down from left to right are: Burnt Sienna (also familiar); Burnt Umber; and Van Dyke Brown (Hue). The rich dark colours in the next row down are formed by mixing the colours from the second row with Ultramarine Blue. The fourth row down is similarly formed but this time by mixing the colours with Sap Green. The bottom row are examples of dark mid-tone colours formed by adding a little white to the row above. Experiment with these and other colours to create deep dark shades, rather than resort to black.

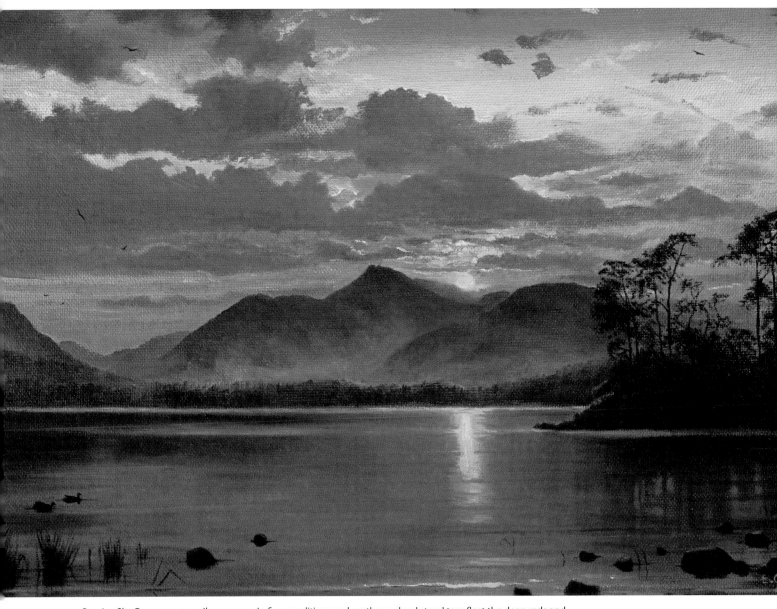

Burning Sky, Derwentwater, oil on canvas. In fine conditions such as these, clouds tend to reflect the deep reds and oranges of the light from the setting sun. Mountain hues, which in daylight are usually a mixture of greens and browns nearby, transform as the red light makes them appear more purple. Details and profiles of crags and ravines are flattened out, often with light mists in the valleys reflecting some warm tones.

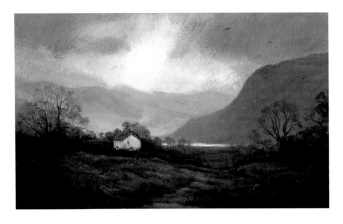

Sunlit Cottage, Crummock. This is a small oil painting, mostly produced en plein air, with some detail added in the studio. In moisture-laden air, the definition of the ridges in the distance becomes obscured. The sun breaking through clouds creates highlights on the fellside and cottage. Some green tones are still visible, contrasting with the warm colours on the vegetation catching the light. Notice the trees, which are semi-transparent as the light shines through them. These were painted using Burnt Sienna enriched with red and yellow.

Fiery Sky, Derwentwater

This exercise is based around a section of the finished oil painting featured earlier in this chapter, *Burning Sky, Derwentwater*. It is intended to be a short, practice piece using fast-drying acrylics, not slow-drying oils. Try to spend no more than three to four hours to complete the basic steps. The acrylic colours used are drawn from those featured in the illustrations pictured earlier in this chapter: 'warm sunset colours' and 'deep shadow colours'. It not essential to buy these colours, but a basic bright red, rich yellow, and the usual Burnt Sienna, Ultramarine Blue and Titanium White will be needed. You can begin this exercise with a warm base (which has been coated with a thin layer of Burnt Sienna mixed with a little red, yellow and white as usual) and then in Step 1 apply a base which instead of being one colour progresses from a light cool colour to warmer and darker at the bottom. Alternatively, simply apply the Step 1 base directly onto the white board.

YOU WILL NEED

- Quick-drying acrylics (I am using standard Golden acrylics):
 - Burnt Sienna
 - Titanium White
 - Warm rich red (I am using Pyrolle Red Light)
 - Strong warm yellow (I am using Hansa Yellow Opaque)
 - Light Bismuth Yellow (not essential but useful for highlights)
 - Blue (I am using Ultramarine Blue)
- Palette for mixing
- Water for thinning, or acrylic medium to increase flow (do not choose a medium which extends drying time)
- Brushes for acrylics: you will not need as many brushes as you may need for oil painting, as acrylics are so much easier to wash between uses. A handy cloth and a large water jar will do the job
- Filbert brush: 1 medium size, approx. 4 to 6 if preferred instead of round, for mountain edges
- Fan brushes: small soft, medium, and large
- Round brushes: 1 or 2 × size 2 to 4, also size 2 to 6
- Small round pointed brush for fine detail, size 0 to 1
- Brush and equipment cleaning materials: paper towels, water
- Support: I have used a Jackson's white gesso panel, 8 × 16in with an acid-free acrylic gesso ground, which has a light texture and fine-tooth surface. This is not a finished piece, however, so the support could be either a prepared board or very thick paper coated with a thick acrylic base. I painted on an 8 × 16in board and used the main central area for the demonstration. If you want to develop the painting in the future, choose a support with more longevity than paper

Step 1: Establishing a base. Mix some light blue cool tones, and also some deep, warm, rich sunset colours. The base should be made up of a thin area of light blue at the top of the composition, progressing to a warmer area and deeper shades at the base. Use a flat 1in brush or large fan brush to apply the colours, and blend them using a fan brush as you go (for the sake of this exercise, I have marked in an area to indicate roughly where I expect to paint in the sun). Allow to dry.

Step 2: Blocking in tones and hues. Emphasize the division between the lighter blue area at the top, the central warm band, and the darker rich shades at the base of the picture. Use a medium fan brush to lightly blend the three zones to avoid harsh lines, but not so much that they become indistinct. Allow the paint to dry.

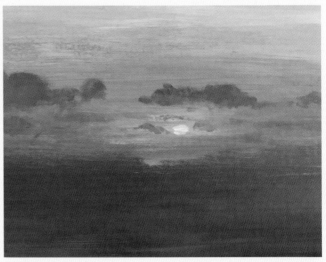

Step 3: Painting the sun. To create a glowing effect around the sun, the colours should progress from an inner white ball (keep it small) to deep purply-red in areas well away from the sun. Try to create the following transition: white; yellowy white; yellow; yellowy orange; reddish orange; red; and finally, purply-red. Try to softly blend the colours so that they do not look like obvious rings. A small soft fan brush is useful for this.

Step 4: Basic cloud shapes. To paint the cloud shapes, mix a shade similar to the tone of the deeper more purple shades that appear in the bottom half of the composition. Use a size 4 or 6 round brush to create varied shapes. These should contrast strongly with the warm orange and yellow shades of the sky. Allow to dry.

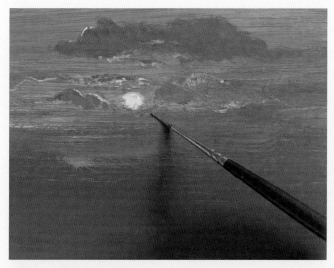

Step 5: Highlights on the clouds. Use a small, pointed round brush, size 1 to 2, to paint in some highlights on the clouds. Use bright white tinted with yellow or orange to paint in tiny touches on the clouds, particularly where they are closest to the sun. Do this very sparingly.

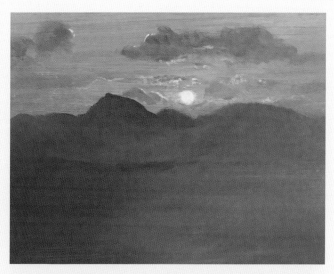

Step 6: Painting in mountain shapes. Paint in the mountains using a deep purple shade mixed from red, blue and a little Burnt Sienna. Add a little white if the shade is too dark. This shade should contrast strongly with the warm sky. A medium round brush or filbert is suitable for this step, in order to create some smooth edges. Allow the paint to dry.

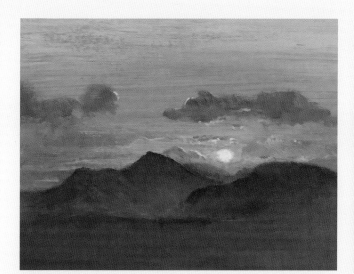

Step 7: Emphasizing mountain lights and shades. Paint some warm highlights on the distant mountains close to the sun, which will catch the light. Use a deeper shade of purple to paint in the shadowed areas of the mountains, and some very muted lighter shades to hint at the mists reflecting light at the mountains' base. These contrasts should be muted, as the sun is behind most of the mountains.

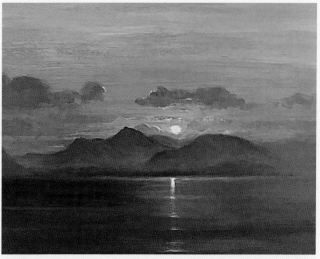

Step 8: The water. Create the lake surface by first painting areas of colour using downward strokes with a medium round brush. Horizontal strokes using a fan brush to blend will create the appearance of a disturbed water surface. Sunset reflections vary in their clarity depending on the state of the water. Flat calm water will often produce sharp, dark mountain and sky reflections. Disturbed water will scatter the light (*see* Chapter 8 for more detailed instructions on painting a lake surface). Even on disturbed water, the sun will usually form an elongated bright column, brighter in the centre and redder on the outer edges. The column will become progressively more fragmented as it approaches the foreground.

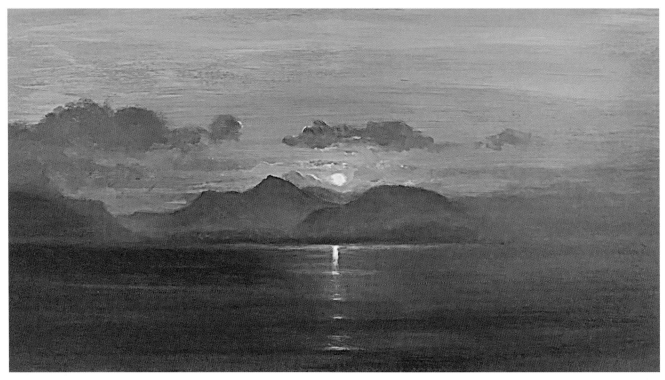

Fiery Sky, Derwentwater: full 16 × 8in practice piece in acrylics.

Having completed this practice piece, you may wish to add extra details to develop the work into a complete painting. If you decide to move on to a new sunset, working outdoors quickly with acrylics is an effective way of capturing the subtlety of the colours, and photographically recorded details such as trees can always be added back in the studio.

ATMOSPHERE, AND NAMING THE PAINTING

Having completed a mountain painting that is ready to be put on show, do not forget to give it a name. Titles are powerful, as they influence the way a painting is interpreted, and often give the viewer a greater opportunity to identify more strongly with the painting and to 'feel' the atmosphere. Spend some time thinking about the words you choose to describe your work, and which aspects of the mountains you want the viewer to experience when they look at it. One of the greatest compliments a mountain painter can be paid is, in my opinion, that the painting is 'atmospheric'. I think what this means is that something about the work has evoked a memory or feeling about the mountains, and for some important reason this affects the viewer in a deep and personal way. Sometimes paintings that are technically 'perfect' fail to make this connection.

I hope that this book has equipped you with new skills and a greater understanding of painting the mountain landscape. More than this, however, I hope that you are able to use those skills to build on your individual style, and to communicate your own personal vision of the wonderful mountains you learn to know, love and paint.

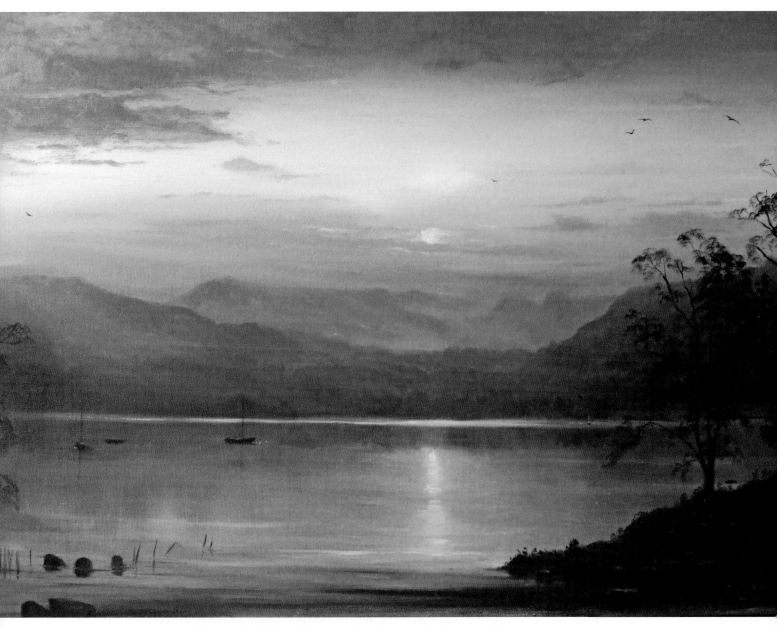

Eventide, Windermere, oil on canvas. Sometimes, when the sun sets over Windermere behind the Langdale Pikes, it produces a rich, red, fiery sky like the one in the last exercise. At other times, however, it is gentler, and the light is a warm yellow rather than a deep red. This kind of sunset, pictured here, is often very transient. It suffuses the Langdale Pikes and surrounding fellsides with a golden hue, until the sun disappears entirely and the mountains become dark inky-blue shapes against the sky.

Saving Your Mountain Landscapes

WRITTEN BY GRAHAM CLARK

An original mountain landscape painting is a unique and expressive representation of a place and a time – and of the person whose efforts have brought it into being. Painted originals are fragile, however, and the media used for their creation limit how effectively a work can be preserved, protected, shared or transported. Examples of the vulnerabilities of original paintings include:

- **Accidental (mechanical) damage:** Surface impacts, including pressure on canvas; scratches; contact with any object before paint or varnish is fully cured or dried.
- **Sunlight:** Ultraviolet light (particularly direct sunlight) fades and degrades many paint colours.
- **Water:** Support materials, including wood frames and board, swell and distort when wet. In high-humidity environments, damp or wet canvas shrinks. This cracks paint and can tear stretched canvas; it also provides a medium for mould growth. Contaminated water (for example from flooding) adds organic and chemical pollution to the toxic mix.

IMAGE (DATA) CAPTURE

The availability of increasingly powerful digital photographic and computing hardware and software in recent decades has made it possible for artists to themselves create, or to commission, digital copies of their work suitable for their personal or commercial use. For many artists, capturing and saving high-quality digital images of their originals as soon as possible after completion (*see* the note on timing this, below) is now an essential part of their practice. For some, this is an economic necessity if they are to gain significant financial benefit from their work. For others, this may later become so, but this choice will only be feasible if the required care has been taken, perhaps over an extended period, to ensure that these images are of a suitably high quality – a policy known as future-proofing. Once acquired, such images can be modified or enhanced for a variety of purposes, using appropriate computer applications, by anyone with the skills and legal right (including copyright) to do so.

A note of advice about timing: high surface reflectivity, such as that from a still-drying original, or from glossy protective varnishes, can make accurate image capture problematic. Therefore, if you plan to varnish originals once they've dried (cured), consider doing so after they've been archivally photographed.

◀ From canvas to digital image.

The red square (arrowed) indicates the area of this picture enlarged in the next picture, to the point where the pixels become visible.

These are some of the thousands of pixels (often millions, measured in 'megapixels') that make up this image, as in every picture in this book, and every scanned or photographed image of the author's work.

Scanning

An alternative to digital photography for image capture is scanning. Some flatbed scanners designed to capture colour photographs, attached to a personal computer, can be configured to make extremely detailed digital images of small, dry original paintings. At sizes larger than A4 (approx. 11.7 × 8.3in), however, an artist's scanning options become significantly limited and more expensive. Galleries, museums and some fine art printers use professional scanning services, or themselves invest in specialist photographic and 'moving-table' scanning equipment typically costing tens of thousands of US dollars. An artist wishing to use such a service must also arrange and pay for the safe transport of their work to and from the scanning provider of their choice. An online search for 'fine art scanning' can help to locate such services.

Stitching or 'photo-merging' (industry-standard graphics software running on suitably powerful personal computers) can 'stitch' together part-images of a set of photographs or scans to recreate a panoramic scene (or a complete artwork). Beware, though, that although this option makes it possible to use a high-end A4 scanner to make multiple, overlapping part-scans of a dry original painting, then to stitch the scans together to create a single, very large image file, this procedure is labour-intensive and requires great care at the scanning stage to be successful.

Photography

The increasing sophistication of the digital cameras on mobile (cell) phones and tablet computers might suggest that these can be used to capture images of mountain landscape artwork suitable for high-quality reproduction, detailed modification and future-proofing. This is not the case. If it were, galleries, museums and professional photographers would do so. They don't. Digital images, whether still photos or video, require a lot of storage space. The more detailed an image (also known as its 'resolution'), the larger the file size that any device has to store, and the larger the image that can then be displayed (or printed) without loss of detail. Very high-resolution images of paintings, if accurately focused and skilfully illuminated when captured, have the potential to be displayed on a scale of metres without loss of detail, or for smaller sections of such images to be used as individual illustrations (as in this book, at the start and end of chapters).

Digital images are made up of arrays of tiny squares of graphical information known as pixels, as shown in the illustrated example (from Chapter 4). For most display or printing purposes, it is important that these pixels remain invisible (invisibly small) to a viewer, even at the large magnifications that may be required of an image – that is to say, to avoid pixellation of the image.

In recent decades, the power of computing equipment available to the public has increased exponentially, while components have reduced in both their size and cost. This has also applied to electronic data storage media. During this period, various methods have been used to minimize the storage space required for digital photographs and/or video recordings. These include saving images in the lowest resolution acceptable for their intended uses – for example, for small pictures to be viewed only on web browsers or small screens, where fine detail and subtle gradations of colour are neither expected nor essential.

Another technique is known as data compression. Here, instead of a camera saving detailed information for every pixel in a photograph, very similar pixels are saved in groups, with their data 'averaged' across the group. An example is the image format known by the filename suffix of 'jpeg', or 'jpg'. This kind of technique or format is described as 'lossy', as some of the fine detail and colour data captured by a camera is 'lost' each time an image is saved (or opened, modified and re-saved) in such formats.

Colour depth is another variable that can be used to reduce image file size. The more precisely that colour shades can be specified in an image, the more accurately the original can be captured as a data file – but the larger the file size. In this case, the number of colours made available to record information about a picture may be limited where (as with resolution) this loss of data is acceptable for the intended use of the resultant image.

A painter of mountain landscapes seeking to photographically preserve as much as possible of the detail and subtle colouration used in their original paintings as they can should, therefore, aim to ensure that the 'archival' versions of their photographs achieve this – whether they decide to acquire the necessary skills and equipment to do this themselves, or entrust the task to a suitably experienced professional photographer or scanning agency. Very large image file sizes, of the order of hundreds of megabytes per image in a 'non-lossy' format such as 'tiff' or 'tif', are not excessive to capture the weeks or months of work that a large canvas may represent. Once such images have been acquired it is a straightforward task, using appropriately powerful graphics software, to reduce their dimensions, resolution or colour-specificity to match their intended usage. This is routine in the commercial use of artwork. If all this data hasn't first been photographically captured, however, and the original artwork is no longer available or is no longer in pristine condition, such choices no longer exist.

Capturing photographic images of mountain landscape features, both large and small, at any season, at different times of the day and in all weathers, so that these 'source' or 'reference' materials can be used to inspire and inform your paintings, is a very different matter. Cheap digital cameras, and the cameras in mobile (cell) phones have, for many years, been perfectly adequate for this purpose. The author's photographs of the English Lake District used as examples in this book are but a few among her collection of thousands taken, securely stored and organized since digital cameras became available to the general public. Being able, with minimal skill and at negligible cost, to take numerous colour photographs of a single subject from various viewpoints and in widely differing light conditions, or to capture details of trees, reflections on water, rock formations, dwellings and the inhabitants of the mountains, would have been the stuff of dreams for earlier generations of landscape artists.

Typically, such photographic images, taken outdoors, will initially be stored on the capturing device in a compressed format. Unlike archival-quality images of original artworks, however, this will rarely be of concern unless the photographer wishes to modify their photographs or sell the copyright to them. In this case, the photographs will typically be taken in 'RAW' format on a higher-specification camera, then converted to another 'non-lossy' format for further processing.

STORAGE: KEEPING THE IMAGES OF YOUR PAINTINGS SAFE

An artist deciding to save high-quality digital images of their paintings for the future may be investing in an increasingly valuable asset. Digital image files can be lost, stolen, physically damaged or corrupted (when the codes in which the data is stored can no longer be read by a computer system). To insure against such risks, it is prudent for artists to make (or have made) multiple digital copies of each archival-quality image file of their original artwork. One or more copies of these potentially valuable files can be stored locally on a computer or attached storage media

Painting the mountains. Modern digital methods offer the ability to preserve the finest details of your mountain paintings.

to which the artist has protected access, as can copies of their 'in-the-field', source-material photographs. Other copies can be stored on mobile media, designed to be easily transportable. Copies of the artist's archival-quality images should all be stored at a different geographical site from those saved on the local computer – in case of the loss of the computer and its attached storage, for any reason.

Another means of saving such data remotely (non-locally) is cloud storage. Based on the payment of a subscription to a major provider of such services, copies of digital files, including images, can be uploaded from a local computer to a data-processing and storage system (known as a 'server') at a distant location, via the internet. The data saved on such servers is itself backed up by further servers, typically at locations in more than one continent. Subscribers, who have secure (password-protected) access to their own uploaded files, can then download a copy of any of their cloud-based files to a computer of their choice, on request.

CONCLUSION

Possession of high-quality digital images of their work enables an artist to offer these to book publishers, publishers of fine art or other commercial interests. Such opportunities may arise years after the original paintings have been completed, although these may no longer be available to the artist as they were first painted – possibly because they have been sold, or for other reasons, as described above. The mountain landscape paintings in this book are just such examples. Capturing their work in digital form, therefore, truly enables an artist to 'paint for posterity'.

Suppliers

Boards

Ampersand
1235 S Loop 4, Ste 400, Buda, TX
78610, USA
www.ampersandart.com
T 800 822 1939
T outside US (512) 322 0278

Jackson's Art Supplies
1 Farleigh Place, Hackney
Downs, London
N16 7SX, UK
www.jacksonsart.com
T 020 7254 0077

Canvases

Winsor and Newton
21 Evesham St, Notting Hill,
London W11 4AJ, UK
www.winsorandnewton.com
T +44 (0) 208 424 3200

Harris Moore Canvases
Quality bespoke gallery canvases
12 Minerva Works, 158 Fazeley Street,
Birmingham B5 5RT, UK
www.harrismoorecanvases.co.uk
T 01216 333687

Easels and Lighting
(Studio Items)

SAA
Online community and shop
www.saa.co.uk
T 0800 98011233
T +44 (0) 207 245 0077

Framers

Grays Picture Framers
19 West Tower Street, Carlisle,
Cumbria CA3 8QT, UK
www.graysframers.co.uk
T 01228 531837

General Art Supplies

Jackson's (details above)

Great Art
Online supplier and at:
41–49 Kingsland Road, London E2
8AG, UK
www.greatart.co.uk
T 0300 303 4224

Paints and Mediums

Acrylics:

Golden Artists Colors inc.
188 Bell Rd, New Berlin, NY, USA
www.goldenpaints.com
T 800 959 6543

Oils:

Winsor and Newton (details above)

Holbein
175 Commerce St, PO Box 555,
Williston, VT 05495, USA
www.holbeinartistsmaterials.com
T 1 800 682 6686

Holbein Japan
2-2-5 Ueshio, Chuo-Ku, Osaka, 542
0004, Japan

Soap, Cleaning Materials

Ethical Superstore
c/o Spark Etail Ltd, Follingsby
Avenue, Follingsby Park, Gateshead
NE10 8HQ, UK
www.ethicalsuperstore.com
T 0333 400 0464

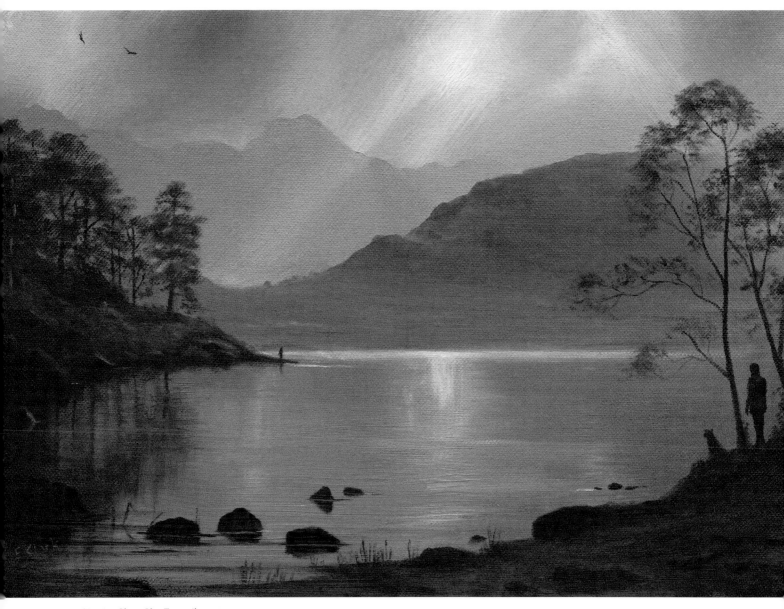

Meeting Place, Blea Tarn, oil on canvas.

Index